MAKING & MEANING

HOLBEIN'S AMBASSADORS

Esso *In association with Esso UK plc*

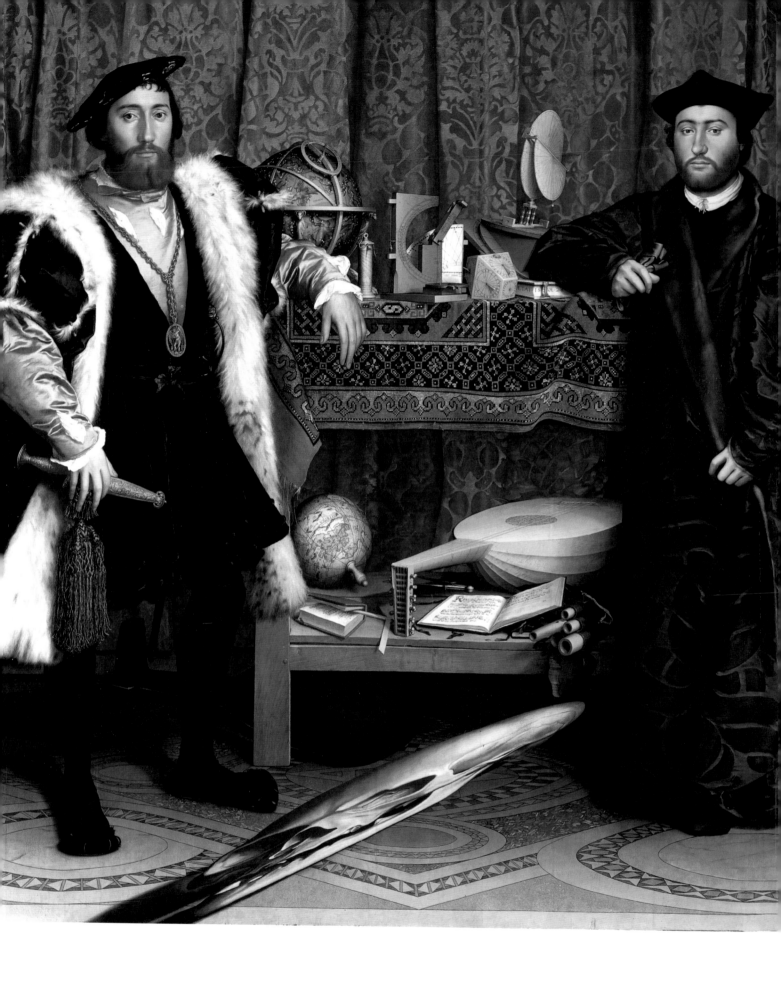

MAKING & MEANING

HOLBEIN'S AMBASSADORS

Susan Foister, Ashok Roy and Martin Wyld

National Gallery Publications, London
Distributed by Yale University Press

This book was published to accompany an exhibition at
The National Gallery, London
5 November 1997 – 1 February 1998
© National Gallery Publications Limited 1997

First published in Great Britain in 1997 by
National Gallery Publications Limited
5/6 Pall Mall East, London SW1Y 5BA

ISBN 1 85709 173 6 paperback
525268

British Library Cataloguing-in-Publication Data.
A catalogue record is available from the British Library.
Library of Congress Catalog Card Number: 97–69598

Editors: Felicity Luard and Celia Jones
Editorial Assistants: John Jervis and Katherine Tweedie

Designer: Andrew Shoolbred
Printed and bound in Great Britain by
Butler and Tanner, Frome and London

Front cover and frontispiece: Details from 'The Ambassadors'.
Back cover: 'The Ambassadors'.
(For full illustration see Plate 114, fold-out, at p. 112.)

Contents

Authors' Acknowledgements

During the investigation of Holbein's complex painting we have made demands on the expertise of a great many people from many disciplines to whom we should like to express our gratitude.

Elizabeth Brown has been deeply generous in sharing with us on many occasions her own research into the Dinteville family. Rosalys Coope has likewise been unstinting in advising and assisting research into the original location of Holbein's painting, the château of Polisy.

We are most grateful to our colleagues in other museums who welcomed us and allowed us to make close examinations of their own works by Holbein, in particular to Peter Berkes, Bernd Lindemann and Christian Muller at Basel, to Gisela Helmkampf and Reindert Falkenburg at Berlin, to John Hand, David Bull and Cathy Metzger at Washington, and to Alan Darbishire and Katie Coombs at the V&A, Christopher Lloyd, Vanessa Remington and Viola Pemberton-Pigott at the Royal Collection, and Catherine MacLeod and Richard Hallas at the National Portrait Gallery. Many lenders to the exhibition have also kindly allowed close examination of their works, and we thank them.

We should also like to thank the following: François Avril, Peter Barber, Giulia Bartrum, Claude Blair, Riccardo Famiglietti, Marlies Giebe, Viviana Giovanozzi, James Bissell-Thomas, Jean Guillaume, Willem Hackmann, Charlotte Hale, Françoise Hamon, Karen Hearn, Alexzandra Hildred, Maurice Howard, Pierre Janin, Brian Jenkins, Peter Klein, Kristen Lippencott, Alan Mills, John Mills, Lisa Monnas, Frances Palmer, Glenn Richardson, Edgar Samuel, Margaret Scott, Pauline Smith, Hubert von Sonnenburg, the staff of the Archives Départmentales and the Office de Tourisme at Troyes, Ian Wardropper.

Finally we should like to thank our colleagues in the National Gallery for all their assistance in the preparation of this exhibition.

Works illustrated are by Hans Holbein the Younger unless otherwise stated.

Sponsor's Preface

It is a pleasure to be once again associated with the National Gallery in this the fifth exhibition in the 'Making and Meaning' series.

As in our previous exhibitions with the Gallery, 'Holbein's Ambassadors' exemplifies the quality of research and scholarship that are the Gallery's hallmarks. We are pleased that the exhibition offers the opportunity to place the newly restored picture in its technical, scientific and historical context. The exhibition is a fitting culmination to the 'Making and Meaning' series.

Our sponsorship of the National Gallery has been established since 1988 and we are pleased that this has enabled the Gallery to explain in depth to the general public more about its vast array of treasures. We are delighted to continue our relationship again this year and fully support the gallery in its very worthwhile mission of increasing public understanding and appreciation of its collection.

K. H. Taylor
Chairman and Chief Executive, Esso UK plc

Foreword

It must be admitted that, as a diplomatic venture, Jean de Dinteville's stay in London yielded little. Sent by the French King to safeguard relations with Henry VIII, this wretched ambassador, who gazes stoically out from the left-hand side of Holbein's painting, had little to do but hang about the English court, waiting for the heavily pregnant Anne Boleyn to be crowned Queen. It was hardly a plum posting, and in this dispiriting process he contrived to grow tired both of London and of life.

In the spring of 1533, however, when spirits were at a low ebb, his friend, Georges de Selve, a bishop who had represented France to the Diet of the Holy Roman Empire, came to visit him, and Dinteville commissioned Holbein to paint their portraits. It is the most lasting achievement of Dinteville's embassy. It is also one of the supreme moments of Renaissance portraiture, Holbein's largest surviving work in the genre and, after a hundred years in public ownership and on public view, one of the most familiar and popular pictures in Trafalgar Square. It is one of the most puzzling too, filled with objects that intrigue and perplex: the broken lute string, the globe showing the edge of a recently discovered America, a range of instruments for measuring time and space, a ready reckoner and a Lutheran hymnal – all depicted between a distorted skull and a half-concealed crucifix.

This exhibition, the fifth in the 'Making and Meaning' series, tries to tease out some of their meanings and to place the picture in the scientific, political and religious world of the two friends. It also examines the picture as a complex object in itself, the result of a long process of great skill, about which much was learnt during the painting's recent conservation.

Holbein's picture conjures a floating, fallible world, in which the certainties are death and salvation and the enduring delight is friendship; and the National Gallery could not have mounted this exhibition about it had we not also been fortunate in our friends. Many lenders have kindly entrusted to us their possessions (as diverse as those in the picture itself) and the whole venture has been made possible by the continuing generosity of Esso UK plc, who have supported this and all the other 'Making and Meaning' exhibitions. That is, like Holbein's *Ambassadors* itself, a monument to a long friendship, for which the National Gallery, and hundreds of thousands of visitors, are very grateful.

Neil MacGregor
Director

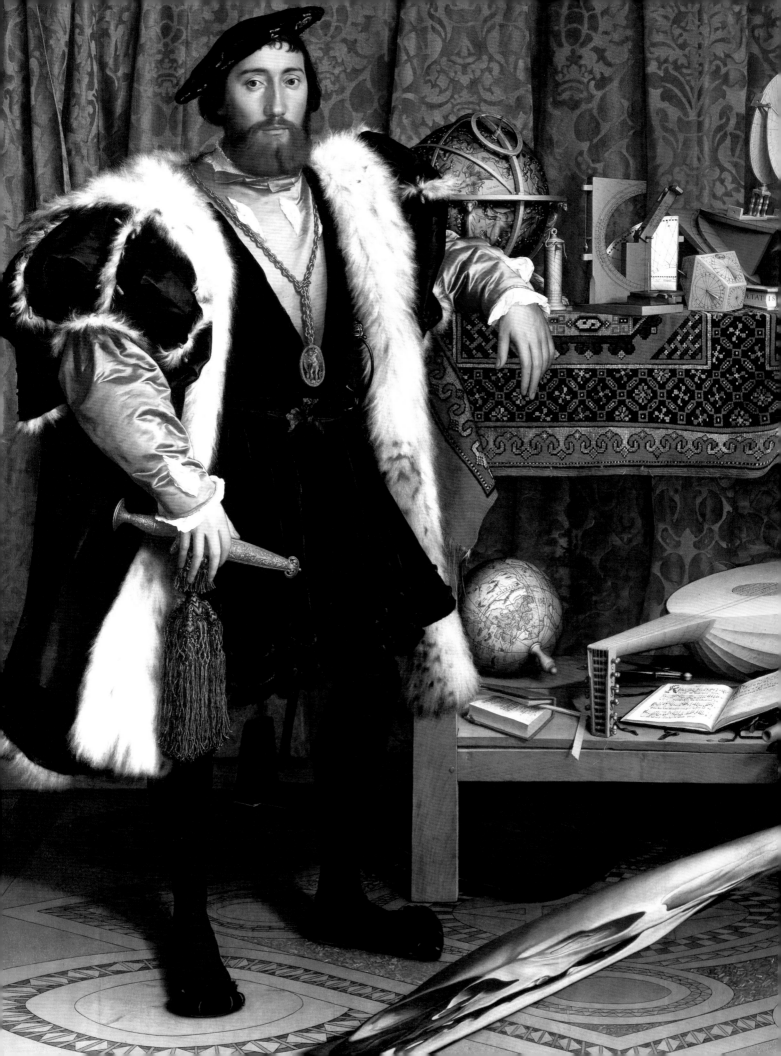

Introduction

Holbein's magnificent double portrait of 1533, known as *'The Ambassadors'*, is one of the best-known paintings in the National Gallery, where it has hung for just over a century. It is also one of the most intriguing, with its array of objects, many of them unfamiliar today, and its famous distortion of a skull, which has long puzzled observers: one former Keeper of the National Gallery, Ralph Wornum, whose life of Holbein was published in 1867, described the mysterious object as 'like the bones of some fish'. [1]

On the left of the painting stands Jean de Dinteville, French ambassador to England in 1533, resplendent in pink satin and a black satin gown trimmed with velvet and lined with lynx. On the right is Georges de Selve, Bishop of Lavaur, who visited him in England in the late spring of that year. The cleric presents a more sober aspect in a long brown damask robe, although the cloth he wears, with its gigantic pattern, is outstandingly luxurious and would have been highly expensive. [2] The embossed decoration of Dinteville's dagger tells us that he is in his twenty-ninth year, while an inscription on the book on which de Selve rests his arm reveals he is in his twenty-fifth year. Between the two men are shelves full of objects: globes of heaven and earth, other astronomical instruments, books and musical instruments. Behind is a green damask curtain, which at the top left-hand corner has been drawn aside just sufficiently to reveal a silver crucifix. The two men stand on a pavement inlaid with coloured marbles in an elaborate design. Between them, at a diagonal in the foreground, is a long greyish shape, the distorted skull.

This, then, is an unusually elaborate portrait, and the artist, Hans Holbein, has trumpeted his authorship. In the lower left-hand corner, on the floor, is his signature in Latin, 'Ioannes Holbein pingebat', and the date 1533 (Plate 2). This is one of the fullest forms of signature ever used by the artist, and one of the most prominently placed. It proclaims a masterpiece, one of the largest panel paintings produced by Holbein, and the most elaborately meaningful of all his surviving portraits.

Hans Holbein the Younger, born in Augsburg in Germany in 1497/8, but by 1515 established in Basel as a painter and designer of prints, had first come to England for two years in 1526. [3] Although the Reformation had not yet touched England, newly hostile attitudes to religious images were already creating difficult conditions for artists. Shortly after Holbein's return to Basel in 1528, that city became Protestant. It was probably a violent outburst of iconoclasm in 1529,

1 Detail of *The Ambassadors*: Jean de Dinteville. For full illustration see Plate 114, fold-out, at p. 112

2 Detail of *The Ambassadors*: Holbein's signature and date.

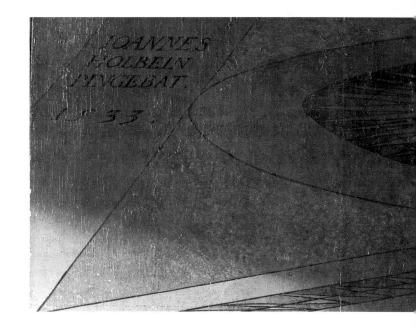

Remarques sur le suject d'un tableau excellent des S.rs d'Inteuille Polizy, et de George de Selue #
En ce tableau est represente au naturel Messire Jean de DInteuile, cheualier Sieur de Polizy pres de
Bar sur seyne Bailly de Troyes, qui fut Ambassadeur en Angleterre pour le Roy Francois premier es
annees 1532 & 1533. & de puis Gouuerneur de Monsieur charles de France second Fils, diceluy Roy,
le quel Charles mourut a foren monstier en l'an 1545, &. le dict Sr de DInteuile en l'an 1555 sepulture
en l'eglise du dict Polizy. Est aussi represente audict tableau Messire George de Selue Euesque de
Lauaur personnage de grandes lettres & fort uertueux, & qui fut Ambassadeur pres de L'Empereur
Charles cinquiesme, le dict Euesque Fils de Messire Jean de Selue premier president au parlement de
Paris, iceluy Sr Euesque decede en l'an 1541 ayant des la Jusdicte annee 1532 ou 1533 passe en
Angleterre par permission du Roy pour uisiter le Jusdict Sieur de DInteuile son intime amy & de
toute sa famile, & eux deux ayant rencontrey en Angleterre un excellent peinctre holandois,
s'employerent pour faire iceluy tableau qui a este soigneusement conserue au mesme lieu de
Polizy iusques en l'an 1653

Euesque de Lauour contenant leurs emplois, et tems de leur deceds.

3 Fragment of an inventory dated 1653
identifying the sitters in Holbein's painting
Manuscript, 18 x 34.5 cm. London, National
Gallery

in which numerous religious paintings were destroyed, which
decided Holbein to return to England again in 1532. This
time he stayed until his death in London in 1543. During this
second visit he was appointed to the post of King's Painter. In
England Holbein concentrated his considerable talents large-
ly on portraiture and the design of jewellery and metalwork,
rather than on the painting of altarpieces and the design of
woodcuts, engravings and stained glass, as had been his prac-
tice in Basel.

Although there were many artists capable of decorating
the royal palaces in early Tudor England, there were few who
would have had the opportunity to become skilled in por-
traiture. Unlike continental Europe, there was apparently no
thriving portrait tradition here. But portraitists of Holbein's
stature were rare anywhere. His ability not merely to take an
excellent likeness, but to establish a sense of physical presence
and character almost unparalleled among his contemporaries,
put him among the most outstanding of European por-
traitists, whom any ruler would have been glad to attract to
his court. He most famously served Henry VIII in the late
1530s by providing the King with portraits of potential
brides. Only three of these images survive: one of Christina
of Denmark (now also in the National Gallery; Plate 64),
whom he did not marry, and two of Anne of Cleves (see Plate
103), whom the King married in 1539, only to divorce her
shortly afterwards. Holbein also portrayed Henry himself,
notably with his third wife, Jane Seymour, in 1537, in the
great wall-painting at Whitehall Palace (lost in the fire of
1698) (see Plate 8). Here the King and Queen were shown
full-length and life-size with Henry's father, Henry VII, and
Elizabeth of York. A Latin inscription between them celebrat-
ed the Tudor dynasty. However, Holbein's appointment also
allowed to him to portray courtiers – and ambassadors. Four
years before the Whitehall composition, a dress-rehearsal for
it had been provided by the elaborate full-length double por-
trait of the two Frenchmen known today simply as *The
Ambassadors*.

Until the beginning of this century, when the identities of
the two Frenchmen were finally established by the detective
work of Mary Hervey, the true names of the two men in the
National Gallery portrait were a mystery, but it was com-
monly assumed that both were English. This was not an
unreasonable supposition, since Holbein produced many por-
traits of English men and women during his long stay in
England, in addition to his work for King Henry VIII.

Holbein's *Ambassadors* had arrived in England from France by the last decade of the eighteenth century, and was bought by the 2nd Earl of Radnor in 1808,[4] one of the huge number of pictures from continental collections dislodged by revolutionary upheavals and the Napoleonic wars. The painting was sold to the National Gallery in 1890 by the 5th Earl of Radnor, and the public interest in it served to intensify the search for the identities of the sitters. The poet Sir Thomas Wyatt was suggested as one possible candidate, among several others, including Richard Pate, Archdeacon of Lincoln, and Sir Hugh Askew, Yeoman of the Royal Cellar. Reading the name of the Dinteville château of Polisy on the globe in the year the painting was acquired, Sir Sidney Colvin of the British Museum correctly proposed that the left-hand sitter was Jean de Dinteville, but speculation continued still, and no one could identify his companion.[5]

In 1900 Mary Hervey, a distinguished historian who went on to write the life of the great seventeenth-century collector, the Earl of Arundel, published her book, *Holbein's Ambassadors*. She alone had found the clues to solve the mystery of the second sitter's identity in seventeenth-century French documents, which also unlocked the history of the painting.[6] These findings led her back to the Dinteville family château of Polisy, on the borders of Champagne and Burgundy, where, she was able to show, the painting had hung early in the seventeenth century, until removed to Paris in 1653 by the family's descendants and probably taken to south-west France.[7] Miss Hervey herself acquired and presented to the Gallery the fragment of parchment inventory dated 1653 which constitutes the earliest record of the names of the sitters (Plate 3).[8]

Much has been written on the interpretation of Holbein's *Ambassadors* since the publication of Miss Hervey's excellent book, which established most of the facts concerning the painting's history and much concerning its content. However, it has only recently become possible to reassess properly many aspects of the painting following the cleaning of the picture undertaken at the National Gallery, and completed in 1996.[9] The condition of the right-hand side of the painting is excellent; substantial losses of Holbein's original paint are largely confined to the left-hand side and the lower edge – to the skull and parts of the clothing of Jean de Dinteville, including his medallion of the Order of Saint Michael, where, although the chain is Holbein's, his medallion is gone and the old restoration of it has been left in place. It is not clear why such uneven damage to the picture arose, but it was probably caused by water. Old attempts to deal with the picture's condition had made much of its detail hard to read. As a result of the cleaning some of the inscriptions on the instruments and books became clearer, and in one area – the hymn-book – letters that had been completely obscured by old repaintings were recovered. We can now be virtually certain of what Holbein intended to paint, which was not the case before. In particular, much of Holbein's distorted skull, where some old damage to the paint surface had occurred, had been covered by early restoration, and what Holbein originally painted is now revealed.

The first part of this book therefore re-examines the content of the painting in the light of this new knowledge. What can be discovered of the background to the commissioning of the painting during Dinteville's embassy to England of 1533 and of the painting's original location in France provides information essential to our understanding of the function of the objects in the painting. Experiments conducted with the aid of the Gallery's Scientific Department, including computer-modelling with images of the cleaned skull, have helped to bring fresh information to bear on the problems of how the distortion of the skull was produced and how it was meant to be viewed. These considerations all contribute to the reassessment of the meaning of the painting that is presented here.

Cleaning *The Ambassadors* has also facilitated a full technical examination, and the second half of this book discusses what has been discovered of the ways in which Holbein designed and painted this extraordinarily complex and elaborate painting. It sets *The Ambassadors* in the context of the development of Holbein's art as a painter, and shows how the National Gallery painting epitomises Holbein's rich and painterly style.

Although the personal nature of the commission ensures that there will continue to be debate about the painting's meanings, the brilliance of its execution can now be understood and appreciated all the more. The care Holbein took to ensure the prominence of his signature on this work – hidden in murk before the recent cleaning – can today be seen to be fully justified. *The Ambassadors* is in all probability the work by which the artist himself wished to be known to posterity.

Jean de Dinteville and Georges de Selve: The French Embassy of 1533

On 23 May 1533, Jean de Dinteville, the French ambassador in London, wrote to his brother François, Bishop of Auxerre: 'Monsieur de Lavaur did me the honour of coming to see me, which was no small pleasure to me.'[1] He went on to say that there was no need for the Duc de Montmorency, the most powerful man in France after the King, to hear anything of this visit. In a second letter to his brother, dated 4 June, he wrote once more: 'Monsieur de Lavaur came to see me, but has gone away again.'[2] The only other record of this secret visit is the painting – more than two metres square – today in the National Gallery, in which both Jean de Dinteville and Georges de Selve are depicted.

Jean de Dinteville was a member of one of the most influential and cultivated families in France. Close to the King, Francis I, members of his family held important and trusted positions in the royal household. Such men were valued as ambassadors, representing French interests by sending back frequent reports on events at foreign courts, often in code. Jean de Dinteville's elder brother François II, Bishop of Auxerre, was for many years French ambassador at the papal court in Rome. Jean de Dinteville himself was first sent as an ambassador to England in 1531. The embassy of 1533 during which he was painted by Holbein was by far his longest period in England, but he was sent to England again on three more occasions, in 1535, 1536 and 1537.[3] In 1537 the Dinteville family underwent a dramatic fall from favour, described in more detail in the next chapter. Although in the following decade their fortunes were restored, Jean de Dinteville undertook no further diplomatic missions, he suffered a paralysing illness, and died in 1555 at the age of fifty-two.

Georges de Selve was born in 1508/9, and made Bishop of Lavaur in south-west France in 1526, while still in his teens, although he was unable to officiate as a bishop until his consecration in 1534.[4] Like Dinteville's brother, he spent much of his life as a diplomat, also in Rome, but at the court of the Emperor Charles V, and in Venice too. He appears to have been much affected by the religious divisions in Europe which had arisen as a result of the Protestant Reformation. In 1529 he attended the Diet of Speyer, one of many meetings in the German lands of the Emperor Charles V where a reconciliation between Catholics and Protestants in Germany was attempted; after this Diet the Protestants were set on their separate path. De Selve's *Remonstrances ... aux dicts Alemans*, his own personal plea to the German Protestants to leave aside their differences and reunite a Christian Europe, was evidently prepared as an address to this Diet. Such thoughts of unity remained a dream, and de Selve died in 1541, an experienced diplomat, though aged only thirty-two.

By 1533, the year of Holbein's painting and of Dinteville's second visit to England as French ambassador, religious differences in Europe had worsened, and the political problems had become more complex, in particular the always delicate balance of relationships between England, France and the Holy Roman Empire. Protestant beliefs, well established in the German-speaking lands of the Empire, were spreading rapidly to other countries, including France and England. The power of the Emperor Charles V, ruler of Spain, the Low

4 Detail of *The Ambassadors*: Georges de Selve

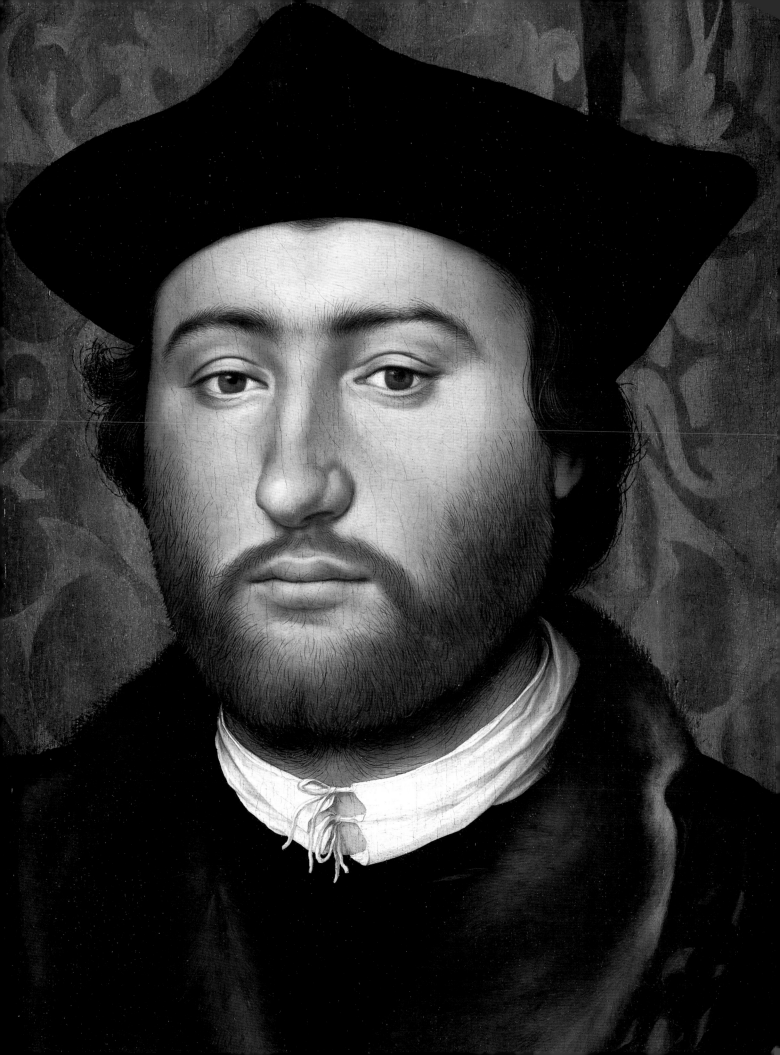

Countries, Burgundy, Germany and Austria, now extended to parts of Italy. In 1524 at Pavia he had inflicted a humiliating defeat on the French King, previously dominant in Northern Italy, and his troops had sacked Rome in 1527.

The political problems of England – and their potential repercussions for Europe, and, especially, for France – were particularly acute in 1533. It was vital for Francis I to have accurate reports of what was going on. Henry VIII desired to divorce Catherine of Aragon to marry Anne Boleyn, since Catherine, the aunt of Charles V, had not borne him a male heir. In the absence of co-operation from the Pope, who was a virtual prisoner of Charles V, the King's solution would be to declare that the Church of England had always been a separate institution from that of Rome. Although Henry VIII was personally unsympathetic to Protestant beliefs, the path he would take opened the way to a Church of England adhering to the new Protestant doctrines. Such developments were worrying for the French King, for they might decisively jeopardise relations with the Emperor and France's position in Europe. Good relations between England and France had endured since 1527, when a peace treaty was signed, and the two Kings had endowed each other with the Order of their respective countries, the English Order of the Garter, and the French Order of Saint Michael; it is the pendant badge of the Order of Saint Michael which Jean de Dinteville wears in Holbein's painting. But in 1533 it seemed that the Anglo-French relationship might be threatened, and even that Protestantism might triumph in Europe.[5] Although both Jean de Dinteville and George de Selve were certainly acquainted with humanists in France sympathetic to Protestant beliefs, and undoubtedly sympathised with the desire for Catholic reform, the divisive nature of the Protestant movement was now clear. Moreover, Francis I was about to embark on a devastating purge, from his court and from Paris, of those with Protestant sympathies.[6]

On 25 January 1533 Henry VIII took a crucial step in the break with Rome and secretly married Anne Boleyn.[7] Jean de Dinteville had already left France for England in order to discover and report on these new events. In May 1533 Henry's marriage to Catherine was finally annulled and the marriage to Anne declared valid by Cranmer, the new Archbishop of Canterbury. Time was short, as Anne was pregnant, and she had not yet been crowned Queen. In his letter to his brother in France dated 23 May, Jean de Dinteville wrote of the coronation, and on 4 June he wrote again: 'This Queen is heavily pregnant'.[8] On 1 June Anne's coronation took place in Westminster Abbey, an event of considerable splendour, which Dinteville attended as French ambassador. It was an occasion that, as he complained on 23 May, involved him in considerable cost, for both clothing and entertainment: 'I shall have to go to great expense for this coronation', he wrote, and he hoped that the money could be swiftly reimbursed.[9]

Anne's pregnancy had delayed Dinteville's stay in England, originally meant to last only six months. He was anxious to return home, yet he was compelled to await the birth of her child, to whom Francis I of France was to be godfather. Dinteville was to attend the christening ceremony as proxy, in place of the French King. The child, not the hoped-for boy, but the future Elizabeth I, was born on 7 September, and in November Dinteville was able to hurry back to France, his longest stay as ambassador to England over at last.[10]

What role did the secret visit of Georges de Selve play in Dinteville's English mission of 1533? This is not easy to establish, as we have no correspondence or other records from de Selve which refer to his visit, and only the two letters from Jean Dinteville to his brother in which he mentions him: the letter of 23 May discovered by Mary Hervey, to which the second letter of 4 June, mentioned earlier, can now be added.[11] These letters discreetly say nothing of the purpose of de Selve's visit, but urge secrecy. This suggests that this was not just a personal visit, but a mission known only to Francis I, probably conveying advice on the thorny problem of the recognition of Anne Boleyn.[12] However, this must be speculative, and we know no more about the relationship between Dinteville and de Selve. The letters that refer to this visit – and Holbein's painting – are the only contemporary record that they knew each other.[13] More information concerning the circumstances in which de Selve found it necessary to cross the Channel in secrecy might well shed light on some of the allusions in Holbein's complex composition.

We are able to catch glimpses of Dinteville's state of mind while he was in England through his correspondence. Lodged at Bridewell Palace in the City of London, the usual accommodation for French diplomats, he would have spent much of his time in attendance at court at Henry VIII's newly acquired Palace of Whitehall, further west. But the time spent in England was longer than he had expected; he clearly missed France and his family a great deal, and the overwhelming impression given by letters to his brother is one of misery. Dinteville was constantly ill from cold and damp, although as he admits in the letter of 4 June: 'I am, and have been, very weary and wearisome.'[14] In the letter of 23 May he complains 'I am the most melancholy, weary and wearisome ambassador that ever was seen.'[15]

We have no documents to tell us how Jean de Dinteville first encountered Holbein, but the cultivated diplomat,

kicking his heels at court, must quickly have realised that there was a portraitist of exceptional gifts at work in London taking the likenesses of many noble English men and women. In the early 1530s Holbein was already portraying a number of courtiers of influence, including the son, daughter and daughter-in-law of the 3rd Duke of Norfolk, the premier peer of England, with whom Dinteville was certainly acquainted.[16] Anne Boleyn was the Duke of Norfolk's niece, fluent in French from a period spent at the French court. She was much interested in the new Protestant beliefs, and sympathetic to at least one French Protestant refugee (Plate 39).[17] Holbein designed a precious metal table-fountain with her coat of arms (Plate 5),[18] and sketched – and perhaps designed – the pageant presented by the German Hanseatic merchants at her triumphal procession into London for her coronation

(Plate 6).[19] Jean de Dinteville must have been keenly aware of the work of this outstanding artist.

Dinteville, however, did not want jewellery or one of the small head and shoulders portraits popular with English courtiers. His portrait was one of only a handful of large-scale commissions which Holbein received during his stay in England. These include the destroyed portrait of the family of Sir Thomas More of about 1527, known from Holbein's drawing and from copies (Plate 7), the destroyed Whitehall wall-painting of Henry VIII and his family, known from a copy (Plate 8) and Holbein's cartoon (Plate 61), and the even larger painting of Henry VIII handing a charter to the newly unified Barber-Surgeons Company (Plate 9). *The Ambassadors* – which anticipates the composition of the Whitehall painting – is arguably the most spectacular commission of all. It is extremely rare for Holbein to show his sitters – other than in royal commissions – at full-length, and, although we know nothing of the prices paid for Holbein's portraits, it must have been very costly for the Frenchmen to have been painted in this way. It must also have been costly for the artist to have spent time incorporating so much detail into the still life between them, and in constructing the distortion of the skull. Plotting the elaborate content of the painting clearly

5 Table-fountain design for Anne Boleyn, 1533 Ink and black chalk on paper, 17.1 x 10.1 cm. Basel, Kupferstichkabinett

6 *Apollo and the Muses on Parnassus*, 1533. Ink and wash on paper, 42.3 x 38.4 cm. Berlin, Kupferstichkabinett

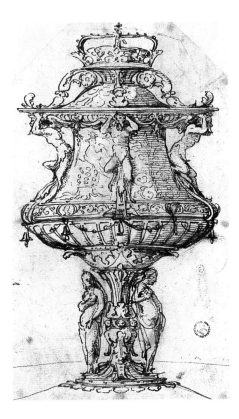

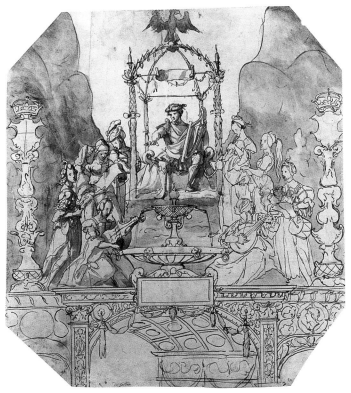

occupied a good deal of Dinteville's otherwise empty hours in England, though no references to it at all have been found in his correspondence.[20]

The two ambassadors are the only sitters to appear in a double portrait by Holbein who are not members of the same family. Their full-length stance, side by side, belongs to a tradition seen in German portraits of rulers, or of married or betrothed couples. There is no known tradition at this period of such portraits of diplomats, nor did portraits of friends appear in Northern Europe until later, although they were produced in Italy in the early sixteenth century.[21] There was no obvious precedent for such a portrait, in Holbein's work or outside it. Much of what it contains was clearly invented for the occasion and for the specific demands of its two

sitters. Nor did the portrait remain in England to influence courtiers with its spectacular vision of what portraiture could be. Although much of his stay as ambassador to England was tedious to Jean de Dinteville, his misery alleviated only briefly by the visit in the spring of Georges de Selve, he had the satisfaction of returning to France in the autumn, and must have carried in his luggage an unusual trophy: Holbein's extraordinary memento of these frustrating months. If the diplomatic mission of 1533 produced no other result, the painting was clearly a triumph, and a distinctive one, differing greatly from any commission Holbein produced for the English King or his courtiers. It was left to a Frenchman to construct such an ambitious antidote to melancholy and the English weather.

7 *Sir Thomas More and his Family*, 1527
Pen, brush, brown and black inks and black chalk on paper, 38.9 x 52.4 cm. Basel, Kupferstichkabinett

8 Remigius van Leemput, copy after Holbein's destroyed Whitehall wall-painting *Henry VII, Elizabeth of York, Henry VIII and Jane Seymour*, 1667. Oil on canvas, 88.9 x 98.7 cm. The Royal Collection

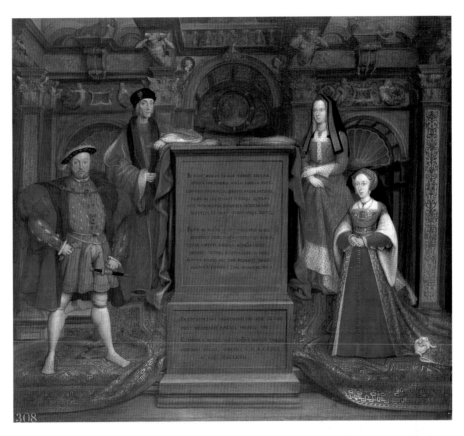

9 *Henry VIII and the Barber-Surgeons*, 1541 Oil on oak, 182 x 311 cm. London, The Worshipful Company of Barbers

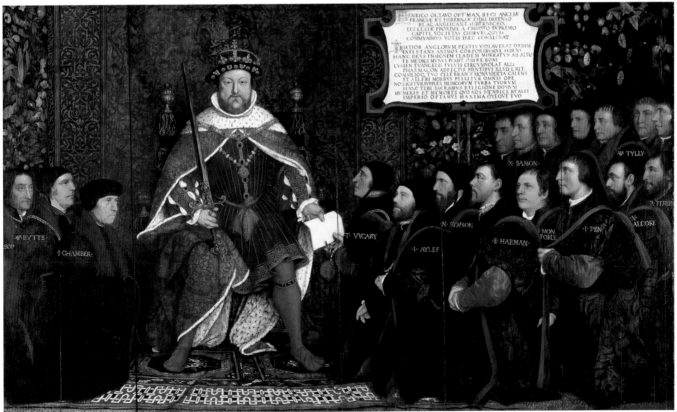

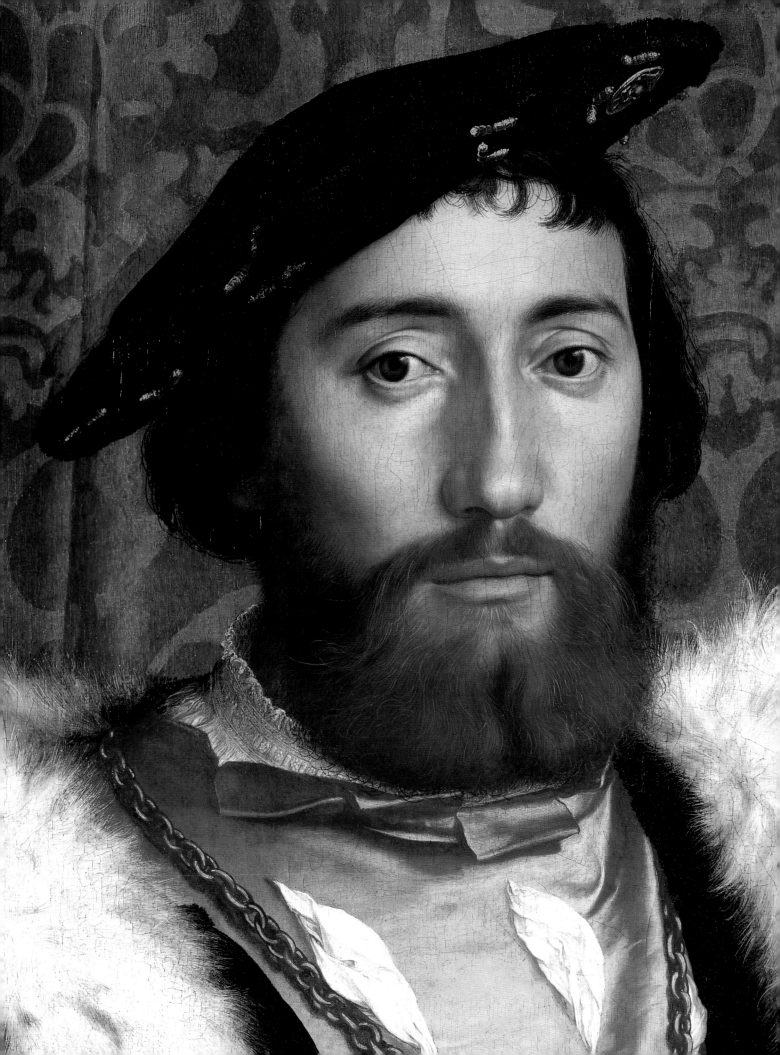

Jean de Dinteville and the Château of Polisy

The Dinteville family were originally from Burgundy, a duchy beyond the western borders of France, but by the end of the fifteenth century they had established themselves in Champagne. Their lands and their château of Polisy lay south-east of Paris, to the south of the city of Troyes, and not far from the forest of Fontainebleau, where, in the sixteenth century, Francis I was to build a spectacular royal residence. The Dintevilles were at court and close to Francis I at a time when the French King was building many such palaces, collecting paintings and antique statues, as well as employing artists of distinction – the Italians Leonardo, Rosso and Primaticcio, and the French portraitist Jean Clouet.[1] Other leading courtiers, such as the Montmorency, Guise and Gouffier families, followed this example by building and decorating châteaux and forming collections of paintings.[2] The Dintevilles were no exception, and *The Ambassadors* was only one of several large and important works commissioned by the family.

The Dinteville family had long been prominent in Europe. Jean de Dinteville's grandfather, Claude, was killed in 1477 at Nancy in the same battle as Charles the Bold, Duke of Burgundy, whose Surintendant des Finances he had been. Jean de Dinteville's father, Gaucher, married Anne du Plessis, and their family consisted of five surviving sons and two daughters. Jean, who was born on 21 September 1504, was the third son.[3] He held the office of Bailly of Troyes, with responsibility for administering justice in the city, and in 1527 he was made Governor of Bar-sur-Seine.[4] These were his local responsibilities, but the family also occupied positions of high importance at the court of Francis I. Gaucher de Dinteville, father of Jean, was *gouverneur*, with overall responsibility for the three royal princes. Three of his own sons, Jean, Guillaume and Gaucher, held posts in attendance on them,

each being responsible for the welfare of one of the sons of the King of France.[5] Jean de Dinteville joined the royal household in 1524, first as cupbearer to the royal children, and then in 1531 as a *gentilhomme*. In 1530 the eldest Dinteville brother, François II de Dinteville, was appointed Bishop of Auxerre, the cathedral town to the south-west of Troyes, in succession to his uncle. He served as French ambassador to Rome from 1531 to 1544, returning briefly to France in 1533.[6] The fifth brother, Louis, a Knight of Saint John, died in Malta in 1532.[7]

In the late 1530s the Dinteville family fortunes underwent a drastic transformation. In 1536 Guillaume was accused of poisoning the Dauphin, but was cleared of this charge; in 1538 his brother Gaucher was accused of sodomy. As a result he fled from court, and Guillaume followed soon after. The brothers exiled themselves in Italy, and, after further intrigue at court, François II de Dinteville lost his bishopric of Auxerre.[8] In 1542 Jean de Dinteville again took up a post in the royal household, shortly followed by Guillaume, and their brother's bishopric was restored to him, although it was not until 1551, under Henry II, for long a supporter of the Dinteville cause, that full restitution was made.[9]

Jean de Dinteville died, unmarried, in 1555. His heir was his brother Guillaume, and through him his niece Claude de Dinteville – who married François de Cessac in 1562 – inherited his property, including Dinteville family paintings. On her death in 1619 the Dinteville line was extinct, and Holbein's picture remained in the possession of the de Cessac descendants until the latter part of the eighteenth century.[10] Other works of art which the Dinteville family had commissioned were scattered, and the sense of their significance has been lost, but in the early sixteenth century the family must have been counted among the major patrons of the visual arts in France.

François II de Dinteville, Bishop of Auxerre and elder brother of Jean, appears to have been particularly active as a

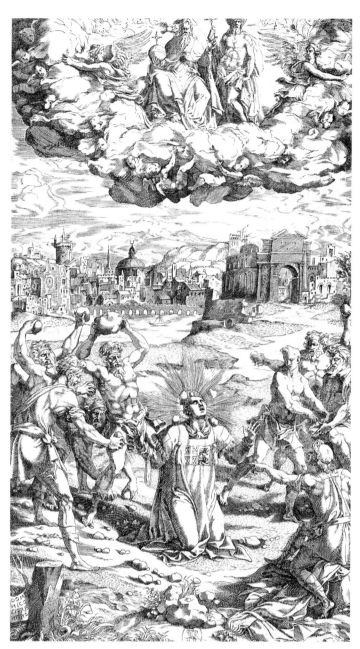

11 Master of the Hours of Henry II,
Illuminated page from 'The Dinteville
Hours', *c.*1553. Manuscript, MS Lat. 10558,
23 x 15 cm. Paris, Bibliothèque Nationale

12 Domenico del Barbiere, *The Stoning of
Saint Stephen*, probably late 1530s. Engraving,
27.2 x 15.5 cm. Paris, Bibliothèque Nationale

patron. The painted decoration of the Dinteville Hours in the
Bibliothèque Nationale bears his arms, and is of exceptional-
ly high quality, the work of the leading French court illumi-
nator known as the Master of the Hours of Henry II (Plate
11).[11] In the Bishop's cathedral at Auxerre are paintings show-
ing the stoning of Saint Stephen, to whom the cathedral is
dedicated, with a portrait of the Bishop as well as stained glass
which François II de Dinteville may have ordered; in his
church at Varzy is the *Martyrdom of Saint Eugénie*, again with a
portrait of the Bishop.[12] An engraving by Domenico del

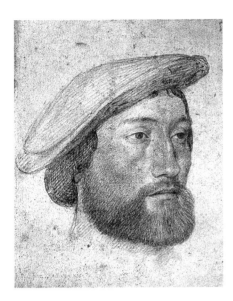

13 Jean Clouet, *Jean de Dinteville*, *c.*1532
Black and red chalk on paper, 25.1 x 19 cm
Chantilly, Musée Condé

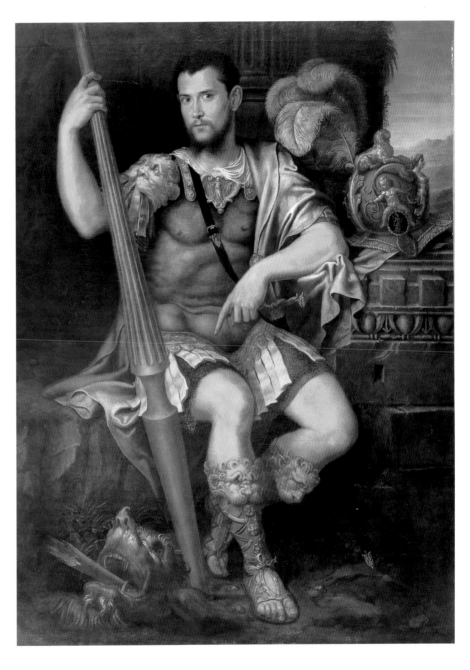

14 Francesco Primaticcio, *Jean de Dinteville
as Saint George*, *c.*1544/5. Oil on canvas,
163.8 x 119.4 cm. The Barbara Piasecka
Johnson Collection Foundation

Barbiere, an Italian working in France, shows the stoning of Saint Stephen in which the saint bears the Dinteville arms on his costume (Plate 12). It has been suggested that it may be based on a lost altarpiece, for one of the Bishop's churches.[13]

Jean de Dinteville was not to be outdone by his brother in the commissioning of paintings, and Holbein's picture is not the only portrait of him. A drawing by Clouet, the portraitist of the French court, is presumably a study for a lost painting (Plate 13). A magnificent full-length portrait of Jean de Dinteville in the guise of Saint George is attributed to the French court artist Primaticcio (Plate 14). It shows him seated, wearing classical armour, the conquered dragon at his feet, and probably dates from the mid-1540s.[14]

Yet another portrait of Jean de Dinteville is included in the other spectacular surviving commission for the Dinteville family, the painting of Moses and Aaron now in the Metropolitan Museum, New York (Plate 15).[15] Dated 1537, it shows all four surviving Dinteville brothers, who are identified by name on the borders of their costumes. The story is taken from the Old Testament: Moses and his brother the

High Priest Aaron go to the Pharaoh in Egypt and ask for the Israelites to be permitted to leave their exile. To show God's power, Aaron turns his staff into a serpent, which appears in the picture as a magical crystalline creature. Aaron, in the garb and head-dress of a Jewish priest, is the portrait of the priest of the Dintevilles, François II, Bishop of Auxerre, and his Moses is Jean de Dinteville. The other two brothers, Guillaume and Gaucher, are ranged behind. If the painting is to be understood as an allegory, it would be logical to see

15 Unknown Artist, *Moses and Aaron before Pharaoh: An Allegory of the Dinteville Family*, 1537. Tempera and oil on wood, 176.5 x 192.7 cm. New York, The Metropolitan Museum of Art

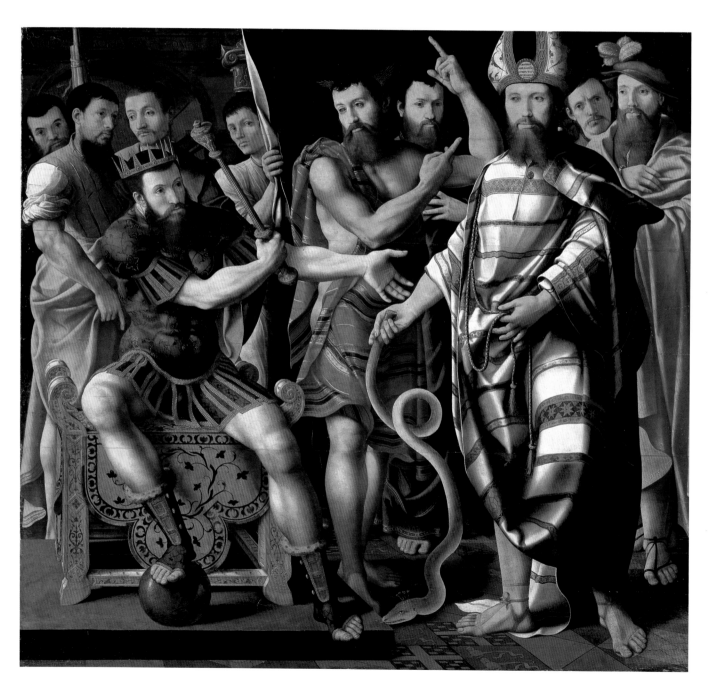

Pharaoh as Francis I (although the figure in the picture does not look very much like the King) and to try to relate the subject of the picture to the misfortunes which the family underwent at this period. However, although it might be supposed that the brothers are intended to be shown pleading with the French King for their release from exile, the exile of the Dinteville family took place only after the date of this painting. Nevertheless the picture may be intended to reflect the family's troubles, which had certainly begun before 1537.[16]

The artist who painted *Moses and Aaron* is unknown; it has been suggested that the style is Netherlandish rather than French, and that the same artist might be responsible for a small picture in the Städelsches Kunstinstitut, Frankfurt, of men in a cellar with barrels of beer, which bears the Dinteville coat of arms.[17] Although the *Moses and Aaron* was painted four years after *The Ambassadors*, it would seem possible that it was designed to match the earlier picture in some way; the two pictures seem to have been regarded as a pair in the eighteenth century, and they were kept together until Holbein's picture came to England. Unfortunately both pictures have been cut slightly, so that it is impossible to establish with precision what the original dimensions of either picture were, but the two paintings are now quite close in size, and must have been much closer originally.[18] The setting for both pictures in the sixteenth century was the Dinteville château of Polisy.

The Château of Polisy

The word Polisy is inscribed at the centre of the earthly globe in the painting of *The Ambassadors*. Polisy had belonged to Jean de Dinteville's father from the early years of the sixteenth century, and became his own residence in 1531. However, as a consequence of a series of alterations made to the château, as well as the absence of plans and other crucial architectural records, the orginal setting in which *The Ambassadors* was displayed is not easily appreciated today; although a recently discovered unpublished inventory of the château, dating from 1589, may help to make sense of its early building history.[19] A drawing, now lost, apparently of early seventeenth-century date, which is reproduced by Mary Hervey and others, shows a plain gabled building with four turrets overlooking the River Laigne (Plate 16), but gives no hint of the rich interior which, it appears, lay within it.[20]

In the late nineteenth century much restoration work was carried out on the château, and aspects of the interior were

assiduously recorded by local archaeologists. The most informative accounts of the château are those given in publications of this period, and by Mary Hervey, who appears to have visited Polisy.[21] It was presumably in the nineteenth century that the exterior of the building was refaced, and the house given the appearance of a villa. The building suffered a number of losses to the interior in the course of the twentieth century, and in 1992, while restoration work was being carried out, a serious fire broke out, during which the roof and upper floor were severely damaged; as a result Polisy is today inaccessible (Plate 17).

The building history of Policy was evidently complex. A reference in a letter of 1533 to his brother the Bishop, when Jean de Dinteville was in England, mentions, intriguingly, that he longs to know what his brother will say of the tower and pictures, and suggests that there may have been some alterations to the château at this time, which could have taken account of the painting he had commissioned in England. In a postscript to another letter of 4 June 1533, he asks his brother to tell him if he has found the pictures done well.[22] These references suggest that Dinteville had commissioned pictures before leaving for England, when his brother was in Italy.

Polisy in 1533, when Holbein's finished painting was presumably brought to France and hung there, must have looked different from the building a decade or so later. Hervey records an inscription dated 1544 referring to the completion of a courtyard by Jean de Dinteville.[23] But decorative work was also carried out on the interior: tiles are recorded which bear dates from the 1540s. These alterations may have meant that the original setting for Holbein's picture was considerably changed – and perhaps elaborated – from what had been envisaged when Jean de Dinteville commissioned it.

In the 1520s and 1530s the rush began to build, or rebuild, châteaux in the newly fashionable Italian Renaissance style, a stimulus provided by Francis I in his works in Paris and around the Loire. He was followed by his contemporaries such as Montmorency, the Dintevilles' cousin, for whom the château of Ecouen, near Paris, was built (Plate 18). The interiors of these châteaux were grand and formal, with elaborate fireplaces and decorative friezes including family mottoes and devices. The decorations at Ecouen, as well as those at Fontainebleau, built for Francis I, show the lavish style then in favour. Paintings were frequently incorporated into panelling or stucco work, often over fireplaces, rather than simply hung on the wall, and colourful ceramic tiles covered the floor.

No doubt both fashion and rivalry played a role in determining the reworking of the Dinteville château in the 1540s,

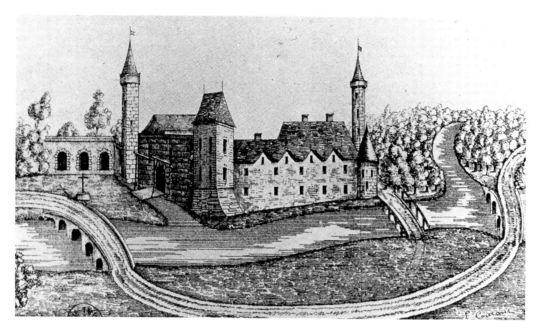

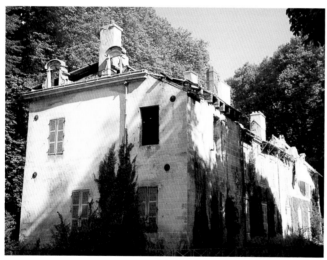

16 The Château of Polisy in the 17th century Engraving from Mary Hervey, *Holbein's Ambassadors: The Picture and the Men*, London, 1900

17 The Château of Polisy today

18 Salle d'honneur, Château d'Ecouen, Musée de la Renaissance, mid-1540s (with some nineteenth-century restoration remaining)

but the deciding factor may well have been the availability of workmen from the royal palace of Fontainebleau, which was within striking distance of Polisy, and their special abilities in stucco decoration. The Italian artist and stuccoist Primaticcio, apparently responsible for at least one portrait of Jean de Dinteville, was working at Fontainebleau, and was in correspondence with Jean's brother, the Bishop of Auxerre, in 1551 or 1552.[24] A second Italian artist, Domenico del Barbiere, or Dominique Florentin, a sculptor originally from Florence, who worked with Primaticcio as a stuccoist, had by 1540 moved to Troyes, just north of Polisy. He is recorded there until 1564, and had a busy practice as a sculptor, receiving major commissions such as the screen for the church of St Etienne at Troyes; he also continued to work for the court, providing the sculpted base for the casket holding the heart of Henry II. He was an engraver too, responsible for the image of Saint Stephen with the Dinteville arms mentioned earlier. He is described as a painter, as well as an *imageur* or sculptor, although there are no documented painted works by him.[25] It has been suggested that Domenico del Barbiere, and perhaps also Primaticcio might have been responsible for the renovation of Polisy.

Domenico del Barbiere, Primaticcio and another sculptor were at Polisy in 1544, one of the dates inscribed on the building, although, since their presence is ascertained only through a legal document concerning Primaticcio, who had been given the benefice of a nearby abbey, their precise architectural contribution is uncertain.[26] Engravings by Domenico del Barbiere, with elaborate scrolled borders similar to the

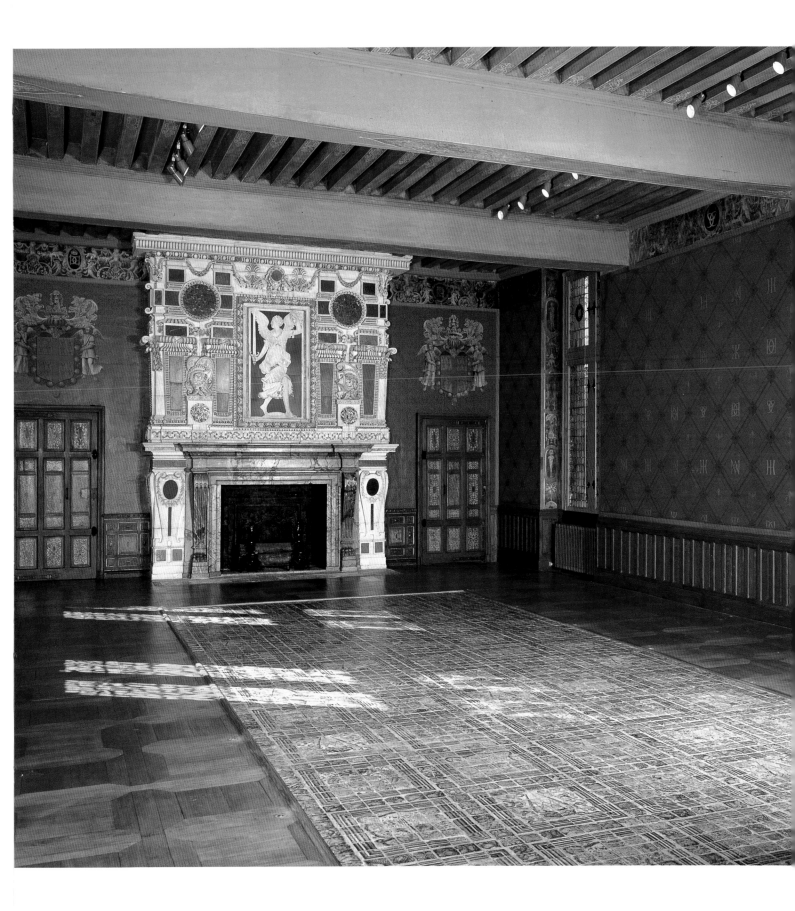

The Objects in the Painting

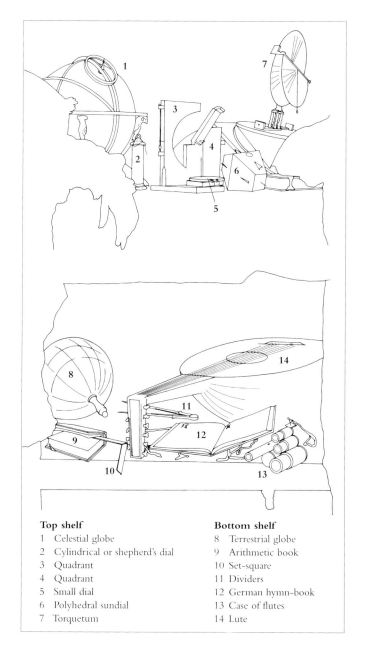

Linking the two full-length figures in *The Ambassadors* is a piece of furniture with two shelves on which are arrayed a large number of different types of object (Plate 21). On the top shelf are a celestial globe and a series of instruments which depended on the use of the sun for operations such as telling the time, measuring altitudes and finding the positions of all the celestial bodies. From left to right these are: a cylindrical or so-called shepherd's dial, two quadrants, one with a small circular dial resting on it, a polyhedral sundial and a torquetum. They are shown on a brightly patterned oriental carpet which hangs over the top shelf.[1] On the lower shelf are a terrestrial globe, a pair of dividers, a set-square, an arithmetic book, a lute with a broken string, a case of flutes and a German hymn-book. On the floor, beneath the lower shelf, lies the case for the lute.

Are these objects that Jean de Dinteville and Georges de Selve might themselves have owned and with which they wished to be depicted, luxurious items to be admired along with the splendour of the garments they themselves wear? The display of objects on shelves was a common method of conveying wealth in the sixteenth century. At banquets or festivities such as the Field of the Cloth of Gold in 1520, when Henry VIII and Francis I met at Calais, plates and drinking vessels of precious metal were laid out on wooden shelves, not for use in the feasting, but, as tapestries were hung on the walls, to create a vivid impression of the magnificence of their owner. Similarly, oriental carpets, items of high value, were at this period displayed as rich table coverings, as is the case here, rather than laid on floors.

In Holbein's painting, two objects immediately suggest that more than a straightforward depiction of ownership is intended. Firstly, the terrestrial globe on the lower shelf has been 'customised' so that in the centre of the depiction of France we read the name of Polisy, Jean de Dinteville's château, which is not to be found on contemporary globes otherwise exactly similar to this (Plate 22). Secondly, the lute

Top shelf
1 Celestial globe
2 Cylindrical or shepherd's dial
3 Quadrant
4 Quadrant
5 Small dial
6 Polyhedral sundial
7 Torquetum

Bottom shelf
8 Terrestrial globe
9 Arithmetic book
10 Set-square
11 Dividers
12 German hymn-book
13 Case of flutes
14 Lute

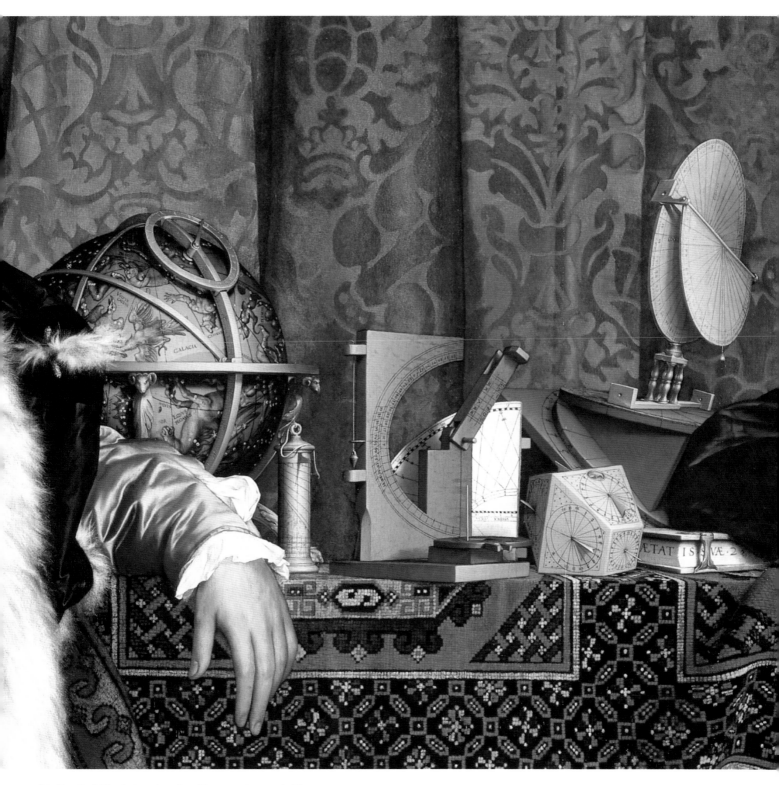

21 Detail of *The Ambassadors*: the objects on the top shelf

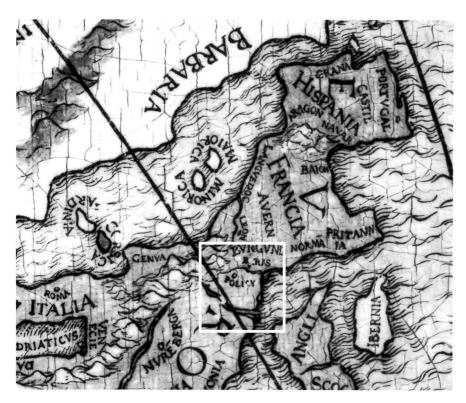

22 Detail of *The Ambassadors*: the terrestrial globe with the inscription 'Polisy'

23 Detail of *The Ambassadors*: the objects on the lower shelf

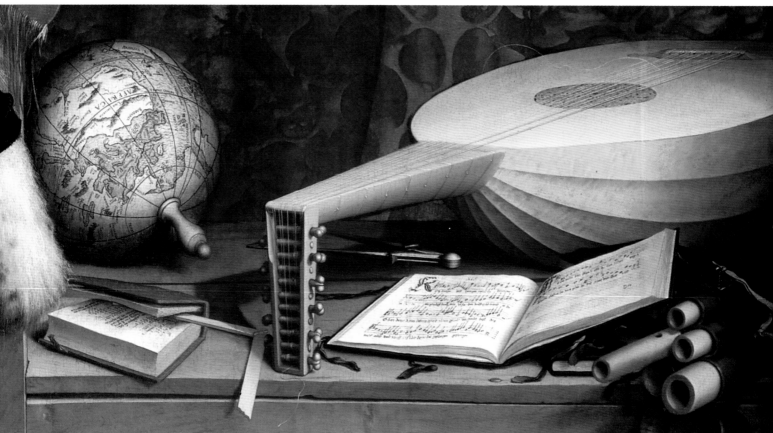

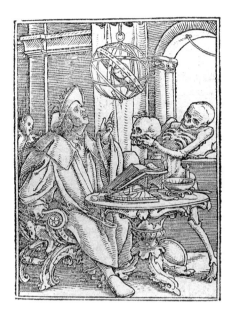

24 *The Dance of Death: The Astronomer, c.*1525
Woodcut, 6.5 x 4.9 cm. London, British
Museum

cannot be played, for one string is broken: a broken string is
painted curling over the others which are properly taut (Plate
23). Such observations alert us to the possibility that gazing at
this display involves us in more than mere admiration.

The objects on the top shelf can be related to the study
of heavenly bodies, to the subject of astronomy, while those
on the lower shelf include a book for the study of arithmetic,
two instruments useful in geometrical calculations, and a
number of musical instruments with a hymn-book. For this
reason the choice and organisation of the objects have been
related to the contemporary way of organising learning, into
the two branches of the three and four scholarly disciplines,
namely the Trivium and the Quadrivium. The latter com-
prised geometry, arithmetic, astronomy and music, and all the
objects in the picture can clearly be related to one of these
categories. It has been argued that the ambassadors them-
selves represent the skills of the Trivium: grammar, rhetoric
and dialectic. Yet there is no hint within the picture that such
meanings are intended, and no obvious means of attaching
them to the figures.[2] It may be by chance that the objects fall
into the four categories of the Quadrivium. Certainly the
balance is uneven, with so many instruments concerned with
heavenly bodies ranged along the top shelf. Moreover, some
of these have more to do with time-keeping than with
astronomy, and there is no armillary sphere, an instrument

used to represent planetary motion, and the usual accompa-
niment to representations of astronomers in Holbein's time.
This is how Holbein depicted the astronomer in the margin-
al drawings he added to a copy of Erasmus's satire, *The Praise
of Folly*, and again in *The Dance of Death* (Plate 24). The
arrangement in *The Ambassadors* seems to have more to do
with a division between the heavens and terrestrial things, and
the choice of objects is clearly affected by other factors: the
lute does not merely represent music, but displays its broken
string for our inspection, while the hymnal is not any music
book, but a Lutheran one.

The astronomical instruments on the top shelf are depict-
ed with a clarity that encourages close study of their con-
struction and the readings they present, although these instru-
ments would normally be used out of doors and there is no
obvious point of entry within the composition for the sun-
shine necessary to cast shadows for some of those readings.
On the left is the cylindrical shepherd's dial (Plates 21 and
28). Like most of the instruments displayed, it appears to be
made out of wood rather than metal, which would denote a
more precious object. Marked off around its circumference
with the names of the months and signs of the zodiac in two
six-monthly circles – here Aries and, apparently, Aquarius, and
perhaps Taurus are visible – it was used as a solar clock and
could be carried from the string attached to its top by a ring.
The metal pointer at the top was turned to the appropriate
date, to an accuracy of perhaps two days, and the sun's rays
would then cast a shadow indicating the time of day.[3] Like
other instruments shown in the picture, the design of the dial
was made to reflect a particular latitude by means of the angle
and height of the gnomon, the triangular piece of metal cast-
ing the shadow: for example a northerly latitude was needed
for London, a different more southerly latitude for Paris. The
date appears to be set to read the time on about 11 April or
15 August. It has frequently been asserted that 11 April should
be understood, on the assumption that Georges de Selve was
in England on this date, and that the painting therefore com-
memorates his visit. It has also been suggested that this date
might have political significance for Dinteville's mission.[4]
However, as we know for certain only that de Selve had left
England before 4 June, and probably before 23 May (see page
14), we cannot be sure that he was in England in April at all.[5]
Moreover, the lack of accuracy in the readings provided by
other instruments should urge caution in making inter-
pretations dependant on specific dates and times, and this
inaccuracy suggests other possible significances, as we shall see.

A little further along the top shelf is a polyhedral sundial
of wood (Plate 25), with a compass on top, inset under a clear

25 Detail of *The Ambassadors*: objects on the top shelf

26 Illustration of a torquetum, from Peter Apian, *Astronomicum Caesareum*, Ingolstadt, 1540. Woodcut, 45.7 x 31.2 cm. London, National Maritime Museum

27 Illustration of a torquetum, from Nicolaus Kratzer, *De Horologis*, c.1517 Manuscript, MS CCC 152, 23 x 17 cm Oxford, Corpus Christi College

pane, perhaps a crystal. This object again could be employed to tell the time with the aid of the sun's rays. The compass was used to place the dial in the correct north–south position for telling the time in a particular latitude. To do so, it needed to be lying flat, which appears not to be the case in Holbein's picture. The dial is shown with shadows giving two different readings for three different faces: 9.30 on one face and 10.30 on two faces. Not only would such a result be impossible, but the gnomon or pointer casting the shadow is not adapted for a northerly latitude: the latitude for which this particular instrument is, in fact, designed is that of North Africa.[6]

Small cylindrical and polyhedral sundials were not only relatively inexpensive, they were meant to be easily portable objects, and it is likely that Dinteville owned one if not several of these. The polyhedral dial has a compass set into it, as already noted, and in his letters from London to his brother Bishop François, Jean mentions a *compas*: 'send me a drawing of the oval compass', he requests in his letter of 23 May, and writes that he is still puzzled by its details.[7] The instrument

mentioned in the letter is presumably a magnetic compass rather than a pair of dividers of the type seen on the lower shelf.

Behind the small dials are two larger instruments: these are both types of quadrant, so called because their design is based on the shape of a quarter circle. The white face of one may perhaps be intended as ivory, but is probably the much cheaper alternative of paper glued to the wooden body of the instrument. Such quadrants were used for determining the angle and altitude of the sun from the horizon, from which it was possible to calculate the time. To do so they would use a plumbline, a small lead or brass weight on a string which would hang straight against the marked segment when the instrument was raised towards the sun. This is clearly visible to the left of the nearer instrument. However, the further quadrant is either incorrectly assembled or incorrectly depicted, and would have been impossible to use – for the sights, the small tab-like objects on the right-hand side – are placed on the wrong side of the quadrant, and the whole object

appears as if upside down.[8] On the base of the other quadrant is a round object with a vertical pointer. This appears to be another small wooden sundial with its needle pointer upright.

On the far right of the shelf is by far the most elaborate instrument, a construction made up of differently angled wooden platforms topped by a large circular dial (Plate 25). This is a torquetum, an instrument first described by the ancient Greek scientist Ptolemy, which could be used to determine the relative positions of the heavenly bodies and tell the time with some accuracy.[9] Its complex construction allowed it to be adjusted for latitude and date; altitudes were measured against a plumbline on the pendant semicircular flap. Knowledge of this instrument was revived in the thirteenth century, and in the fifteenth and sixteenth centuries there was much interest in designing versions of it, only a very

few of which survive. One such instrument was designed by Peter Apian of Nuremberg, one of the leading instrument makers in the early sixteenth century, and published in his *Astronomicum Caesareum* in 1540, a copy of which was presented to Henry VIII (Plate 26).[10]

On the far left of the shelf is a heavenly globe supported by a base of brass rams' heads (Plates 21 and 28). The heavens are depicted with the constellations made up into the mythological beings from which they took their names – Hercules, Pegasus the winged horse, the Lyre Bird, as well as the Milky Way, for example. Such a globe could be used as an aid to viewing the heavens and making out the fainter constellations. As with the instruments making use of the sun, it was necessary to turn the globe to the correct latitude, otherwise the relative positions of the stars would not be correctly

29 Johannes Schöner, Celestial globe on wrought-iron stand, 1533. 26.5 cm diameter London, Royal Astronomical Society/Science Museum

28 Detail of *The Ambassadors*: the celestial globe

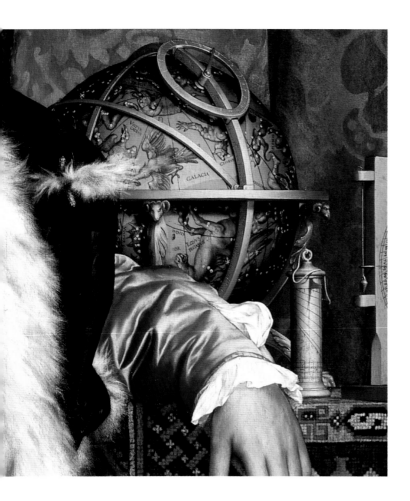

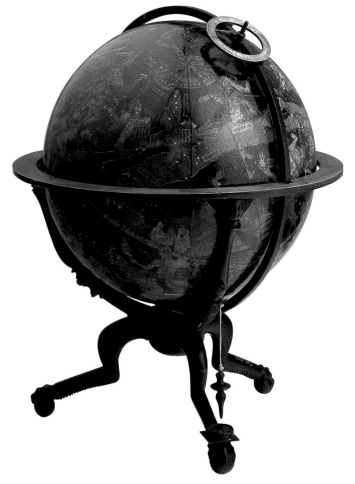

shown, and some might well be invisible. However, the latitude to which the globe is turned here is once again incorrect: instead of the 51½ degrees that would be correct for London, it is shown at 42 or 43 degrees, which is too far south, the latitudes of Italy or Spain. Holbein may perhaps have relied on a drawing or engraving showing such a setting, rather than an actual globe.[11]

Holbein's globe is, however, extremely close to a surviving globe (today in the Science Museum, London) dated 1533, the year of the painting, and designed by the Nuremberg astronomer Johannes Schöner (Plate 29).[12] Such a heavenly sphere would be a luxurious object, one which might well have been owned by a noble courtier such as Jean de Dinteville. His brother Gaucher de Dinteville owned a sphere: whether heavenly or earthly is uncertain, but it is listed in the inventory of his effects of 1550.[13] It is questionable whether Jean would have brought such a large and precious object with him to England.

Holbein would not have had to rely on instructions from Jean de Dinteville in the representation of these instruments. Nicolaus Kratzer, the German-born astronomer to Henry VIII, was a good friend of Holbein's. In 1527 Holbein and Kratzer worked on a design showing the heavens for the ceiling of a temporary royal theatre at Greenwich.[14] The two men also collaborated in 1528 on an illuminated book of instructions for the use of an astronomical instrument which was a New Year's gift to Henry VIII (Plate 30). In the 1530s Kratzer and Holbein were used to send German Protestant books to Thomas Cromwell.[15] The two men would probably have talked together in German: Kratzer's English is supposed to have been poor.

Holbein painted Kratzer in 1528 in London (Plate 31). In this portrait Kratzer is shown seated at a table making a polyhedral sundial extremely similar to that in *The Ambassadors*. On the table are a rule and a pair of dividers resembling those on the lower shelf of the large painting, as well as a small dial with an upright needle pointer. Behind him on a shelf are two instruments, a quadrant which is again very similar to one of those in *The Ambassadors*, and a shepherd's dial. It seems more than likely that Kratzer would have had instruments that Holbein could have studied for the double portrait. It is also possible that Holbein merely reused sketches that he had made for Kratzer's portrait, or that he relied on Kratzer's drawings or copies of them. A drawing of a torquetum not dissimilar from that in Holbein's painting appears in Kratzer's notebook (Plate 27). The notebook also includes a drawing of a polyhedral dial with an inset compass similar to that in Holbein's pictures (Plate 32). A similar brass polyhedral dial

30 Illuminated page from Hans Holbein the Younger and Nicolaus Kratzer, *Canones Horoptri*, 1528. Manuscript, MS Bodley 504, fol. 1r, 23 x 16 cm. The Bodleian Library, University of Oxford

survives today which has some claim to be Kratzer's work.[16]

Kratzer was a court astronomer, rather than a scientist of any originality: his tasks mostly consisted of making fairly ordinary sundials (Plate 33).[17] But the most striking aspect of the instruments in *The Ambassadors* is the extent to which they ignore what any professional astronomer would have known: the correct depiction of a quadrant, or the angle of a gnomon required for London's latitude. It is difficult to avoid the conclusion that either the instruments are no more than an elaborate backdrop suggesting the passing of time, for which accuracy of depiction seems to have been unnecessary, or that they are deliberately intended to be read as

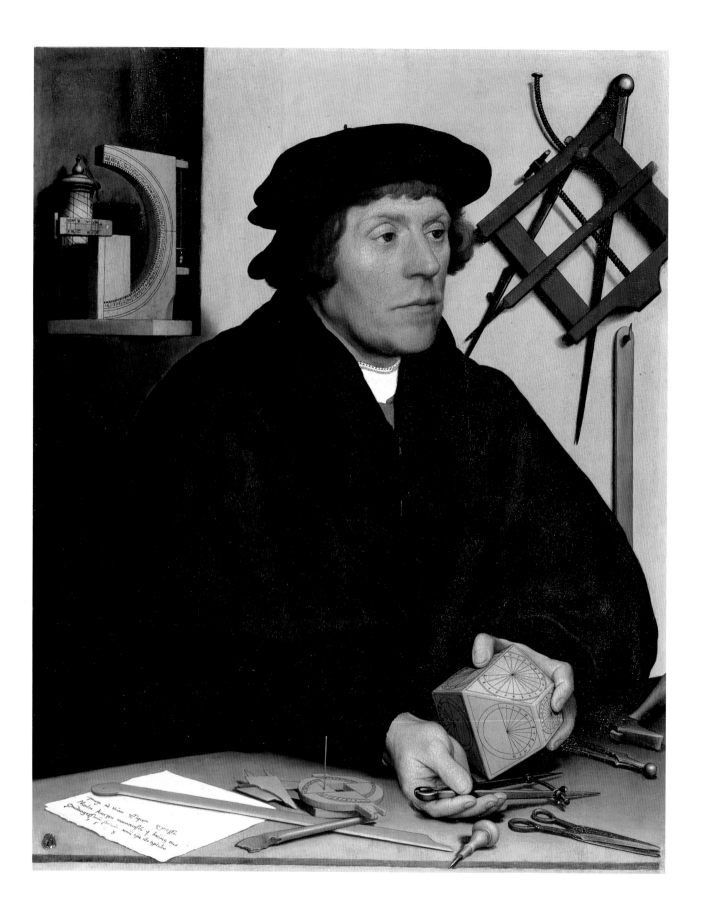

31 *Nicolaus Kratzer*, 1528. Oil on oak, 83 x
67 cm. Paris, Musée du Louvre

32 Illustration of a polyhedral dial from
Nicolaus Kratzer, *De Horologis*, c.1517
Manuscript, MS CCC 152, 23 x 17 cm
Oxford, Corpus Christi College

33 Nicolaus Kratzer, polyhedral sundial
from Acton Court, 1520. Carved limestone,
34.9 x 26.7 x 34.9 cm. City of Bristol
Museums and Art Gallery

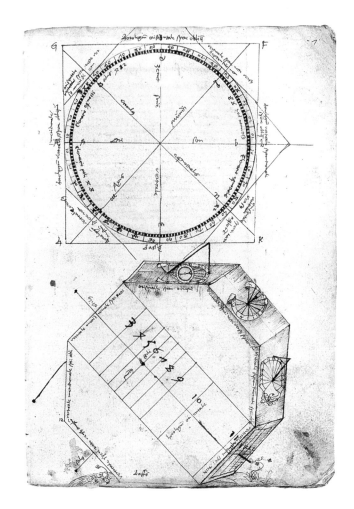

mis-depicted and mis-set, to suggest that the times are some-
how 'out of joint'.

The terrestrial universe about which such instruments
gave knowledge to educated families such as the Dintevilles
was being better plotted than ever before. The globe that
Holbein shows lying directly underneath the heavenly globe
includes a clear depiction of the New World and of the line
established by the Pope at the Treaty of Tordesillas in 1494,
which divided the Spanish and Portuguese colonial posses-
sions.[18] However, the heavens were still understood in much
more traditional terms, on a model going back to classical
antiquity, in which all the planets revolved around the earth.
This model would only be upset later in the sixteenth century.
The instruments Holbein depicts on the top shelf in *The
Ambassadors* are not instruments of scientific innovation, but
largely variants on clocks telling the time.

The impression of a symbolic rather than a literal sense of
the objects is strengthened by examining those on the lower
shelf, a more heterogeneous group. The terrestrial globe is not
supported by a stand, but has a wooden handle by which it
would have been held. (This handle is not Holbein's paint,
but the work of an early restorer that has been left during the
recent cleaning.) The map of the world depicted here has
been related to one published by Johannes Schöner at
Nuremberg in 1523; such gores or shaped sections of maps
were printed so that they could be applied to spheres to form
globes.[19] As mentioned earlier, a number of places have been
added, including Polisy, which has been given a central posi-
tion. The inscriptions 'Baris' for 'Paris' and 'Pritannia' for
'Brittany' are assumed to reflect Holbein's own pronunciation
of these French names.[20] There are many other additional
European locations.

Beside the globe is a pair of dividers or compasses which
could be used to measure distances on it, as well as a set-
square for measuring right angles. Compasses could have
symbolic meaning in the sixteenth century: images of
Prudence wielding a compass were well known in France as
a symbol of good governance, and were used as such in a

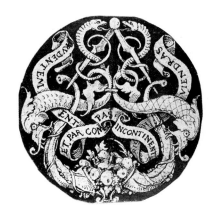

34 Design for a medallion with a pair of compasses, serpents, dolphins and cornucopias, *c*.1533. Pen and black ink wash on paper, 4.9 x 5.1 cm. London, British Museum

book made for the young King Francis I.[21] Indeed Holbein designed a small badge or medallion with a pair of compasses and a French text: *Prvdentement et par compas incontinent tu viendras* (You will come immediately in a prudent and measured way) (Plate 34). This badge has been associated with Anne Boleyn, who was well acquainted with French, although many other courtiers had also spent time in France and owned books in French.[22] However, it seems worth considering the possibility that the badge could have been designed for Dinteville, for it might be read as a suitable motto for a diplomatic mission. Geometrical instruments including the compass and the set-square were also sometimes depicted as attributes of the planet Saturn, a malign, chaotic influence, and were linked with melancholy in Dürer's famous engraving of 1514, in which the personification Melancolia holds a pair of compasses and is seated by a polyhedron.[23] It thus seems equally conceivable that these instruments could have been included in Holbein's painting for their association with disorder and the melancholy of which Jean de Dinteville complained. However, other objects on the lower shelf appear to bear a much more overt meaning.

Next to the globe is a partly open arithmetic book (Plate 35). Enough can be seen of its pages to identify it as Peter Apian's *Eyn Newe unnd wohlgegründte underweysung aller Kauffmanss Rechnung* (A new and reliable instruction book of calculation for merchants), published in 1527 (Plate 36). Although this was produced as a merchant's arithmetic book, it might have been used by many others as a guide to calculation. But the most significant aspect of this book is

probably the page at which it is open, which begins with the word *Dividirt* (Divide). This book, the hymn-book and the instruments above them all lend themselves to interpretations involving division and disharmony, and their opposites, unity, harmony and reconciliation, matters with which it appears Dinteville and his friend de Selve may have been much concerned in 1533.

The other book on the lower shelf is a Lutheran hymnal (Plate 37). The first edition of Johannes Walther's *Geistlich Gesangbuchli* (Holy Hymn-book) was published at Wittenberg in 1524 (Plate 38). There are two hymns given here in German on facing pages, both in the tenor part. On the left is the '*Veni Sancte Spiritus*' (Come Holy Spirit) and on the right is the 'Ten Commandments'. Both were traditional anthems of the Catholic Church, but Lutheran Wittenberg published German versions, following the publication of the Bible and other church texts in German. The book shown in the painting seems, however, to be a carefully doctored version of the original, for the two hymns are neither consecutive in Walther's editions, nor numbered as here.[24] The '*Veni Sancte Spiritus*' is here XIX, but in the book is II. The 'Ten Commandments' is there XIX and is found many pages further on. The effect is as though several pages have been removed. It is conceivable that Holbein copied an unknown or defective edition, but probable that these two hymns have been specifically chosen for display: the whole opening of this book is clearly visible and readable, which is not the case with the arithmetic book. Moreover, it seems unlikely that this book was chosen at random. Although Holbein had attended Protestant services in Reformed Basel and was to create a number of designs for Protestant publications in England, and even a painting (Plate 95), neither Jean de Dinteville nor Georges de Selve was a Protestant convert. A Lutheran text in German, to conservative opinion a highly contentious book, could hardly have been included in the portrait without the express wish of the sitters.

It is probable that it was Georges de Selve, on whose side of the picture the book is placed, who wished the book to be included. In 1529 de Selve had composed his *Remonstrances ... aux dicts Alemans*, in which he had urged the German nation to leave behind their differences and unite with the whole of Christendom. If the Lutheran translations allude to discord, the texts themselves were of universal Christian significance, and their choice could be read as a plea to German reformers: the traditional prayer for the intervention of the Holy Spirit (always the unifying force in the universal church), on the left-hand page, can be seen as a reinforcement of de Selve's message in his own book. Christian disunity was

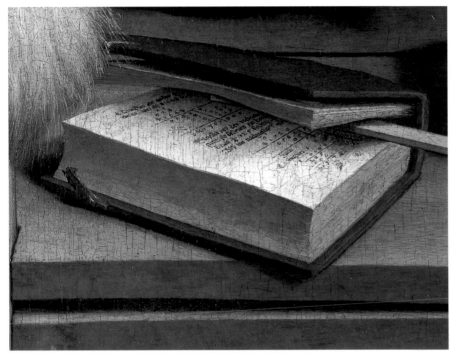

35 Detail of *The Ambassadors*: the arithmetic book

36 Peter Apian, *Eyn Newe unnd wohlgegründte underweysung aller Kauffmanss Rechnung*, Leipzig, 1543. 16 x 9.5 cm. Cambridge University Library

37 Detail of *The Ambassadors*: the Lutheran hymnbook

38 Johannes Walther, *Geistlich Gesangbuchli*, Wittenberg, 1525. 13 x 16 cm. Vienna, Österreichische Nationalbibliothek

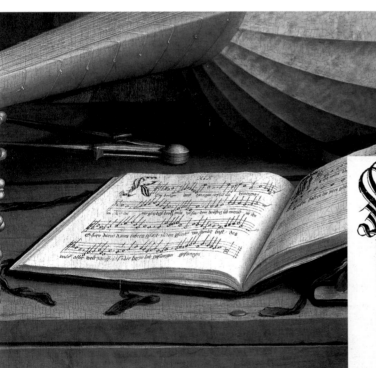

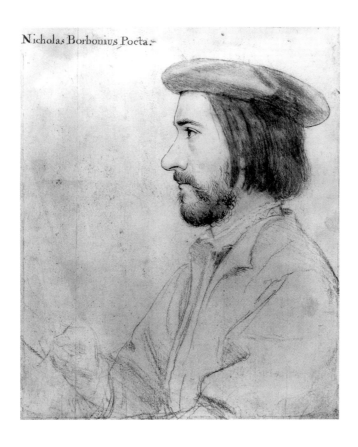

Nicholas Borbonius Poeta.

39 *Nicholas Bourbon*, c.1535. Black, white and coloured chalks, pen and black ink on pink-primed paper, 30.7 x 26 cm. Windsor, Royal Library

40 Andrea Alciati, *Emblemata*, Augsburg, 1531. 14.4 x 8.7 cm. Cambridge University Library

FOEDERA ITALORVM.

Hanc cytharam à lembi, quæ forma halieutica fertur
Vendicat & propriam mufa latina fibi.
Accipe Dux, placeat noftrũ hoc tibi tempore munus
Quo noua cum focijs fœdera inire paras.
Difficile eft nifi docto homini tot tendere chordas,
Vnáq; fi fuerit bene nõ tenta fides.

the most important issue in Europe in 1533, and one with which both ambassadors were closely concerned. Jean de Dinteville was observing the disintegration of the Catholic Church in England during his own embassy, and in France there were deep divisions over which Francis I was maintaining unity with some difficulty.[25] Anne Boleyn herself was to receive French Protestant exiles at the English court, one of whom, Nicholas Bourbon, had his portrait taken by Holbein (Plate 39).

On the lower shelf are, in addition, musical instruments. There is a lute, the case of which lies upturned on the floor beneath the shelves. There are also flutes of differing diameters in a leather case which fastens with a lock and key. Some similar instruments, as well as the remains of a leather case which may have been of this type, have survived from the wreck of the *Mary Rose*.[26] However, such flutes were not generally considered instruments for gentlemen, and would almost certainly not have been played by Holbein's sitters. They might, however, have learned the lute.[27] Again, the lute is extremely accurately depicted with the right number of strings, and would be eminently playable were it not for the single broken string.

Musical instruments were common symbols of harmony, and heavenly harmonies were imagined when the spheres in the cosmos moved about the earth.[28] Lack of harmony, discord, was a commonplace metaphor for worldly conflict, and is used in precisely this sense in the emblem book published in 1531 by Andrea Alciati, an Italian who had spent much time at the court of France, and whom Dinteville is likely to have known. Alciati's book also included the Latin line *Virtutis Fortuna Comes* (Fortune is the companion of Virtue), which members of the Dinteville family had adopted as their motto. Alciati's emblems, many of which had been in circulation for some time, consisted – when published – of a woodcut image, an enigmatic motto and some verses. The emblems were riddles, devices of the sort which courtiers such as Dinteville often wore as badges, with literary texts. One of Alciati's emblems shows a lute, and the text refers to the broken string of the instrument, signifying discord (Plate 40).[29] Since Dinteville's embassy took place in the context of pan-European divisions and disharmonies, with which de Selve was also deeply concerned, it is hard to believe that the lute has a function other than to highlight their troubled world. Moreover, the flutes too may be intended to underline this

sense of lack of harmony, for one of them is missing from the case. In addition, the music of flutes is associated with war, and it has been suggested that the function of the flutes might therefore be to underline the presence of conflict and dissension in the world of the two sitters.[30]

Beneath the feet of Jean de Dinteville and Georges de Selve is a magnificent pavement, made up of inlaid pieces of coloured stones, of a type known as 'Cosmati work', after the thirteenth-century Italian family of marble workers who made this their speciality. Most Cosmati work is found in Rome, and it was largely ancient Roman remains, particularly porphyry columns cut into circular slabs like Italian sausage or salami, that provided the raw materials for the patterned inlays. There was, however, one such pavement in England, which Jean de Dinteville would certainly have seen during his embassy, in the sanctuary of Westminster Abbey, where Anne Boleyn was crowned on 1 June 1533 (Plate 41).[31]

The floor in *The Ambassadors* is similar but not identical to the floor in Westminster Abbey.[32] Although there is a generic similarity in the design of linked circles within a square, there are some small differences, and one larger one, namely the presence of a six-pointed star in the centre of the floor in the painting.[33] Holbein appears to have taken his inspiration from the Abbey floor, but did he do so with any intention to convey meaning in this part of the picture? The floor of the Westminster Abbey sanctuary with its inscriptions was completed in 1268 and designed to have its own symbolism. Its circular patterns were intended to represent the cosmos.[34] We cannot be certain that this meaning was still clearly understood in Holbein's time, and it is possible that the floor was simply a rich pattern which Holbein copied and adapted, perhaps with some anticipation on Dinteville's part of the richness of the fashionable tiled floors later to be laid at Polisy. However, the general design of Holbein's floor is close enough to his model to echo its meaning intentionally, and, if this was indeed the case, a pattern symbolising heaven and earth would have a clear connection with the celestial and terrestrial globes of the painting, and the evident division of the objects on the shelves into heavenly and earthly realms.

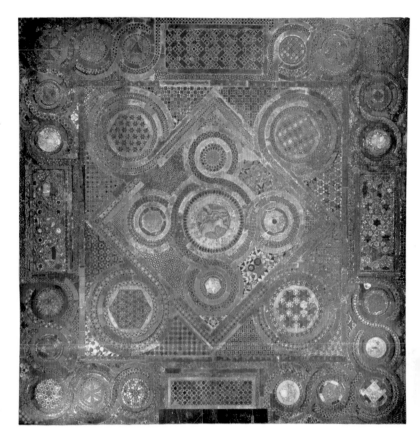

41 Odericus of Rome, Inlaid stone pavement, 1268. 1173 x 1173 cm. London, Westminster Abbey

The objects in *The Ambassadors* and the way they are arranged seem to bear special significances for their owners. Yet these meanings must be considered further in relation to the two objects marking the picture's dominant diagonals: the distorted skull in the foreground, whose significance must be death, and the silver crucifix placed at a right angle in the top left-hand corner of the painting, with its promise of salvation and everlasting life.

Death and Distortion:
The Skull and the Crucifix

Whatever significance is held to reside in the objects on the shelves of *The Ambassadors*, they must be negated or overshadowed by the skull (Plate 49), the meaning of which can only be mortality. In paintings of the sixteenth and, especially, the seventeenth century, objects such as the books and musical instruments in *The Ambassadors* are frequently shown with skulls, hourglasses or snuffed candles, indications that all earthly endeavour is vain illusion and soon turns to dust.[1] Such *vanitas* still-life paintings became an especially common genre among Dutch painters of the seventeenth century, but in earlier centuries skulls commonly intruded to complete the meaning of religious paintings and portraits.

Since Christianity proclaims the idea of eternal life following the short earthly span, it is not surprising to find skulls as symbols of mortality in religious painting. They appear lying under the cross in scenes of the Crucifixion, at Golgotha, the place of the skull. They also appear in a more symbolic sense. For instance, the reverse of the shutters of the Braque triptych of Christ, the Virgin and three saints, by the fifteenth-century Netherlandish painter Rogier van der Weyden, shows a skull on the left and a cross on the right, representing the two polarities of death and resurrection, a precursor of their appearance in Holbein's painting (Plate 42). With the skull is the coat of arms of the owner of the triptych. A similar arrangement occurs on the back of the diptych painted for Jean Carondelet by Jan Gossaert early in the sixteenth century, now in the Louvre. The fronts of the two panels show Carondelet praying before the Virgin, while on the back of his portrait is his coat of arms, and on the back of the image of the Virgin is a skull with its lower jaw-bone dropping down.

Many portraits were produced in the sixteenth century in which the sitters were shown with skulls as reminders of mortality. In one painting now in the National Gallery an unidentified Netherlandish painter has depicted his sitter at

42 Rogier van der Weyden, reverses of the shutters of *The Braque Triptych, c.*1452. Oil on wood, 41 x 34 cm each panel. Paris, Musée du Louvre

43 Detail of *The Ambassadors*: the crucifix

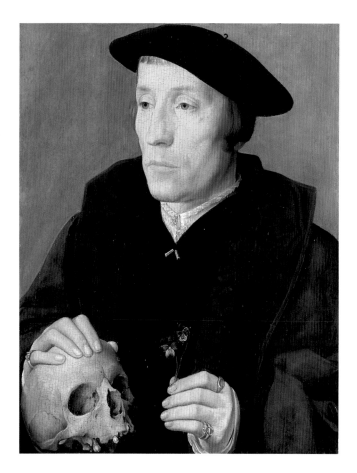

44 Netherlandish School, *A Man with a Pansy and a Skull*, c.1535. Oil on oak, 27.3 x 21.6 cm. London, National Gallery

half-length, with his hand on a skull and holding a bunch of pansies: the name of the flower in French being also the word for thought, *pensées*, the painting suggests a meditation on death (Plate 44).

In some portraits the skull – or even a decaying corpse in some German examples – was only to be discovered when the painting was turned over.[2] More commonly in the sixteenth century, portraitists such as Barthel Bruyn from Cologne kept to the conventions of the sitter posed with a skull, and sometimes also an hourglass, or of a skull painted on the back. Many of these paintings also included inscriptions, which make the sitter's concern with mortality quite clear, a counter to any accusations of personal vanity in having a painted likeness produced. In England in the mid-sixteenth century a musician, Thomas Whythorne, commissioning his third portrait of himself in 1562, after an interval of a dozen years, noted changes in his appearance, and wrote that many

people 'do cause their counterfeits to be made to see how time doth alter them … and to pray to God that as they do draw toward their long home and end in this world, so they may be the more ready to die.'[3] Such a sentiment provides a clear contemporary explanation for the inclusion of skulls in portraiture.

Skulls were frequently worn in the sixteenth century as badges or other macabre forms of jewellery. Jean de Dinteville himself wears a small badge with a skull on his hat (Plate 45). This may not be as significant as is sometimes supposed, for there is no evidence that Dinteville used a skull as a personal device, and the badges were not uncommon. Dürer records in his diary that when he was in Cologne in 1521 he paid two pfennigs for 'a little death's head', and portraits by artists such as Hans Eworth show sitters wearing rings set with small skulls.[4] The Marquess of Northampton was sketched by Holbein wearing jewellery including a pendant inscribed with the word MORS, death (Plate 46).

Holbein's portraits, however, are in general remarkable for their lack of concern with mortality. Those portraits in which death plays a part clearly reflected the interests of the sitter. It is notable, for example, that the several portraits of the

45 Detail of *The Ambassadors*: Jean de Dinteville's skull hat-badge

46 *William Parr, 1st Marquess of Northampton*, c.1541–2. Black and coloured chalks with white bodycolour and ink on pink-primed paper, 31.7 x 21.1 cm. Windsor, Royal Library

BRIANVS TVKE, MILES. AŇ ETATIS SVÆ. LVII

. DROIT ET . AVANT .

47 *The Dance of Death: Coat of Arms of Death*, c.1525. Woodcut, 7.4 x 5.1 cm. London, British Museum

48 *Sir Brian Tuke*, c.1527–8 or c.1532–4. Oil on oak, 49.1 x 38.5 cm. Washington, National Gallery of Art

Hanseatic merchants in London include inscriptions and sometimes specific still-life details, of a kind that are not present in portraits of English sitters. The background to the portrait of Georg Gisze includes a number of details which may contain references to mortality, such as the flowers in a vase and the scales on the shelves, the latter perhaps alluding to the Last Judgement (Plate 91).[5]

Only one known portrait of an English sitter appears to show a preoccupation with mortality, the portrait of Sir Brian Tuke, Henry VIII's Treasurer and Postmaster (Plate 48). Like others he chose Holbein to paint his portrait, but unlike others he had included in it not only a prominent crucifix with a badge of the Five Wounds of Christ, a popular devotion in the early years of the sixteenth century, but also a related inscription. The text draws attention to the brevity of Tuke's lifespan, possibly because Tuke had suffered a severe bout of sweating sickness, from which he recovered, but the words are also a conventional expression of piety. In some later copies of the painting Tuke is accompanied by a skeleton, who appears to be about to drag him away, but this motif does not form part of the original painting.[6]

Such figures appear many times in Holbein's famous woodcut series, *The Dance of Death*, which was designed in the 1520s in Basel, though not published until 1538. Skeletons drag a noblewoman from her bed, disturb an astronomer with his armillary sphere (Plate 24) and pull a baby out of his parents' poor hovel. At the end of the book the triumph of death is complete, and a skull is presented on a shield, with two elegantly dressed supporters, a man and woman, standing on either side (Plate 47). Showing a skull on a shield was no novelty – Dürer had depicted such a shield in an engraving in which two lovers are approached by death – but the similarity between Holbein's woodcut design and the composition of *The Ambassadors* is striking. The skull in the painting is centred in exactly the same way, but it is hidden from us. Whereas other portraitists who wished to separate the intimation of mortality from the main depiction would paint it on the back of the panel, Holbein boldly conceals his skull on the front of the portrait. The fact that its shadow falls in the opposite direction to others in the painting may serve to indicate the presence of an object from a dimension beyond the temporal.[7]

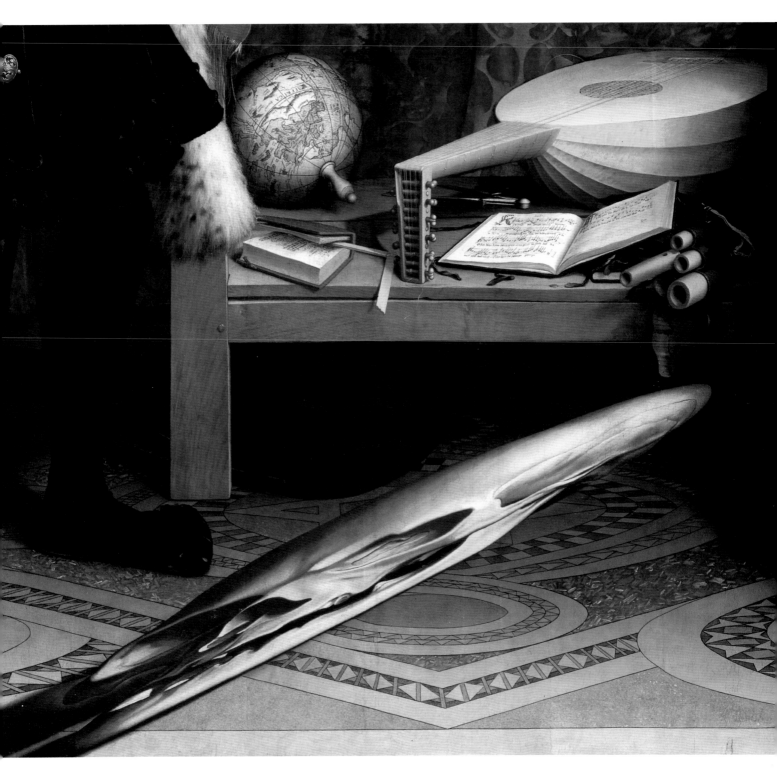

49 Detail of *The Ambassadors*: the skull

The counter to death, symbolised by the skull, is resurrection, and it is clearly for this reason that the silver crucifix is placed in the top left-hand corner, at a right angle so that, like the skull, it is deliberately difficult to discern and must be discovered (Plate 43). It is probably the last thing in the picture that the viewer will find: after admiring the two splendidly dressed ambassadors, the sign of their, and our, mortality becomes evident, and finally the hope of resurrection appears.

The combination of double portrait and hidden skull in *The Ambassadors* is unprecedented, and occurs nowhere else in Holbein's work. However, the way in which the skull is concealed (Plate 49), using the distortion known as anamorphosis, was not unusual in the sixteenth century. Indeed, anamorphosis appears to have been somewhat fashionable. Anamorphic woodcut portraits of the Emperors Charles V and Ferdinand, for example, were produced by the German artist Erhard Schön (Plate 50): long and thin, they were restored to normal proportions when viewed sideways. Holbein and his two sitters in *The Ambassadors* may have known these prints. Jean de Dinteville may also have known of the similar experiments produced by Leonardo da Vinci during his years at the French court.[8] The most famous example of this painted witticism in sixteenth-century England was the portrait of Edward VI in Whitehall Palace, today in the National Portrait Gallery (Plate 51). It once bore the signature of the artist William Scrots and the date 1546, the year before Edward became King. Looking directly at the portrait, it appears as an oval, in which the head is vastly elongated, with a grotesquely long nose. When viewed from the right-hand side, however, it is clear that this is a circular portrait in profile of a normal young boy (Plate 52).

The portrait of Edward is of special interest in relation to *The Ambassadors* and other anamorphic portraits, because we know exactly how contemporaries looked at it soon after it was made. Visitors to Whitehall Palace in the late sixteenth century describe it as one of the great wonders to be seen there. It was viewed from the right-hand side with the aid of a telescopic device. This was pulled out to its full extent and at its end it had a metal plate with a pinhole: looking though the pinhole gave a clear undistorted view of the painting.[9] This device is now lost, but a notch cut in the right-hand side of the frame, which has survived with the portrait, serves to allow an unobstructed view of the picture plane, and the reverse of the frame still clearly shows where the apparatus was originally attached.[10] Another such device is described in the collection of William Cartwright in the late seventeenth century. A painting showed a man and woman in a tent, and there was 'a thing to pull out, & at ye end of it a brass playt with a Lickell hole in it, Look through that hole with on eye, & winke with ye other … & you may perfitly see them.'[11]

Was *The Ambassadors* meant to be viewed in a similar way? The original frame is long lost, so that it is no longer possible to establish whether it had any viewing device attached. *The Ambassadors* is of course a much larger painting than the portrait of Edward, and it is difficult to imagine that it would have been studied in the same manner as a small peepshow-type painting.

The recent cleaning of *The Ambassadors* has shown that the skull as Holbein painted it, although damaged, was also considerably obscured by later restorations. The skull as it is now visible is a much more anatomically accurate depiction than was previously apparent. For instance, older photographs, taken from one side to correct the distortion, are unable to produce a convincing nose bone, but this area was the most heavily overpainted, because most damaged. Now that old and confused restorations have been removed, a fresh view of what Holbein originally painted has been revealed. This has allowed new investigation into the difficult question of how the anamorphosis was meant to be seen and how the distorted skull was created.

50 Erhard Schön, *Anamorphosis of Emperor Ferdinand*, *c.*1531–4. Woodcut, 17.3 x 76.7 cm. London, British Museum

51 William Scrots, *Edward VI*, 1546. Oil on wood, 42.5 x 160 cm. London, National Portrait Gallery

52 The portrait in Plate 51 viewed from the side with the anamorphosis corrected

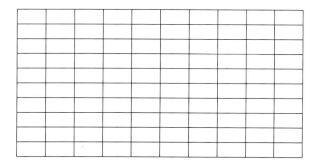

53 Detail of *The Ambassadors*: the skull manipulated on the computer to simulate its creation by using an elongated regular rectangular grid. The resulting image is not fully resolved

54 Detail of *The Ambassadors*: the skull manipulated on the computer to simulate its creation by using a trapezoid grid with irregular intervals. The resulting image is convincingly resolved

55 Detail of *The Ambassadors*: the skull manipulated on the computer to simulate its creation using a glass cylinder, a distortion equivalent to a rectangular grid with intervals extending at irregular intervals from a central point. The resulting image is not fully resolved

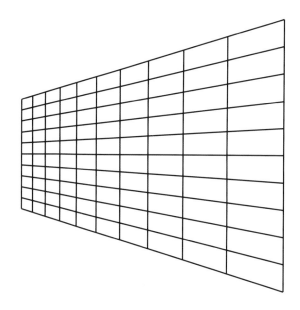

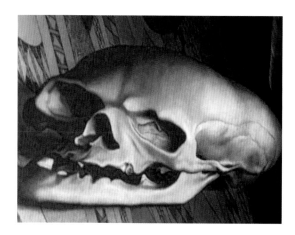

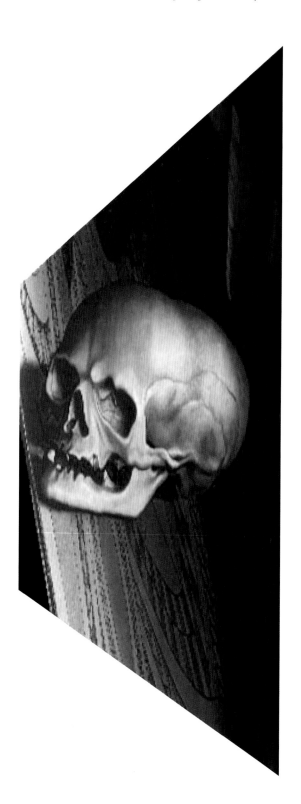

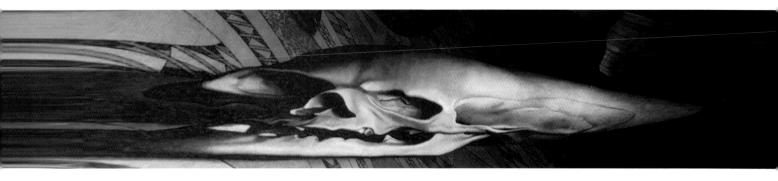

Handbooks giving instructions to artists on how exactly to make an anamorphosis have survived from the late sixteenth century onwards.[12] As mentioned earlier, Leonardo experimented with drawings of such distortions, and the existence in Northern Europe of anamorphic prints and paintings, including Holbein's, from the first half of the sixteenth century, shows that methods for making anamorphoses existed long before they were published. A simple method of producing a distortion which would become legible on viewing the image from one side, as the portrait of Edward VI and others were to be viewed, involved transferring an image square by square to an elongated regular rectangular grid. However, when Holbein's image is refashioned in this way with the aid of computerised image-processing techniques, the resulting picture of a skull is unconvincing, and indicates that Holbein cannot have constructed his anamorphosis using this simplified method (Plate 53). A more sophisticated method used intervals in the squaring process spaced further and further apart, and a trapezoid grid to take account of the angle of viewing and achieve a more convincing resolution of the distortion in perspective. When Holbein's elongated skull is subjected to manipulations on the computer imitating this process in reverse, the result is a perfectly drawn skull, the image with which he must have begun (Plate 54). Holbein

may have made a drawing from life of a real skull, or possibly copied a print or drawing by another artist. He was then ready to transfer the outlines to the trapezoid grid.

However, the skull is a complex three-dimensional object, strongly lit from the right, and it would have been a difficult task to transfer all its details to a such a grid and maintain such an accurate depiction. (It is notable that Holbein, though one of the greatest draughtsmen of the time, did not find it possible to draw completely accurate ellipses in the floor design of *The Ambassadors*.) It is possible that another method was used, namely projecting the outlines of a drawing of the skull by means of shining a light through a pinhole on to the drawing at an angle, and then on to a wall or other surface, a method which would result in a perspective distortion.[13] The outlines of the resulting distortion could then be traced and used to prepare the outline of the skull as shown in the painting.

Since the anamorphosis of the skull was prepared with a system in which the focal point for the perspective distortion lies to the right-hand side of the painting, the image of the skull is more easily resolved when viewed from the right-hand side of *The Ambassadors* than from the left. There is an optimum viewing point when standing to the right, in a position at a right angle 120 millimetres away from the wall surface, 1040 millimetres from the bottom of the picture, and some 790 millimetres from the right edge of the painting.[14] Entering a room from the right keeping close to the wall on which the painting was hung would enable the skull to be seen clearly, as would viewing the painting descending a staircase if the painting hung on the right-hand side of the viewer. However, as previously discussed, the château in which the picture was displayed is unlikely to have included a large enough staircase for the picture to be viewed in this way.

An alternative method of viewing has been suggested. This involves holding a glass cylinder at a slight diagonal at a distance of a few metres in front of the picture. The image of

56 Lucas van Leyden, *Saint Jerome*, 1521
Black chalk with brown and dark washes,
ink, heightened with white, blue bodycolour
on paper, 37.6 x 28.1 cm. Oxford, Ashmolean
Museum

57 Joos van Cleve, *Saint Jerome in his Study*,
*c.*1524–30. Oil on wood, 99.7 x 83.8 cm
Cambridge, Mass., Fogg Art Museum

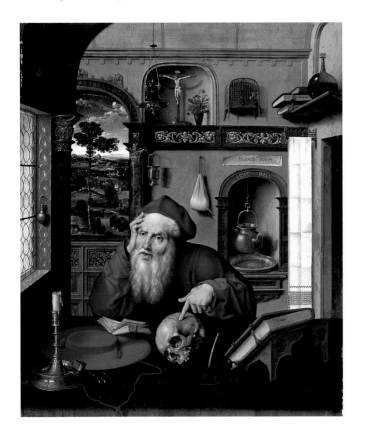

the skull appears reflected in it, with only a little distortion to
the left and right, which can be corrected by moving the
cylinder slightly; an excellent image of the undistorted skull
may be obtained in this way.[15] The precise diameter of cylin-
der required is unimportant, and any ordinary hollow glass
object may be used, for example a vase or drinking glass of a
type which would have been common in Holbein's time. This
method of viewing the picture has the merit of comfort, since
one can stand in front of it, and there is no need to bend or
stand at right angles to the wall. But it is difficult to establish
whether sixteenth-century viewers would have known about
it. Certainly anamorphoses of a different kind to Holbein's
and designed for viewing with cylindrical mirrors were very
common in the seventeenth century: Cartwright's collection,
mentioned above, included five such paintings to be viewed
with the 'Sellinder glass'.[16] However, even if this method was
used for viewing the skull, manipulations of Holbein's skull,
once again using a computer, show that it cannot have been
used to create it (Plate 55).[17]

A large full-length double portrait incorporating so many
objects and so much trickery must have required an immense
amount of planning. The second section of this book will
describe some of the techniques used to prepare and paint it.
But, although *The Ambassadors* is a highly complex portrait,
the source for the essential juxtaposition of figures, skull and
crucifix may be a simple one. There was in the early sixteenth
century a precedent in a very popular composition including
a figure with both a skull and a crucifix, as well as books and
other objects: that of Saint Jerome in his study. Holbein may
well have drawn on such compositions as a model for his own
painting, tailoring them to suit Dinteville's own preoccupa-
tions, for the significance of these images comes close to the
melancholy of Dinteville's thoughts at this time.

The image of the scholar-saint in his study had developed
in Northern Europe in the early sixteenth century into a
meditation on mortality. Increasingly, large numbers of images
of Saint Jerome were made showing the saint with portents
of death and judgement. The saint was frequently associated
with the Last Judgement: texts stated that Jerome had heard
the trumpets of the Last Judgement when he was in the
desert, and there were other writings ascribed to the saint
describing the fifteen signs of the coming of the Last
Judgement.[18]

In the early sixteenth century, images of Jerome, whether
in penitence in the desert or at work in his study, usually
included both skull and crucifix. Dürer's famous engraving of
the saint in his study of 1513, showing him tranquilly at his
work, includes both objects. A painting by Dürer in Lisbon

58 Attributed to Dirck Jacobsz., *Vanitas: Unidentified Couple*, 1541. Oil on wood, 100 x 130 cm. Amsterdams Historisch Museum

slightly later in date focuses simply on the saint's head and shoulders and these two attributes, as does a magnificent drawing by Lucas van Leyden dated 1521 (Plate 56). Very close to these images of the saint, but far more elaborate, are the paintings produced by the Netherlandish artists Joos van Cleve (Plate 57) and Marinus van Reymerswaele and their followers. These show the saint in his study, clearly meditating on mortality, as inscriptions and other objects indicate. In the Reymerswaele type, the saint points to an illuminated book with an image of the Last Judgement, and in versions of the van Cleve type, the Last Judgement appears in the sky through the window. The inclusion of objects such as candles and clocks emphasise the *vanitas* nature of these compositions.

Jean de Dinteville and Georges de Selve stand and do not

sit, but they are placed in a narrow space in which the accoutrements of the study are on shelves between them, and in which the principal axes of meaning of the composition are a skull and a crucifix. The two men are not depicted in the guise of Saint Jerome – although Cranach at this period depicted his patron Cardinal Albrecht of Brandenburg in this role – but, like Jerome, they are juxtaposed with the symbols of death and redemption. Some portraits by Holbein seem to show him strongly influenced by contemporary Saint Jerome imagery: his portraits of Erasmus in his study, for example, where the scholar is connected with Jerome both through the setting and through his own work of editing the saint's texts (Plate 78). Other artists too may have taken their compositional cue from the iconography of Saint Jerome when wishing to show their subjects meditating on mortality: a painting by a Netherlandish artist in Amsterdam dated 1541 shows a couple, a man and wife, half-length rather than full-length, but accompanied by the familiar objects of clock and candle, and with the skull and crucifix seen in the background through a window (Plate 58).[19]

We know that Jean de Dinteville was miserable and melancholy during much of his time in England in 1533, and that he was also frequently ill. It is highly probable that he often thought of death and, as a Christian, of Judgement and of Redemption. Together with Holbein the sitters may have

constructed a pictorial meditation on their mortality. Some contemporary literature encouraged such thoughts: it has been suggested, for example, that a source for Holbein's painting may lie in writings on the vanity of the world by the magus Cornelius Agrippa, who was at the French court in the early 1530s, and whom Dinteville may have known.[20] However, such writings were part of Christian currency, and similar texts can be found in the Bible, notably the Old Testament Book of Ecclesiastes, with its invocations to 'Vanity of vanities'. Anne Boleyn possessed an illuminated commentary in French and English on this book, called *The Ecclesiaste*, decorated with illuminations in the French style, one showing an astronomical instrument, an armillary sphere, representing the world, source of all vanity (Plate 59). Though Holbein's imagery is more complex, such a traditional text provides as valid a gloss on *The Ambassadors* as the more obscure work of Agrippa.

The whole painting then may be read as a meditation on Dinteville's melancholy and misery, and on de Selve's despair at the condition of Europe. Standing on a floor which may allude to the cosmos, and placed between objects including astronomical instruments, perhaps arranged to simulate heaven and earth, and which certainly allude to a world of chaos, both men think of the brevity of life and their end, but also of the hope of the life to come.

59 Historiated initial letter from *The Ecclesiaste* showing armillary sphere, c.1533–6 Illuminated manuscript, Percy MS 465, fol. 34r, 19.5 x 13.5 cm. Collection of the Duke of Northumberland

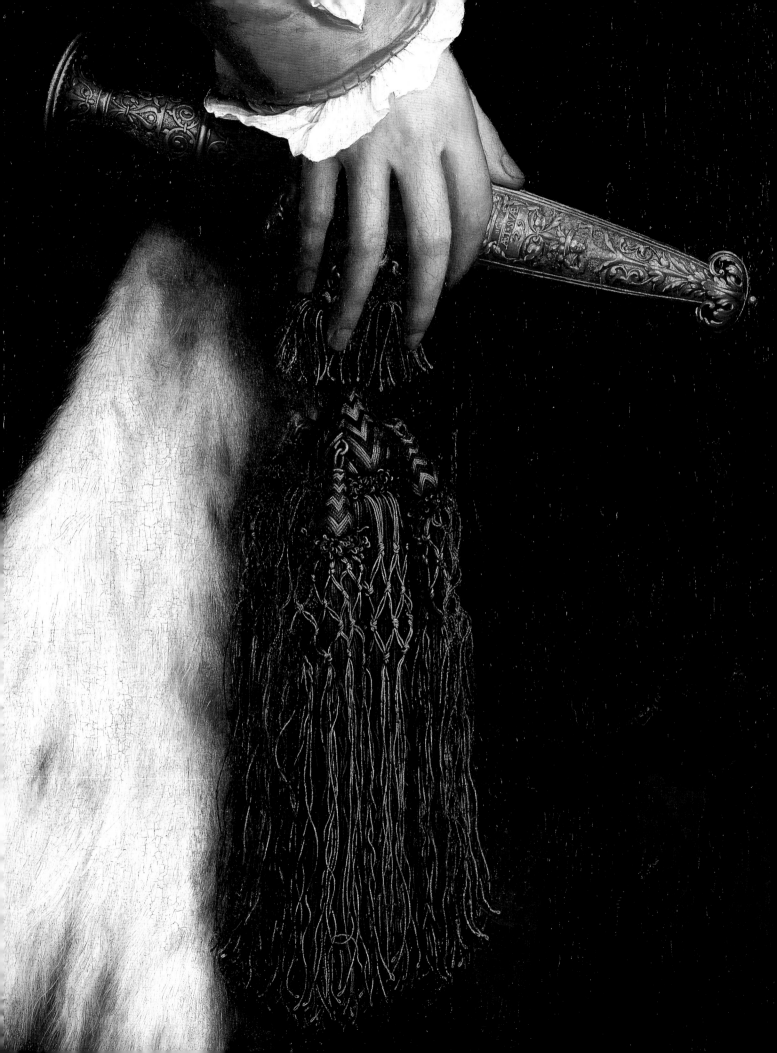

Holbein as a Painter and the Making of
The Ambassadors

Holbein's *Ambassadors* marks the artist's fullest achievement as a portraitist and painter on panel and exploits the repertoire of techniques he evolved and refined over a working career of almost two decades, from 1515 to 1533. The development of his painting practice had by this time reached a high level of sophistication: not only was his execution almost flawless, but his painting method was sure and economical and his understanding of the properties of the materials with which he worked exceptional. By comparison with many of his sixteenth-century German contemporaries, Holbein's paintings are superbly preserved. *The Ambassadors* displays not only his mastery of portrait painting but also his great skill in capturing the textures of a wide variety of surfaces: silk, satin, velvet, fur, metalwork, wood, leather and paper. He succeeds as well in suggesting the weight and thickness of the Anatolian wool rug and the subtle play of light on its folds, as in depicting the glint of gold threads twisted and knotted with blue silk in the tassel of Dinteville's dagger (Plate 60). Such painterly effects were the culmination of Holbein's development during his years in Basel and London, away from his birthplace, Augsburg in Germany.

Holbein's father, Hans Holbein the Elder, ran a busy and successful painters' workshop in Augsburg, producing large altarpieces, often working in collaboration with sculptors. Although there is no documentation of the younger Holbein's training, it is highly probable that his father taught him the techniques of panel painting. These would have

encompassed preparing wood panels, chalk grounds, the techniques presumably of drawing and underdrawing, the preparation of pigments, methods of gilding and the use of the oil medium.[1] In Germany, at the end of the fifteenth century, these techniques had become an established and stable tradition, evolved largely to serve the needs of the workshop method for the production of altarpieces. In the early decades of the sixteenth century, however, German painting, like that of the Low Countries, became subject to many outside influences and as the century advanced, painters became more individualistic and concerned to advance their personal reputations. Holbein was no exception. The complexity and scale of *The Ambassadors* reflects the ambitions of the patrons and of Holbein himself. The painting's elaborate design would have required considerable planning.

Planning *The Ambassadors*

It is highly improbable that Holbein ever stood with his easel and paints before the two ambassadors posing with their shelves of objects in front of a green curtain upon a coloured marble floor. What we know of Holbein's working practices suggests that *The Ambassadors*, like other portraits by Holbein, was constructed piecemeal, using drawings to recreate the facial likenesses, and probably many other drawings as well. Its exceptionally large scale would have made this approach all the more necessary. In fact no preparatory drawings for *The Ambassadors* survive, but it is possible to reconstruct Holbein's procedures by surveying the range of drawings that he used in the planning of other large compositions. In addition, it is

60 Detail of *The Ambassadors*: Jean de
Dinteville's dagger and tassel

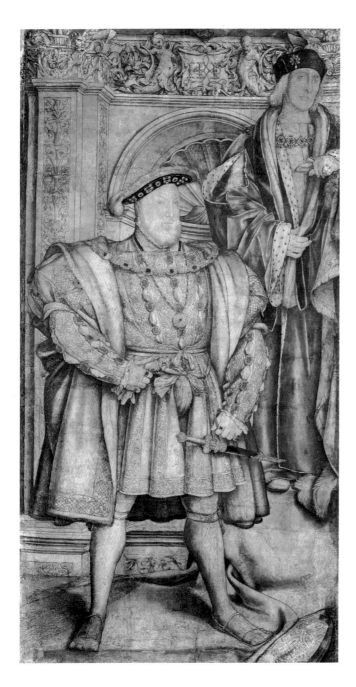

61 *Henry VII and Henry VIII*, cartoon for the destroyed Whitehall wall-painting, *c.*1536–7 Ink and watercolour on paper mounted on canvas, 257.8 x 137.2 cm. London, National Portrait Gallery

possible to reveal and record the preparatory drawing present beneath layers of paint by means of infra-red examination, but the effectiveness of this technique depends on the materials and layer structure of the picture. For example, black underdrawing lying on a white ground beneath flesh paint is generally clearly visible. Unfortunately, *The Ambassadors* has a mid-grey ground making it very difficult to detect by this method any underdrawing that might be present (see Plates 92 and 101).

The Ambassadors is an exceptionally large composition, particularly for a painting on panel. Apart from the even larger panel used for the portrait of Henry VIII and the Barber-Surgeons, a work probably begun by Holbein and completed after his death (Plate 9),[2] Holbein's other large-scale portrait works were carried out on different supports: on fine canvas for the lost More family portrait, and on a wall for the dynastic painting of Henry VIII and his father (also destroyed). However, drawings survive for both the last two compositions, and these help to illustrate a series of different compositional procedures and techniques, which may have been used in combination for all the large-scale works, including *The Ambassadors*.

Two preparatory stages survive for the portrait of the Mores: individual chalk drawings for the different portrait heads, and an outline drawing of the whole composition (Plate 7) , with annotations in Holbein's hand, and names and ages added by the astronomer Nicolaus Kratzer, so that the drawing could be sent to the sitters' friend Erasmus in Basel. The drawing of the whole composition may record a stage at which it was discussed with Sir Thomas More: the alterations noted include one to the effect that the musical instruments should lie on the cupboard, not hang up, and one that Lady More should sit and not kneel. It is easy to imagine that a similar drawing might have existed for *The Ambassadors*, which Jean de Dinteville could have discussed with Holbein. The drawing of the Mores also shows how Holbein might embellish and alter poses and costumes that he had recorded in the drawings made at individual sittings. For example, Anne Cresacre appears to stand in the group drawing, but in the individual drawing of her (Royal Collection) the back of the chair on which she is seated is clearly visible.

No such compositional sketch exists for the Whitehall wall-painting, only one drawing of Jane Seymour (Plate 79), which also served as the basis of a portrait (Vienna, Kunsthistorisches Museum). However, in this case, evidence of a further stage necessary for the preparation of a large-scale composition survives. Preparation for the wall-painting involved the making of a cartoon: a full-size drawing which

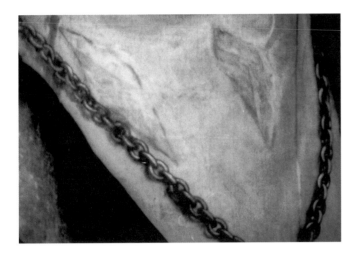

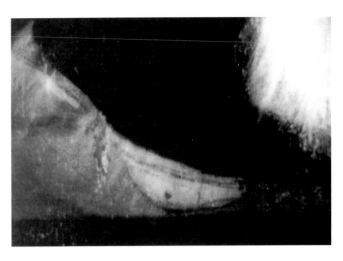

62 Infra-red reflectogram detail of *The Ambassadors*: Jean de Dinteville's chain, showing underdrawn lines indicating initial position of the chain

63 Infra-red reflectogram detail of *The Ambassadors*: fur trim at the hem of Jean de Dinteville's coat showing underdrawn lines indicating its position

would have been positioned against the wall in order to transfer the design. In this case the design was transferred by pricking rather than tracing over the outlines, and possibly also pouncing, by forcing charcoal powder through the holes of this or another, auxiliary cartoon.[3] The cartoon which survives in the National Portrait Gallery (Plate 61) shows only half the composition: the two Kings on the left and not the Queens on the right. The composition has a close affinity with that of *The Ambassadors*, four years earlier: in particular the pose of Henry VII with his elbow resting on the tablet in the centre is very like that of Georges de Selve, in reverse, and the arrangement of figures either side of a central square is similar, the square being transformed into the shelves in *The Ambassadors* and the Latin-inscribed tablet in the dynastic composition.

In the cartoon the figures themselves are made of small sheets of paper glued together, but are cut out separately and stuck against the background, perhaps so they could be moved around before the final positions were fixed. The composition then appears to have undergone a final process of adjustment, by comparison with the copy of the painting made in the seventeenth century: the head of Henry VIII was turned to the front, and the costume was also adjusted (Plate 8). No drawings of the Kings exist, but the drawing of Jane Seymour shows that considerable amendments were made to her dress and jewellery, to bring them up to the required standard of grandeur for this dynastic portrait. The even larger

panel painting of Henry VIII and the Barber-Surgeons was also made using a cartoon, which survives in an overpainted state. The pricked holes of the cartoon correspond to the dots of the pounced underdrawing seen in infra-red photographs and reflectograms.

It is possible that a full-scale cartoon of all or parts of *The Ambassadors* composition was made, but the limited extent of underdrawing revealed by examination with infra-red reflectography does not provide evidence of pounced dots. There are indications, however, from cross-sections and infra-red reflectography of some underdrawing on the grey priming, in a dry black material such as black chalk or charcoal, and reinforcement of these lines with a black ink or fluid paint. Because of the infra-red absorbing properties of the grey priming, it is likely that only a fraction of the underdrawing actually present can be detected by infra-red reflectography. This is particularly the case where dark paint layers occur over the priming, as in the rug. In addition, thin dark lines of paint present at the surface, for example in the designs on the scientific instruments, the globes and the tiled floor would conceal any underdrawing beneath the paint layers. Similarly, the black paint of Dinteville's costume and the dark brown of de Selve's robe, which contains a high proportion of lamp-black pigment, would also obscure any underdrawing that might otherwise be detectable by infra-red reflectography.

A certain amount of underdrawing, however, can be detected in areas where the paint layers that lie above can be

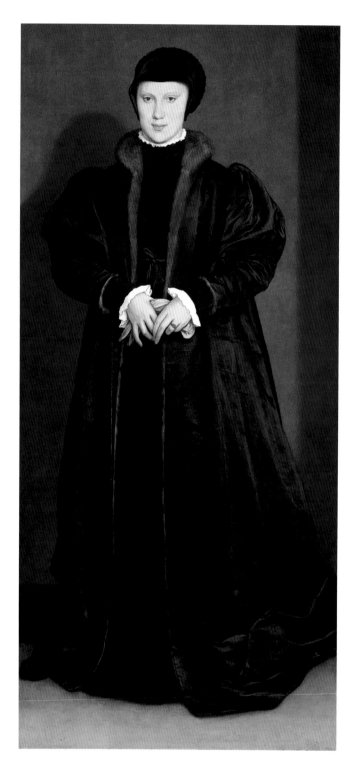

64 *Christina of Denmark, Duchess of Milan,*
*c.*1538. Oil on oak, 179.1 x 82.6 cm
London, National Gallery

penetrated. For example, where the chain worn by Jean de Dinteville crosses his pink satin doublet an underdrawing of parallel lines is visible (Plate 62). This characteristic notation can be seen with the aid of infra-red in other portraits, such as that of Sir Henry Guildford, who wears the chain of the Order of the Garter. There is also some drawing, visible only by infra-red, on the left-hand side of the skirt of Dinteville's tunic, where the contours have been adjusted slightly, and around the edge of his right shoe. Some rather discontinuous dark lines revealed by infra-red in the fur trim at the hem of the tunic represent the basic underdrawing method Holbein employed (Plate 63).

Typically, little underdrawing can be discerned in Jean de Dinteville's face, except for traces of black chalk or charcoal around the nose. Black chalk or charcoal has also been detected on the grey priming under the face of Georges de Selve, together with a reinforcing line of fluid black paint or ink – such as is frequently seen in portrait drawings of this period. The chalk lines are presumably the result of transferring the outlines of portrait drawings of the sitters that are now lost.

Drawings for Portraits

We can be certain that Holbein's normal practice during a portrait sitting was to make a drawing from life, from which a painted portrait could be worked up, without any need for the sitter's presence. In the case of *The Ambassadors* this would have been particularly useful, since the visit of Georges de Selve may have been quite brief, without much time for portrait sittings. This may also explain why, unusually, de Selve's face is a little lacking in animation. Jean de Dinteville, on the other hand, had time to spare, but it is probable that he spent it devising the complex content of the painting, rather than sitting for Holbein. His portrait is almost certainly based on a drawing as well. This was not the first time Dinteville had sat for a portrait drawing, for a drawing of him by the French artist Clouet exists, and was presumably a study for a painted portrait which no longer survives (Plate 13). Clouet is said to have needed six hours for his portrait sittings.[4]

In March 1538 Holbein was sent to Brussels to take the portrait of Christina of Denmark, Duchess of Milan, a potential fourth bride for Henry VIII (Plate 64). The image of Christina that he produced was pronounced 'very perfytte' after a sitting of 'but three hours space'.[5] This is the only indication we have of the length of time Holbein would have with his sitters, but unfortunately this was a far from ordinary commission. As a royal commission, and an exceptional

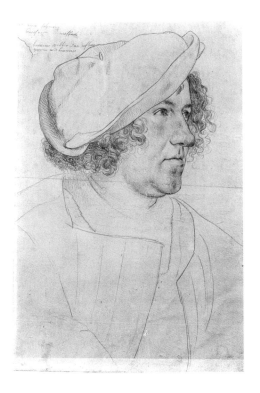

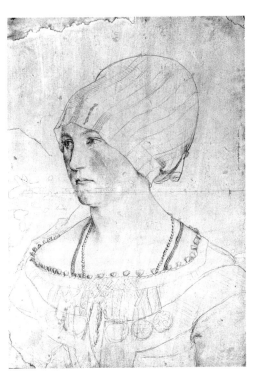

65 *Jakob Meyer zum Hasen, Mayor of Basel*, 1516. Silverpoint and sanguine on paper with white priming, 28.1 x 19 cm. Basel, Kupferstichkabinett

66 *Dorothea Kannengiesser, Wife of Jakob Meyer zum Hasen, Mayor of Basel*, 1516. Silverpoint and sanguine on paper with white priming, 28.6 (left)/29.3 (right) x 20.1 cm. Basel, Kupferstichkabinett

67 *Jakob Meyer zum Hasen, Mayor of Basel*, 1516. Oil on limewood, 38.5 x 31 cm. Basel, Kunstmuseum

68 *Dorothea Kannengiesser, Wife of Jakob Meyer zum Hasen, Mayor of Basel*, 1516. Oil on limewood, 38.5 x 31 cm. Basel, Kunstmuseum

full-length portrait for a very specific purpose – the approving of a royal bride – the time for this particular sitting cannot be taken as typical of the sittings that Holbein had with courtiers in England. The panel would surely have been too big and unwieldy to take across the Channel, but Holbein may have made several sketches enabling him to produce a full-length portrait of exceptional beauty: it is difficult to believe that he did not make a special sketch of Christina's hands. He may also have made a full-length costume study.

Although no drawings remain for the portraits of either Jean de Dinteville or Georges de Selve, there are nearly a hundred portrait drawings from Holbein's two visits to England, giving a clear idea of the kind of drawings he would have made of the two ambassadors, and also of the manner in which they would have been used. The vast majority are in the Royal Collection, and with their annotations of colour and fabric, marginal sketches of jewellery and costume, and even in one case a scale, they are clearly working drawings, made during the production of the painted portraits (Plates 46 and 81). In some instances both Holbein's painted portrait and his drawing have survived, and comparisons between them can show exactly how they were used.

The first portraits that Holbein made in Basel at the age of eighteen or nineteen were based on careful but already confident sketches of his sitters in metalpoint and coloured chalks, annotated with reminders of the colours to be used (Plates 65 and 66).[6] Like the drawings for his portraits of English sitters ten and over twenty years later, Holbein made head and shoulders sketches only, omitting the hands which are included in the painted portraits, and leaving the backgrounds empty; only at the painted stage do the elaborate Renaissance arches make an appearance (Plates 67 and 68). This type of portrait drawing varied little throughout Holbein's career, although he changed his drawing technique, abandoning metalpoint for coloured chalks in the 1520s, and elaborating his drawings in the 1530s by means of flesh-coloured backgrounds and the use of ink and sometimes wash as well as chalks.

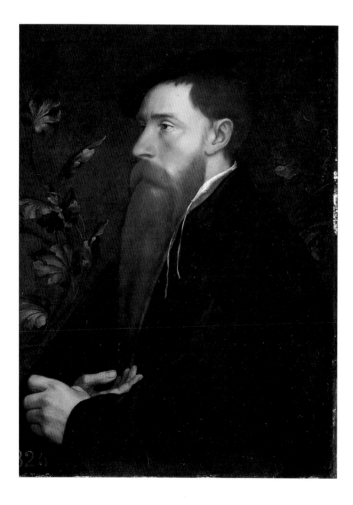

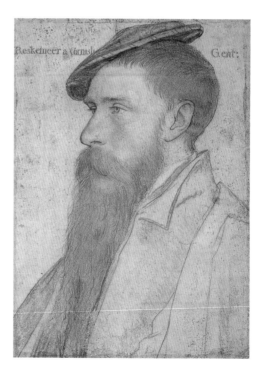

69 *William Reskimer, c.*1533. Oil on wood, 46 x 33.5 cm. The Royal Collection

70 *William Reskimer, c.*1532–3. Black, white and coloured chalks with metalpoint on pink-primed paper, 29 x 21 cm. Windsor, Royal Library

71 Studies of heads and hands, after 1538
Pen and chalk on paper, 13.2 x 19.2 cm
Basel, Kupferstichkabinett

The sizes of some pairs of drawings and paintings correspond so closely that it is obvious that the painted portrait must have been traced or copied from the drawing, for example those of William Reskimer (Plates 69 and 70), Lady Butts, Jane Seymour, Sir Richard Southwell and William Warham.[7] Infra-red photography and reflectography have also revealed that many of the painted portraits are drawn with lines that are clearly traced, rather than executed freehand.[8] In other instances it is impossible to discern any underdrawing in the painted outlines of a face or figure, undoubtedly because they follow so exactly the traced drawing.

How were the features transferred from drawing to panel? Holbein must have used his drawings to trace their outlines on to the panel, with the help of a piece of paper with some black chalk on the back.[9] Little pressure is required to produce a satisfactory transferred outline, which would have shown up well on a panel ready grounded for painting, even with the mid-grey that Holbein used for *The Ambassadors*. The relative position of the features was crucial, although in some instances Holbein appears to have made slight alterations even to these. The nostrils, line of the mouth, eyelids and ears were normally outlined in brown paint, as they are in *The Ambassadors*, in a similar manner to the black-ink reinforcements that Holbein used in his drawings. The relative position of the features was observed, rather than calculated according to any mechanical system of proportion, although a drawing survives in Basel which shows Holbein experimenting with systems such as Dürer employed (Plate 71).[10] Nor does Holbein appear to have used any special apparatus to capture likeness: Dürer also describes a device for portraiture that involved tracing the sitter's contours on to a pane of glass. This would have resulted in a very small image, and would have been complicated to use rather than speeding up the portraitist's work.[11]

Once Holbein had transferred the outlines of his portrait drawings to the surface to be painted, the rest of the figure and composition could be mapped out and adjustments made. Where pairs of painted portraits and drawings survive, they are extremely alike in the facial features, but the paintings include alterations and embellishments to this basic likeness. For example, in the drawing and painted portrait of William Reskimer the faces are identical in all respects, but the painted portrait includes hands and a background of leaves which do not appear in the drawing (Plates 69 and 70). Similarly, in the drawing and painting of Simon George (Plates 72 and 73), the hand, which holds a flower, is again omitted in the drawing, and a bunch of violas and a hat badge, apparently showing Leda and the swan, are included in the

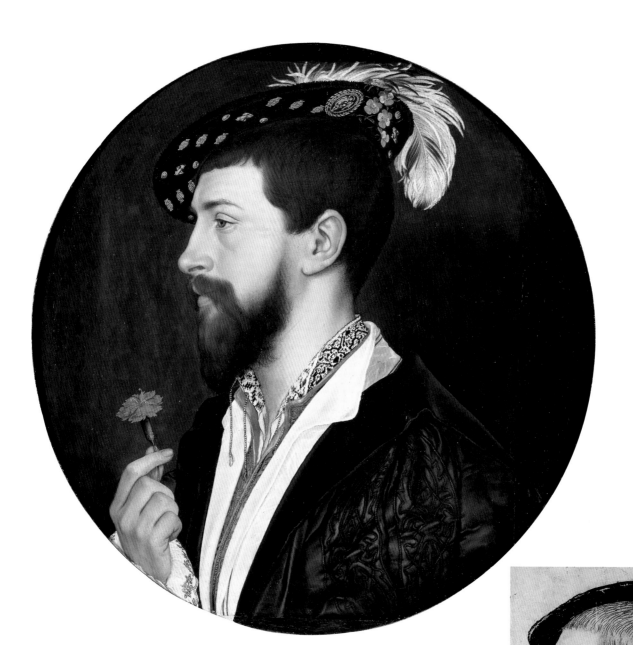

72 *Simon George, c.*1535. Oil on wood, 31 cm diameter. Frankfurt am Main, Städelsches Kunstinstitut

73 *Simon George, c.*1535. Black and coloured chalks with black ink on pink-primed paper, 27.9 x 19.1 cm. Windsor, Royal Library

finished painting. The most striking difference in the face is the presence of a beard in the painted portrait, which Simon George was evidently in the process of growing when the drawing was made: at this stage he had only a moustache and a stubbly chin.

A Lady with a Squirrel and a Starling (Plate 74) provides a particularly interesting example of Holbein making changes to a portrait during its execution, although some of them are hard to interpret with certainty. No drawing for the painting survives, but the underdrawing revealed by infra-red reflectography (Plate 75) – with no contours or modelling, and only a little drawing visible in the face – suggests strongly that Holbein followed his usual method of making a preparatory drawing and tracing it on to the panel, after which he reinforced and extended it with a particularly fluid and beautiful brush drawing. He made further alterations during painting. The right-hand side of the hat was narrowed, and

74 *A Lady with a Squirrel and a Starling*, *c*.1526–8. Oil on oak, 56 x 38.8 cm. London, National Gallery

75 Infra-red reflectogram of Plate 74

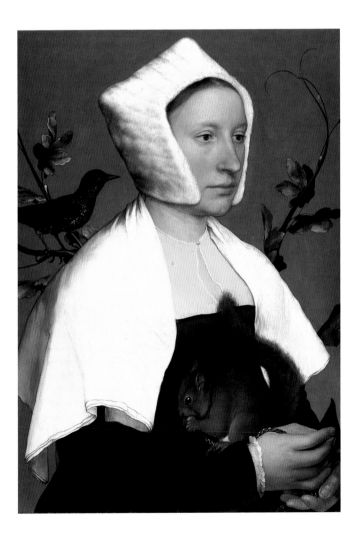

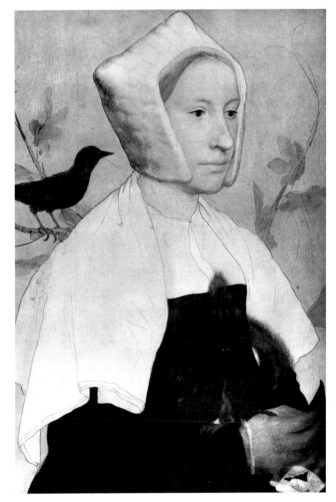

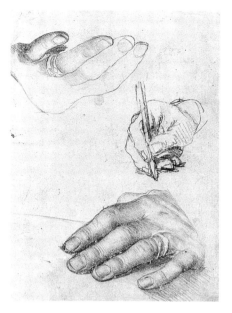

76 Study of head and hand of Erasmus, *c*.1523. Metalpoint with red and black chalk on paper, 20.1 x 27.9 cm. Paris, Musée du Louvre

77 Study of hands of Erasmus, *c*.1523 Metalpoint with red and black chalk on paper, 20.6 x 15.3 cm. Paris, Musée du Louvre

78 *Erasmus*, 1523. Oil on wood, 73.6 x 51.4 cm. Private Collection on loan to the National Gallery

the lower part of the sitter's body quite altered, for the squirrel was not included in the original plan. The X-radiograph shows a belt was originally placed where the squirrel now is; the lady's arm must have been rather lower, and the position of her hands has been changed.[12]

The pose and composition are similar to the portrait of William Reskimer (Plate 69), made a few years later, which also shares the background of vine leaves, although the leaves are not treated in an identical fashion. It is easy to imagine that Holbein kept notebooks to supplement his collection of portrait drawings, in which he collected motifs such as leaves; when he came to start a new picture, these would be subtly varied. Drawings of hands, perhaps not invariably made from life, may also have been kept separately. Only one example is known where Holbein used drawings of hands which were clearly studied in detail from life: the portraits of Erasmus of 1523. Studies of hands in chalk and metalpoint survive on

two different sheets (Plates 76 and 77), and were used both for the profile versions in Basel and the Louvre, and for the three-quarter-face portrait on loan to the National Gallery (Plate 78).[13] Even these drawings were altered and transformed during the making of the latter version of the painted portrait, probably because the viewpoint of the painting was slightly different from that of the drawings.

As the example of the wall-painting of Henry VIII shows, it was possible, and may often have been considered desirable, to make adjustments to a large composition at a late stage, just as was the case in a small work such as *A Lady with a Squirrel and a Starling*. Final decisions concerning costume and jewellery could well be deferred, and if the details were not taken from drawings made when the portrait likeness was taken, they could be sketched later on, without the sitter being present. Indeed, in some of the drawings the sitters are shown dressed with an informality which they would not have considered correct for the permanent record of a painted portrait. Charles Wingfield is drawn bare chested, completely shirtless, Lord Cobham with an open shirt. Although Holbein's painting of Lord Cobham is lost, in a copy of it he is fully clothed.[14] Where only such copies of Holbein's portraits exist they may not always be a reliable guide to what Holbein

painted, but there does seem to be a consistent pattern of a sitter's clothes being informal in the drawing and suitably elaborate in the painting. Thus Jean de Dinteville and Georges de Selve may have posed for Holbein more informally clad than their portrait shows.

Holbein may well have been able to borrow a sitter's clothes in order to complete a portrait. In the drawing of Jane Seymour she wears what appear to be simple pleated linen undersleeves (Plate 79), but in the Vienna portrait and the copy after the Whitehall wall-painting, her dress and jewellery are far more elaborate; the Whitehall wall-portrait, as might be expected, is the most formal of all, with fur-lined sleeves and massed gold chains. Surviving inventories of Jane Seymour's clothes and jewellery list items such as chains, borders, sleeves and gowns to which Holbein may have had access: 'item oone peir of sleevis of crymsen satten embraudred with venice gold' recalls the sleeves of the Vienna portrait, which it can be seen are pinned on, while a pair of lapis lazuli beads 'lyke potts dressed wt golde wt a piller at thende' resembles the style of girdle worn in the same picture.[15] A drawing of a female sitter front and back might show such a dress being modelled for Holbein by a lady-in-waiting rather than the sitter herself (Plate 80); alternatively the costumes could have been mounted

79 *Queen Jane Seymour, c.*1537. Black and coloured chalks, with metalpoint and pen and ink on pink-primed paper, 50 x 28.5 cm. Windsor, Royal Library

80 Costume study of a woman, *c.*1527/8 or 1532/3. Black ink with pink and grey wash on paper, 15.9 x 11 cm. London, British Museum

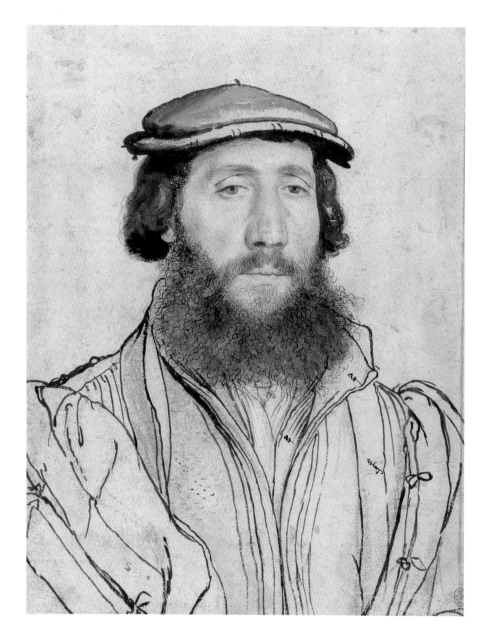

81 *An Unidentified Gentleman, c.*1532–4
Black, white and coloured chalks with black
ink on pink-primed paper, 27.2 x 21 cm.
Windsor, Royal Library

for Holbein to draw and paint from directly. It is highly prob-
able that Jean de Dinteville allowed Holbein to borrow his
lynx-lined black coat and his pink satin doublet to copy.

Colour notes are frequent in Holbein's portrait drawings,
but notes of texture even more so, particularly silk, satin and
velvet, as may be seen in one particularly beautiful drawing of
a man, enlivened with black wash (Plate 81). His coat is anno-
tated three times with the German word *atlass* (satin), but the
borders of the slashed sleeve are of a different texture, like Jean
de Dinteville's, here silk, or possibly velvet, indicated by the
letter S. Many of his sitters on his second visit to England

wore black clothes, but Holbein excelled in depicting in
monotone the subtly varied effects produced by combinations
of different types of fabric. Even the colours of the smallest
jewels were often indicated: although those in the necklace
worn by Lady Audley were altered from the colours noted in
Holbein's drawing when he subsequently painted his portrait
miniature of her. He used different combinations of coloured
chalks to indicate the differences between the colouring of
sitters' hair, eyes and complexion, but occasionally also made
notes of these details: the eyes of Sir Richard Southwell were
'a little yellowish'.[16]

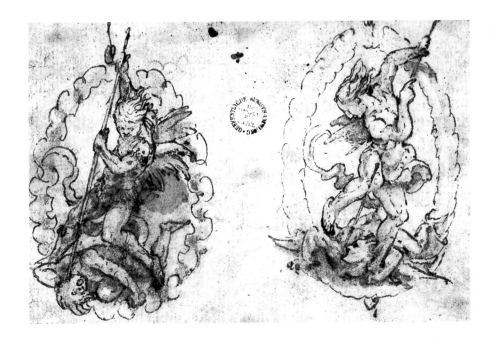

82 Two sketches of Saint Michael, *c.*1532–6
Black chalk and grey wash on paper, 6.3 x
9.2 cm. Basel, Kupferstichkabinett

In order to render costume accurately, Holbein noted in his portrait drawings many details of embroidered collars and jewelled borders. He often drew one section of the pattern only, so that he could repeat and complete it in the finished pictures. Sometimes he would leave a medallion blank, and make a separate sketch of the design elsewhere. He does this for example in the drawing of William Parr, where the design for a medallion is noted separately (Plate 46). This drawing also includes a design with the word MORS for death, recalling the skull hat badge worn by Dinteville. Two small drawings of Saint Michael exist at Basel, and it is possible that these were made by Holbein in preparation for Dinteville's medallion of Saint Michael (Plate 82).[17] (The medallion in the painting is a later restoration and may not follow Holbein's original accurately.) If so, these would be the only surviving preparatory drawings for *The Ambassadors*. Perhaps two were made because Dinteville had not brought his medallion of the order with him, and Holbein had to experiment with different designs for him – although both the Dukes of Norfolk and Suffolk had been presented with the Order, which he might have seen.

Holbein may also have borrowed the instruments which adorn the shelves in *The Ambassadors* from his friend the astronomer Nicolaus Kratzer. These are extremely close to those shown in Holbein's portrait of Kratzer painted in 1528 (Plate 31). However, they are not in identical positions: indeed, Kratzer is making the polyhedral dial in his own portrait, and in *The Ambassadors* it is finished. It is also possible

that the instruments were drawn in detail in 1528, and Holbein used these drawings again in 1533; if he did so, this might account for the fact that some of the readings of the instruments and the positions of the gnomons do not make sense. It is perhaps more likely that he should have misinterpreted his own notes and drawings, than that he should have rendered a still life inaccurately – unless of course this inaccuracy was intentional, as we have seen.

Holbein's drawings provide evidence of a highly subtle process, one which would both assist him in the need to produce a continuing procession of portraits as swiftly as possible and provide his patrons with the image of themselves they desired, as well as allowing Holbein to exercise his considerable powers of illusion and transformation.

Painting at Basel 1515–26: The Development of Holbein's Painting Technique

In Basel, where Holbein worked from 1515, he established a painting business on a smaller and more personal basis than his father's had been. During this period, he painted relatively few altarpieces and a number of smaller pictures, including portraits. Also at this time, he began to exploit a number of different kinds of media and supports: painting on walls, on canvas and paper, as well as on wood. Over the course of a decade, his technique for painting on wooden panels began to evolve towards the sophistication of his English works. The

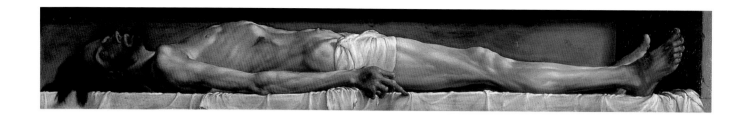

83 *The Dead Christ in the Tomb*, 1521/2
Oil on limewood, 30.5 x 200 cm
Basel, Kunstmuseum

84 Detail of Plate 85: *The Carrying of the Cross*

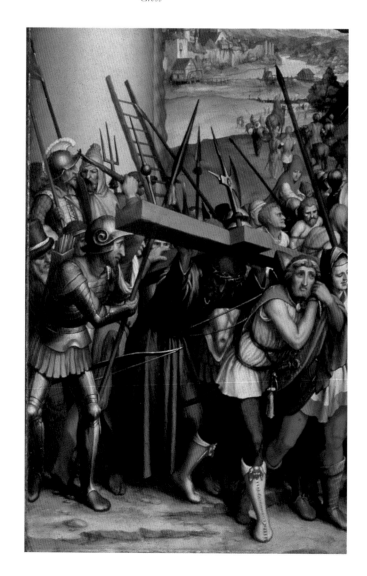

earliest of his paintings in Basel are very different, but by the 1520s techniques which he would exploit more fully in *The Ambassadors* are already evident.

Holbein's first surviving dated portraits are of Jacob and Dorothea Meyer of 1516, in Basel (Plates 67 and 68). Although the imaginary architectural backgrounds attempt to establish a sense of depth,[18] the figures themselves are curiously two-dimensional. Their clothes are painted in relatively unmodelled, flat areas of colour – for example, the woman's dress consists solely of a vermilion underlayer, thinly glazed with red lake, and the only indication of form is provided by cursory lines of black paint in the sleeve. The golden highlights on Dorothea Meyer's embroidered bodice, her husband's ring, the coin he holds and the architectural background are all touches of paint;[19] no gold leaf or powdered gold paint (shell gold) is used as it is in later portraits. The faces, however, based on drawings from life, are more subtly defined and capture the individual likenesses of the sitters in ways that already suggest Holbein's skills as a draughtsman of the human face.

The Meyer portraits are painted on white or off-white grounds and the reflective quality of the priming, in conjunction with Holbein's use of fairly thin layers of flesh paint, tends to contribute to the flatness of the figures. However, during the decade in which Holbein first worked at Basel, his painting technique varied with subject, scale and medium. In *The Dead Christ* of 1521/2 (Plate 83), for example, he used a dark grey oil paint priming with the texture of the freely applied brushstrokes clearly visible, quite distinct from the enamel-like finish he employed for the *The Passion Altarpiece* shutters (Plates 84 and 85), which are thought to be close in

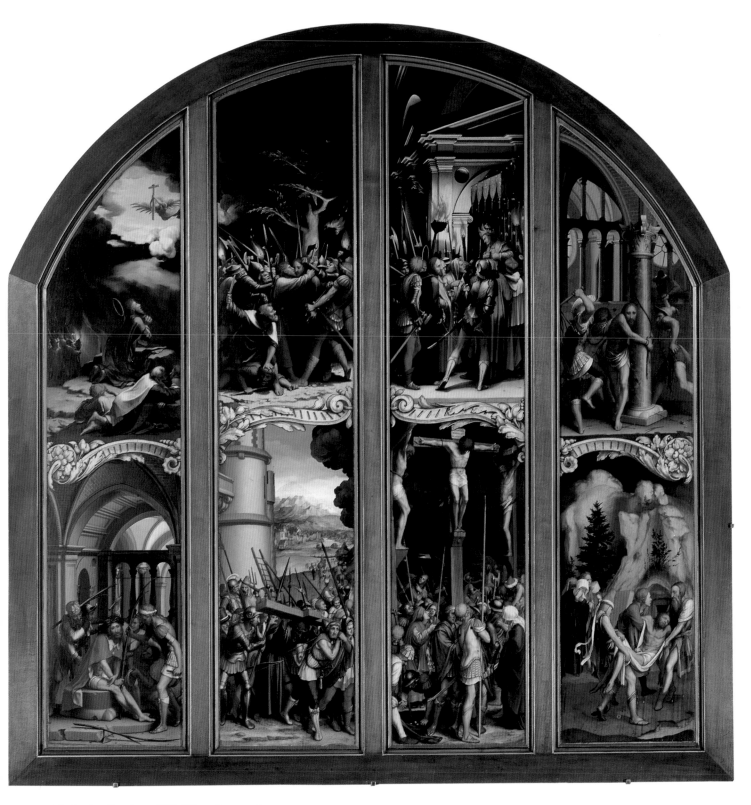

85 *The Passion Altarpiece*, *c.*1525. Oil on limewood,
149.5 x 124 cm. Basel, Kunstmuseum

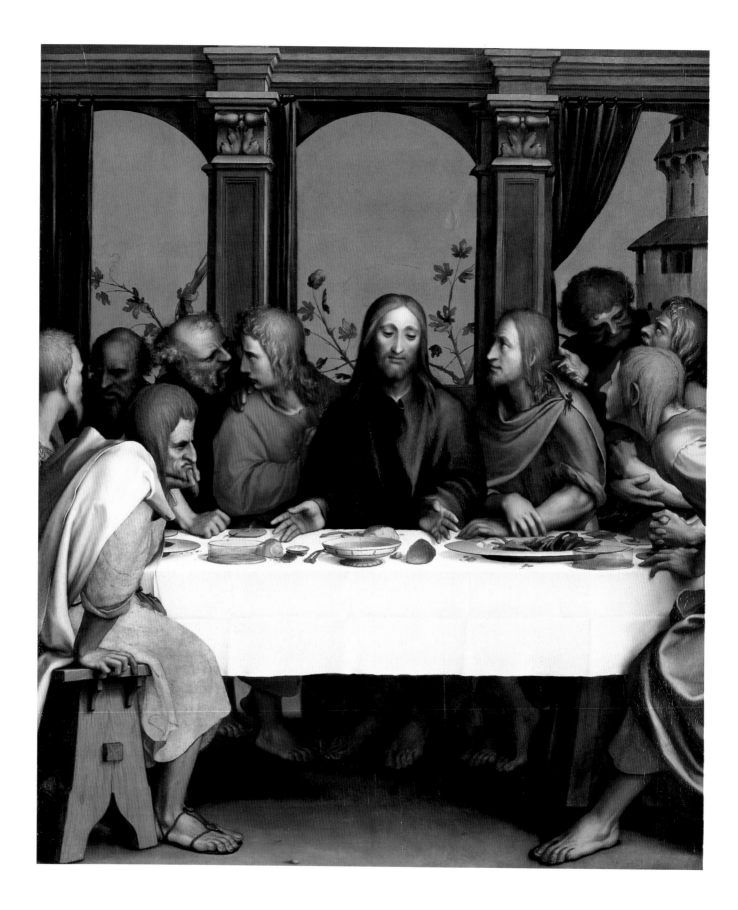

86 *The Last Supper, c.* 1525. Oil on limewood, 115.5 x 97.5 cm. Basel, Kunstmuseum

87 *Laïs Corinthiaca*, 1526. Oil on limewood, 35.5 x 26.5 cm. Basel, Kunstmuseum

date. The cool dark priming on *The Dead Christ* introduces a sombre, almost monochromatic, tonality, particularly in the figure of Christ with its greenish cast, and contributes also to Holbein's modelling of the form. By contrast, on the altarpiece shutters with their many small-scale figures and focused detail, Holbein uses a wide range of strong and saturated colour, colour contrasts and gilded decoration over a smooth ground.

The Last Supper of about 1525 (Plate 86), although its figures are on a much larger scale, shares something of the brilliance of colour of the Passion scenes, but with more naturalistic light effects. No decorative gold is used. As well as the bright vermilion of Saint John's robe and the brilliant orange worn by Judas, it is possible to see both similarities of design and a similar treatment of light and shade to *The Ambassadors*. For example, the woodgrain and carpentry of the bench, the shadow under the table and the gleam of the grey metal curtain rings and dish can all be paralleled in *The Ambassadors*. The clearest correspondence between the two pictures occurs in Holbein's construction of the green background curtains in each composition. Although that in *The Last Supper* is without a pattern, both are built up in solid layers of verdigris, white and lead-tin yellow, with final verdigris-containing glazes.

The modelling of light and shade in *The Last Supper* shows a clear debt to Leonardo, particularly in the treatment of the more grotesque heads such as that of Judas, the head of the apostle directly behind him and also in Holbein's depiction of the deep shadow under the table. On a smaller scale the *Laïs Corinthiaca* (Plate 87), dated 1526, and *Venus and Cupid* (Plate 88), both in Basel, show Holbein's experimentation with *sfumato*-like effects in the transitions of light and shade in the flesh of the figures. In the head of Cupid in particular, Holbein employs a blurred translucent brown shadow around the right eye, nose and mouth, and a similar effect can be seen in the shadows of the face and neck of Venus.[20]

In these two small panels, Holbein introduces a newly sumptuous and tactile quality in his painting of the richly coloured costumes, which anticipates the direction of his achievement in portraiture in England in the following year. The dresses in both pictures display voluminous sleeves of a rich golden-orange silk with prominent highlights and deep shadows in the many folds, the sleeves attached to the shoulders with ribbons of pink and green *cangiante* or shot fabric. The bodices and the undersleeves in the *Laïs* are a rich, dark, red velvet which makes full and sophisticated use of the optical qualities of the three pigments employed. The understructure is modelled in black and vermilion, glazed with a

88 *Venus and Cupid*, *c.*1525–6. Oil on lime-wood, 34.5 x 26 cm. Basel, Kunstmuseum

89 Lucas Cranach the Elder, *Portrait of a Woman*, 1520s. Oil on beech, 35.9 x 25.1 cm. London, National Gallery

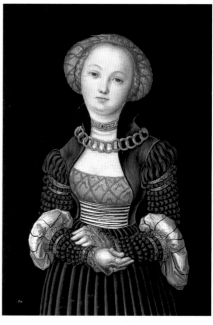

deep red lake and highlighted in almost pure vermilion, giving a range of colour from glossy purple-blacks to brilliant reflective reds. The bold and unusual use of so much dark paint in the fabric reinforces our sense of its weight and volume. Although similar pigments, creating a comparable range of colour, are seen for example in the work of Lucas Cranach the Elder at just this period, he appears content with a much flatter and more mechanical effect (Plate 89). In spite of Holbein's painterly achievements in *Laïs* and *Venus and Cupid* he makes use of final minute gilded details, such as the gold aiglets fastening the slashes in Laïs' dress, to enrich further the

overall effects. Holbein continued to use gold in this way in the first portraits he painted in England in the following year, as well as in *The Ambassadors* and in later works.

The Development of Holbein's Portraiture, 1515–33

In the *Laïs* Holbein had begun to develop the richness of technique that he was to apply to portraits produced in England in the second half of his career, including *The*

90 *Sir Thomas More*, 1527. Oil on oak, 74.2 x 59 cm. New York, Frick Collection

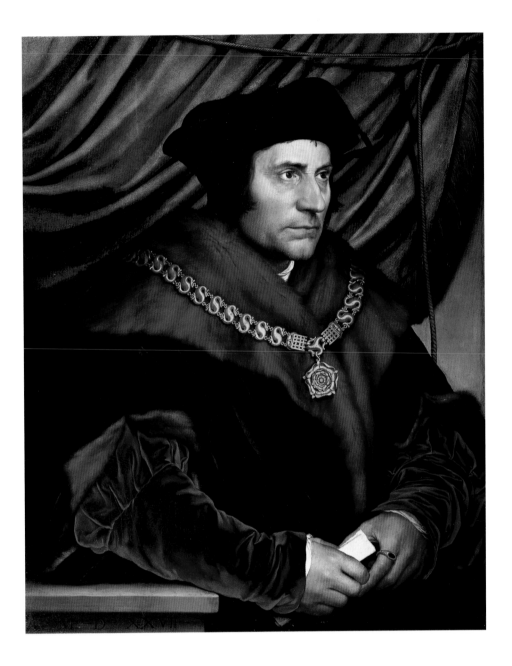

Ambassadors. Early on in Basel, his technique for painting portraits was relatively simple. In the Meyer portraits the paint is applied in a solid and largely unmodelled manner with a sparing use of shadow. Later, there is a greater range of tone and more attention to capturing in paint the different surface qualities of the faces, necks and hands of his sitters.

In the *Erasmus* (Plate 78), dated 1523, also painted in Basel, Holbein established the template for the type of half-length composition in which the sitter is shown in three-quarter face against a background suggesting a domestic setting, although not always clearly defined as such, with objects alluding to the sitter's occupation and interests. It is an exceptionally thinly painted portrait and the underdrawing can be seen clearly in the hands and to some extent in the face; the drawing must contribute greatly to the strength of the final image. The technique has not developed far from that of the Meyer portraits, but the face of the sitter is painted with a penetrating psychological characterisation and degree of subtlety new to Holbein's portraiture. In England Holbein was to specialise in portraiture to a far greater extent than in Basel, and to concentrate the development of his technical skills in this genre above all.

91 *Georg Gisze*, 1532. Oil on oak, 96.3 x 85.7 cm. Berlin, Gemäldegalerie

The portrait of Sir Thomas More of 1527 (Plate 90), painted in England, shares some clear affinities of technique with the *Laïs* (Plate 87) in the depiction of the red velvet sleeves and the gilded chain of office and ring. In this portrait Holbein begins to extend the textural effects seen in the *Laïs* and *Venus*, for example in the finely painted fur, the highlighting of the black velvet robe and the creation of the folds in the green background curtain. In comparison to the early portraits of the Meyers (Plates 67 and 68), the *Sir Thomas More* shows a greatly developed interest in, and elaboration of, colour, texture and the use of light and shade. In the More portrait the strong lighting contrasts and directional quality give an almost theatrical effect; a use of light which is not

repeated in later portraits. In the Meyer panels, as we have seen, a three-dimensional architectural background frames the sitters against a flat expanse of blue sky. In *Sir Thomas More*, space is suggested by devices such as the shadow cast by the red cord against the deep folds of the green curtain and the characteristic shadow beneath the ledge on which More rests his arm. The relatively simple space in this portrait is unusual at this point in Holbein's career.

The portrait of Georg Gisze now in Berlin (Plate 91) is closest in style and technique to *The Ambassadors* and was painted one year earlier in 1532. The priming over the ground is a comparable cool mid-dark grey and the colour range in the picture repeats much that is seen in *The*

Ambassadors.[21] The carpet, although different in pattern, is painted in a very similar fashion. Gisze's pink sleeve mirrors closely the construction used for Dinteville's sleeve. The green wood panelling background has a similar paint layer structure to the green curtain in *The Ambassadors* and probably makes use of the same pigments: verdigris, white and an opaque yellow, with thin glazes in the shadows, particularly in that cast by the sitter. The painting of Gisze's face is superficially dissimilar to the handling of the ambassadors' faces, but this appears to be the result of a change made to the position of Gisze's head and the direction of his gaze rather than a substantive difference in technique. In making this modification, Holbein painted the left part of Gisze's head over the green background. This pentimento with its extra layers of flesh paint has caused an area of pronounced cracking across Gisze's face not seen in *The Ambassadors*; the technique otherwise, however, is comparable in its essentials. There were other changes to Georg Gisze's portrait: Holbein made major alterations to the background panelling and shelves and some modifications to the figure, particularly in the sleeve. The vase of flowers and herbs was a late addition.

92 Paint cross-section of deep green of the curtain to the left of the hem of Dinteville's black coat. The lowest layer is the mid-grey *imprimatura* consisting of lead white and lampblack (no chalk ground is present in this sample). Some particles of black underdrawing in a dry material are visible on top, marking out the early drawn outline of Dinteville's costume. Over this is a yellow-brown underpaint, perhaps representing wood-panelling intended as the background, but abandoned by Holbein in the course of painting. The sequence of green paint layers making up the curtain lies on top. Photographed in reflected light under the microscope at 700x; actual magnification on the printed page, 430x.

The Painting Technique of *The Ambassadors*

The Ambassadors, although a large and complex composition, shows only slight alteration to the design in the course of painting, but, as with his other paintings, Holbein had, presumably, planned the arrangement of the figures, objects and setting in advance using drawings. The composite X-ray image of the picture (Plate 104) reveals some of these minimal adjustments, for example the lowering of the left-hand side of Dinteville's hat, a small change to his right hand and cuff, as well as possible minor modifications to the outline of his costume. Less easy to account for is the presence of dense yellow-brown underpaint only beneath the left-hand part of the green of the curtain, near the figure of Dinteville, perhaps an initial depiction of a wood-panelled wall at the left, abandoned by Holbein as he evolved the composition (Plate 92).[22] The X-ray image is more helpful in revealing the basic structure of the panel and ground layers and the disposition of the denser layers of paint, such as those used for the faces of the sitters, parts of the background curtain, the shelves and rug, and sections of the distorted skull in the foreground.

The large panel support is made up of ten vertical planks of high-quality oak from the Baltic-Polish region, with an even, straight grain, joined edge to edge with the help of dowels.[23] The X-ray image is lighter in the left half of the picture and particularly in the plank immediately to the left of the centre join, and this can be accounted for by variations in the thickness of the priming layers on the panel.

The initial grounding of the panel is a conventional layer of natural chalk bound in a medium of animal glue, applied in at least two layers. The lower layers contain a proportion of fibres, probably of vegetable origin, mixed in with the chalk, so as to increase the mechanical strength of the ground and its adhesion to the panel. Over this chalk ground, Holbein laid a cool mid-grey priming composed of lead white tinted with lampblack in a binding medium of lean linseed oil, vigorously applied over the chalk ground (Plate 101). The thickness of this upper priming varies from place to place, and the brush-marks register fairly strongly in the X-ray image (Plate 104). This cool mid-grey ground was the surface on to which Holbein imposed his design in layers of oil paint.

A full technical study of *The Ambassadors* was carried out during the course of the recent cleaning and restoration.[24] Analysis of the paint binding medium Holbein used for *The Ambassadors* has shown it to have been linseed oil; in some of the paint layers it had been heat treated before mixing with the pigments to thicken it and therefore to assist in its drying. This is particularly desirable for those passages involving

pigments which dry poorly in oil. The flesh paints, for example, make use of plain untreated linseed oil, whereas the red glaze paint on Dinteville's sleeves and his black costume are bound in heat-bodied oil, since red lakes and the majority of black pigments dry slowly and the heat pre-treatment of the oil medium tends to correct this. In the most translucent and glaze-like parts of the painting, such as the pink sleeves and green curtain, pine resin was detected in addition to heat-thickened linseed oil. This was presumably incorporated into the paint by Holbein in order to impart a higher gloss to these sections of the composition as well as to increase the depth and richness of colour.

The handling and build-up of the paint layers vary greatly, from the straightforward and direct method used for the main parts of the costumes of the two sitters, to a more complex technique for the green background curtain and pink sleeves. The painting of the striking sleeves of Dinteville's costume provides a clear example of the systematic development of Holbein's technique, and of his desire to bring together within the complex design of *The Ambassadors* a considerable array of the specific painting methods he had refined over his earlier career (Plate 93). Dinteville's pink satin doublet has an elaborate paint structure compared to his dark clothes and involves modelled underlayers containing lead white, areas of bright red vermilion and a strongly coloured, translucent red lake glazing pigment prepared from a dyestuff extracted from the lac insect.[25] This glaze is applied thinly in the highlights and is thickly accumulated in the shadows. A rather turbid layer of lake with a little added lead white, giving some opacity, occurs in the mid-tones, but the overall effect is somewhat translucent. The vermilion is used principally beneath the shadowed and more fiery colours of the left sleeve.

Pink sleeves of this kind are characteristic of Holbein's mature painting style. Just as in paintings of the 1520s, such as the *Laïs* and the portrait of Sir Thomas More, Holbein developed particular techniques to depict the richness of red velvets, so in the works of the 1530s he paints pink satin garments with a special verve. The sheen of satin and the play of light on the complex folds of the material are a prominent feature in a number of compositions, including, for example, the *Allegory of the Old and New Testaments* (Plates 94 and 95) in Edinburgh, and the portrait of a man thought to be Anthony, Duke of Lorraine (Berlin, Gemäldegalerie). On a smaller scale a similar effect is seen in the pink satin doublet in the portrait of Simon George in Frankfurt (Plate 72). The prominent pink sleeves in the portrait of Georg Gisze (Plate 91) correspond closely to the construction used for those of Dinteville in *The Ambassadors*, while those in the portrait of

93 Detail of *The Ambassadors:* Jean de Dinteville's sleeve

94 Detail of Plate 95

LEX

GRATIA

MYSTERIVM IVSTIFICATIONIS

IVSTIFICATIO NOSTRA

AGNVS DEI

PECCATVM

HOMO

MORS

MISER EGO HOMO,
QVIS ME ERIPIET EX
HOC CORPORE MORTI
OB NOXIO · RO. 7

VICTORIA
NOSTRA

ESAYAS PROPHETA

IOANNES BAPTISTA

ECCE VIRGO CONCIPIET ET PARIET FILIVM · ISA. 7

ECCE AGNVS ILLE DEI, QVI TOLLIT PECCATV MVDI. IO. 1

95 *Allegory of the Old and New Testaments,*
*c.*1535. Oil on wood, 50 x 60 cm. Edinburgh,
National Gallery of Scotland

Robert Cheseman in The Hague (Mauritshuis) are more
densely painted, hotter in tone and the appearance evidently
strongly influenced by the use of an extensive underpaint of
vermilion beneath surface pinkish glazes.

Many of Holbein's English sitters in the 1530s are portrayed
wearing black clothes. Although the painting technique for
these dark fabrics is straightforward, often worked in just a
single layer of paint, the variety of effects that Holbein
achieves is astonishing, ranging from matt velvet to shiny satin
and the contrasting weaves of patterned silks. The sophistica-
tion of these techniques is very different from the flat unmod-
elled black of Jacob Meyer's coat in the portrait of 1516. The

effect of the raised stitching on the dark brown shoulder and sleeve in the portrait of Simon George gives Holbein the opportunity to exploit the interplay of light and shade, texture and colour in a particularly complex manner. In the portrait of Hermann Wedigh in New York (Plate 96), which is exceptionally well preserved, the sitter wears a glossy self-patterned coat, subtly modelled, wet in wet, with saturated deep blacks blending into cool greys. Dinteville's black costume is painted in a similar fashion. Holbein employs the same economy and skill in painting Georges de Selve's fur-lined robe of luxurious chestnut silk damask, with an exceptionally large-scale pattern repeat.[26] Here he uses a fine red earth added to the black pigment. A similar rich brown fabric is depicted in the tunic of an unidentified man in a portrait in Vienna dated 1541 (Plate 97).

In *The Ambassadors* the sitters' costumes, other than Dinteville's pink satin doublet, are constructed from single layers of paint. Dinteville's black tunic is principally a glossy layer of lampblack in oil, containing some pine resin, with the dark greyish highlights at the edges of the pleats formed by

working a little lead white into the wet paint. De Selve's fur-lined gown is also a single layer, the pattern constructed from varying proportions of a fine red earth, mixed with lampblack and white, and the different tones blended wet into wet. Some vestiges of a bright red paint, composed of red earth, occur beneath the surface in the lower part of the gown, indicating that initially, perhaps, Holbein may have intended different dress for de Selve.

The finished appearance of the heads of Dinteville and de Selve (Plates 10 and 4) is considerably influenced by the mid-grey priming present beneath the composition as a whole,

96 *Hermann Wedigh*, 1532. Oil on oak, 42.2 x 32.4 cm. New York, Metropolitan Museum of Art

97 *Portrait of a Young Man*, 1541. Oil on oak, 46.5 x 34.8 cm. Vienna, Kunsthistorisches Museum

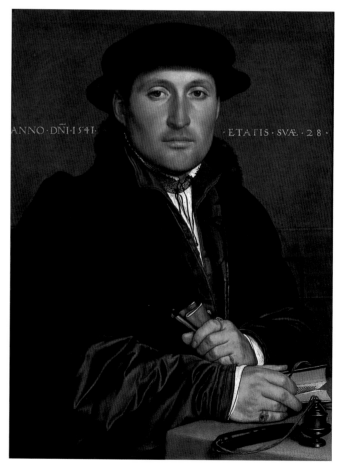

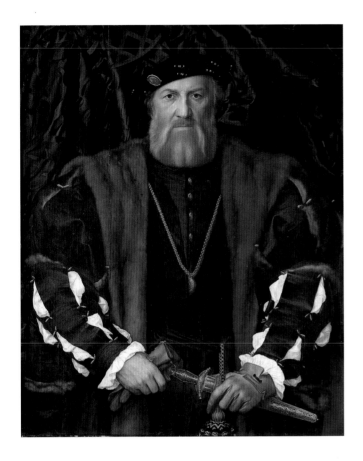

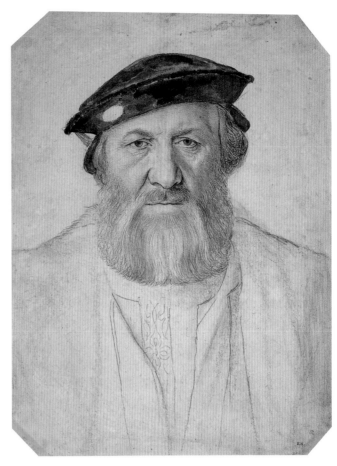

98 *Charles de Solier, Sieur de Morette*, 1534–5
Oil on oak, 92.5 x 75.5 cm. Dresden,
Gemäldegalerie Alte Meister

99 *Charles de Solier, Sieur de Morette*, 1534–5
Black and coloured chalks, ink and water-
colour on pink-primed paper, 33 x 24.9 cm
Dresden, Kupferstich-Kabinett

though this has little optical effect on the green curtain and
the darker parts of the sitters' costumes. Although the flesh
paint is relatively opaque, particularly that of Dinteville's face,
the grey priming has a slight deadening effect in comparison
to, for example, other portraits by Holbein painted on light
grounds. The main structure of flesh is worked in two layers:
a warm pale-coloured paint, principally white with a little
vermilion, and a cooler shadow paint, containing in addition,
red earth pigment, a fine brownish black, and, in certain pas-
sages, a scumble of finely ground mineral azurite. For some
parts of the faces and hands, the light pinkish paint is applied
over the darker paint; elsewhere the order is reversed. Very
thin glaze-like shadows were laid in over these more solid
underlayers and the final details of hair, beards, eyebrows and
eyelashes were applied as the last stage with a fine brush in
fluid browns and blacks.

In other portraits of the 1530s the painting of flesh is
approached in differing ways, and in some the use of a prim-
ing layer is exploited in a particularly effective manner.
Christina of Denmark, Duchess of Milan, painted in 1538 (Plate
64), has a grey priming under the costume and azurite back-
ground, but not under the face and hands, which are painted
thinly and have a more luminous quality as a result. By con-
trast the face in the portrait of Hermann Wedigh of 1532 is
more thickly painted, evenly lit, with a high pinkish tone
subtly modelled with small, smoothly blended brushstrokes.
The portrait of the Sieur de Morette in Dresden (Plates 98
and 99), painted only two years later, is exceptional in its
unusually dramatic use of shadow on the sitter's face, contrasts
that Holbein had planned in his preliminary full-size drawing
for this portrait. This portrait has a mid-grey priming similar
to *The Ambassadors*.[27] The portrait of Edward, Prince of Wales

100 *Edward, Prince of Wales*, c.1539. Oil on oak, 56.8 x 44 cm. Washington, National Gallery of Art

in Washington (Plate 100), probably painted in 1539, is based on a drawing that, although less well preserved, was always comparatively slight. The drawing, like all Holbein's portrait drawings of this period, is on pink-primed paper and, unusually, the painted portrait has been found also to have a salmon-pink priming, perhaps to accentuate the Prince's youthful complexion.[28]

The most delicate and refined parts of the design of *The Ambassadors* are constructed using fine lines of paint at the surface, most notably in the handling of the sitters' hair and beards, the edges of the fur on their costumes, and the linear designs on the scientific instruments, the mosaic pavement, the globes, and the music and script depicted in the open books on the lower shelf.

The rug, seemingly complex in its treatment of colour, texture, the play of light on the folds, and the depiction of the signs of wear and tear to the fabric, is in fact a fairly straightforward piece of painting. Holbein used a very dark grey, virtually black, underpaint for the whole of the rug and exploited its optical effect in the final image by applying over

it a loosely connected network of small square slabs of red, yellow, blue, white and grey paint to represent the knotted threads (Plates 101 and 102). Virtually the whole of the design is constructed in this manner. The use of highlights has been confined to the upper part of the rug, the ribbing along the border, the painted stitches denoting repair, and the plain border hanging at the left. The surface paint makes use of vermilion, red lake, azurite, ochre, white and black to represent the coloured weave.

The tiled floor in the foreground is also simply painted, consisting of a basic, faintly greenish-grey undercolour over which single layers of warm grey, pink, buff, translucent yellow, greenish-brown and olive-grey paints were applied, with final impasto flecks of lead-tin yellow, to denote the inlaid serpentine borders, and lines of thin black paint marking out the designs on the tiles (Plate 49).

The background curtain, by contrast, is built up in a complex sequence of layers in order to solve the problem of depicting the hanging folds and the pattern passing from light to shadow, as well as to express the varied colour effects and degree of saturation of the green fabric (Plates 43 and 92). The pattern repeats clearly are painted freehand without the use of a stencil. Holbein first laid in the basis of the textile design in solid, opaque underpaints containing verdigris mixed with white, and some yellow ochre. The darker paints contain a proportion of black pigment, while in the lighter more yellow-green underlayers black is omitted, and lead-tin yellow is used to lighten the colour. There is also a tonal variation in the green undercolour, with certain parts of the pattern created in cool solid tones solely of verdigris and white, which blend into the more yellow-green parts. The upper layers used to create the finished transitions of colour, light, shade and depth consist of several thin applications of a green glaze composed of verdigris in oil, containing a proportion of pine resin.[29]

The Ambassadors is one of the last paintings in which Holbein used the device of placing his sitters against the backdrop of a green curtain, which he had developed in the 1520s. In the latter part of the 1530s Holbein seems to have abandoned its use, and for the most part he no longer includes

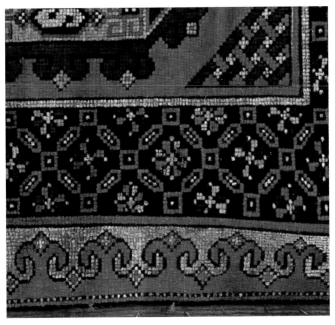

101 Paint cross-section of bright red of the carpet. The lowermost layers are the chalk ground and mid-grey *imprimatura*. The black underpaint for the carpet lies over this, with an intense red consisting of vermilion, red lake pigment and white on top. (There is a trace of red-brown overpaint lying on the original.) Photographed in reflected light under the microscope at 400x; actual magnification on the printed page, 260x.

102 Detail of *The Ambassadors*: the carpet

furniture and objects as part of the composition. Instead, he uses the deep greenish-blue often regarded as characteristic of portraits by Holbein. In these late portraits the plain blue backgrounds, which in the early portraits of the Meyers represents a light-coloured sky, no longer suggest outdoor space, since the sitters' cast shadows and inscriptions in gold are applied to them.

In another early portrait, that of Bonifacius Amerbach in Basel, dated 1519, the sitter is clearly placed out of doors, against a blue sky with trees and distant mountains. This kind of setting appears in simplified form in a series of pictures, from *The Last Supper* (Plate 86), painted in Basel in about 1525, to English portraits of the early 1530s such as that of William Reskimer in the Royal Collection (Plate 69). This simplified design consists of green vine leaves and curling tendrils over a plain blue background which may be read as sky. These effects of spatial ambiguity greatly heighten the sense of the illusion of the sitters' presence. Where the paint of these blue backgrounds has deteriorated, the effect is diminished. This is particularly so when the blue pigment used is smalt, an unstable cobalt-containing glass which is pulverised and mixed with oil medium, but which frequently becomes grey or brownish with time, as it has in the background of *Edward, Prince of Wales* (Plate 100).[30] When the blue pigment used is mineral azurite, the paint layer and its colour are usually very much better preserved, although sometimes there is a distinctly greenish tone to this pigment. *Christina, Duchess of Milan* (Plate 64) has an azurite background of striking intensity overall and particularly in the strip of shadow to the right. In *A Lady with a Squirrel and a Starling* (Plate 74) the beautifully preserved background is composed of azurite mixed with white and has a faintly turquoise hue. Holbein appears only very rarely to have used the much more expensive pigment derived from lapis lazuli (natural ultramarine) in his portraits on panel. The background of the small portrait of Henry VIII in the Thyssen Collection in Madrid is perhaps not surprisingly one such exception. Unusually, the miniature of Anne of Cleves on vellum (Plate 103) is made up in part of ultramarine, which shades into azurite.

One of the last stages of painting *The Ambassadors* would have been the decoration using gilding of the chain around Dinteville's neck and the case for his dagger with its hanging tassel (Plate 60). The method of gilding, known as mordant gilding, is one Holbein appears to have used throughout his career. He first designed the structure of the object to be gilded in a chestnut-coloured paint containing earth pigments, creating the detail over this in a greyish-yellow oil 'mordant' or adhesive, for the metal leaf. He then applied the gold leaf,

finally adding with a brush the most minute finishing touches in paint of gold powder.

In the portrait of Georg Gisze (Plate 91) there is no decorative gilding; the suspended spherical twine dispenser, for example, is depicted in blue and brown with gold-coloured highlights of lead-tin yellow. In *The Ambassadors* (painted the following year), equivalent effects such as the tassel attached to the case of Dinteville's dagger are achieved using mordant gilding and powdered gold paint. However, it is the portrait of Gisze rather than *The Ambassadors* which appears to be the exception in this respect, for the use of gold is characteristic of Holbein's English portraits. The brilliant exploitation of gold is notable in the portrait of Sir Henry Guildford of 1527, in the Royal Collection, and continues in later English portraits such as *Edward, Prince of Wales* (Plate 100), in Washington, which, interestingly, also makes use of silver leaf, now tarnished, under red lake glazes in the child's cap.[31]

Over his entire working life of nearly three decades, spent in two different cities, Holbein reveals his interests in developing and refining painting techniques to serve his aims as a portraitist and painter of subject pictures and to satisfy the expectations that his reputation engendered. *The Ambassadors*, with its impressive and unusual scale, its complex design and its extensive range of colour and painterly effects, is the paradigm of Holbein's technique on panel. The recent cleaning of *The Ambassadors* allows clearer comparisons to be made with Holbein's achievements in his other, smaller, portraits and emphasises the magnitude of his painterly skills.

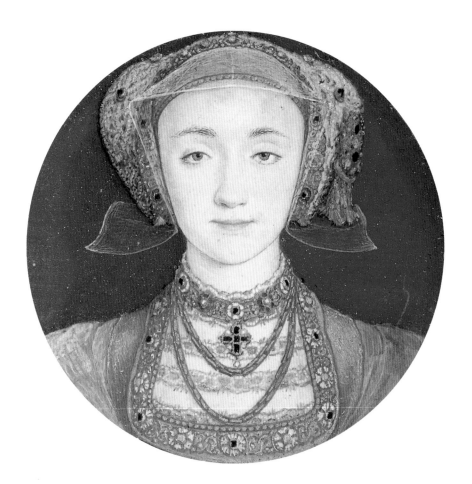

103 *Anne of Cleves*, 1539–40. Watercolour on vellum in an ivory box, 4.5 cm diameter London, Victoria and Albert Museum

The Provenance of *The Ambassadors*

The Ambassadors was presumably taken back to France by Jean de Dinteville in the autumn of 1533 and installed in the château of Polisy, but the first reference to its presence there occurs in an inventory of 1589.[1] In 1653 it was once more listed in an inventory (Plate 3), this time with the subjects correctly identified, when the painting was taken to Paris from the château of Polisy by François de Cazillac, Marquis de Cessac, a descendent of Claude de Dinteville, the niece of Jean de Dinteville who had married into the de Cazillac family in 1562, and had inherited Polisy.[2]

At this point references to the painting are lost for a period of sixty-five years, during which it was probably taken to south-west France, where the Marquis de Cessac owned properties. The painting probably passed through the collection of the granddaughter and heiress of the Marquis de Cessac, Marie-Renée le Genevois, to that of her own heir Chrestien II de Lamoignon, named in her will of 27 April 1716. *The Ambassadors* is recorded in the inventory of his wife, Marie-Louise Gon de Bergonne, dated 30 January 1728, and again in 1759, when it was in the possession of his son Chrétien-Guillaume de Lamoignon.[3] By the time the inventory of his grandson, Chrétien-François II de Lamoignon, Marquis de Basville, was taken on 4 June 1789, the painting had passed out of the possession of this family. Chrétien-François II de Lamoignon was the executor of Nicolas Beaujon, and *The Ambassadors* was listed in the Nicolas Beaujon sale in Paris on 25 April 1787 (lot 16 bis). Presumably, the Marquis de Basville took advantage of the Beaujon sale to dispose of some of his own property. Another Dinteville picture with the same provenance, the *Moses and Aaron* (Plate 15) now in the Metropolitan Museum, was also in this sale (lot 16).

The Ambassadors was bought at the Beaujon sale by the dealer J.-B. Lebrun and sold to England by 1792. In 1808 it was sold by Buchanan to the 2nd Earl of Radnor.[4] In 1890 the National Gallery bought *The Ambassadors* from the 5th Earl of Radnor by special grant and with gifts from Charles Cotes, Sir E. Guinness, Bart (subsequently Lord Iveagh) and Lord Rothschild.

The Conservation of *The Ambassadors*

The acquisition of *The Ambassadors* by the National Gallery in 1890 gave rise to much comment and correspondence in the papers. An article in *The Times* in September 1890 included the comment that 'the condition is faultless, except that the panel is coated with old and perished varnish which should surely be carefully removed'. This, sadly, turned out to an over-optimistic view.

The following extract from the Gallery's Manuscript Catalogue is the only known record (in the absence of contemporary photographs) of *The Ambassadors* at that time. It also describes the work carried out the following year by two restorers who were regularly employed by the Gallery: William Morrill who worked on the panel, and William Dyer, who worked on the paint surface.

The picture, when acquired, was in a very unsatisfactory condition. At some former period most of the planks which go to form the whole panel had been separated and rejoined. They were concavely warped in their width, and their edges, curving outwards, had left V-shaped spaces between each two contiguous planks, necessitating a stopping of cement. Partly to conceal this stopping, and partly to cover various abrasions and other injuries, much repainting had been resorted to. The hanging, or curtain, which formed the general background, appeared (as it afterwards proved) to be a piece of coarse restoration from one end to the other. The whole surface of the picture was obscured by coatings of old discoloured varnish. As the picture had to be exhibited at once, no immediate steps could be taken towards improving its condition, or testing how far [the] restorations might have been justified by actual lesions. But in 1891 the work was examined, and the course to be pursued was determined upon. The first thing necessary was to reduce the cast in the planks. These had to be taken asunder, excepting the two on the right, the joining between which had never given way, and which were not warped. But all had to be planed down at the back, and those which had warped subjected to heavy pressure so as to bring them back to a level. It was found that they had originally been fastened together by small cylindrical oaken dowels, neatly and firmly inserted. A few iron pins were probably of more recent date. The

fine-grained oak of the planks was perfectly sound, and nowhere worm-eaten. When all were once more in place, and firmly united, the whole was stoutly parqueted at the back, and the picture itself now presented a perfectly even surface. On the coats of darkened varnish being got rid of, the old restorations showed more distinctly. The removal of these was more tedious than difficult; only the dark heavy green overlying the curtain offered any serious resistance. The removal laid bare the original beautifully painted light green curtain, with its fine XVIth Century pattern, and also revealed a silver crucifix on the extreme left, which had been quite obliterated by the over-painting. As the original curtain had not been damaged but in one or two spots, the motive for so complete an over-painting is not clear, unless it was the notion that a darker background would more strongly throw out the heads, which it was Holbein's design to relieve by opposition of colour alone. The restoration of some few details in the picture which had suffered badly from rude abrasion was, though ill executed, and carried now and then beyond the injured parts, indispensable, and was for the most part confined to the closed book and some objects near it on the lower shelf on the stand, some spots where scaling had occurred on the lower half of the principal figure, and some damages on the tessellated floor. The heads of both figures had escaped both injury and retouching. The whole right half of the picture was intact.

The restoration now required was, therefore, on the whole, not extensive, and demanded only patience and care on the part of the restorer, Mr W. Dyer.

The image of the picture which is so familiar today is not that which was seen by the Gallery's visitors in 1890. The effect of the overpainting of the curtain and crucifix in a blackish green, the layers of old varnish and restoration, and above all the physical irregularity of the surface resulting from the concave warping of the planks, their gaping joins 'filled with cement' and covered by retouching, can only be imagined. The treatment described in the Manuscript Catalogue was quite reasonable by the standards of the time: planing down and cradling warped or splitting panels was a universal practice.

104 X-radiograph of *The Ambassadors* taken in 1984

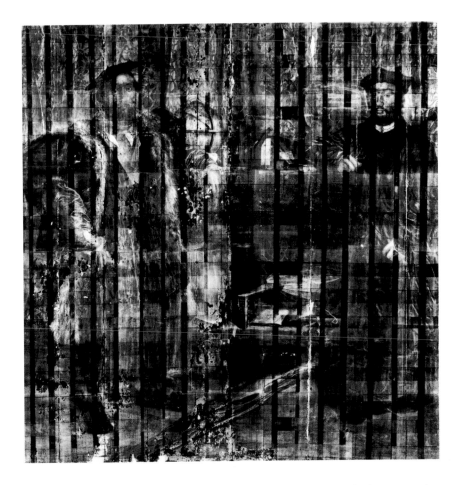

On 7 August 1891 *The Times* reported that

Today the great Holbein from Longford Castle will be for the first time visible to the public, having been brought up from the ground floor and placed on a screen in Room VI of the National Gallery. We say 'for the first time' advisedly, for what was visible during the last autumn was the real picture, but the picture disguised by coat upon coat of discoloured varnish, and by the accumulated dirt of many years. As Sir Frederic Burton [Director of the National Gallery] explained in a recent letter, the picture has for some months been in the hands of the cleaner, Mr Dyer, thanks to whose great skill and tender care it has now emerged in all its pristine glory. As is almost always the case with Holbein's work, the colours have stood in the most remarkable way; and, after three centuries and a half, the picture may be said to be finer than ever – a painful example to English painters, who, following their great chief, Sir Joshua, too often paint in a medium that cracks after twenty years, and is hopelessly perished in less than fifty.

The concave warping of the front of the planks, across the grain, can only have been caused by the exposure of the back of the panel to water or damp. The flaking in the lower left half of the picture almost certainly has the same cause, particularly so as much of it occurs along the joins. Paint may have been further loosened by being compressed as a result of the warping. That the two right-hand planks had neither warped nor been separated before is an indication that the left part of the panel had been more exposed to damp than the right. Whether this was a sudden or gradual process cannot be determined, but the fact that after thinning 'heavy pressure' had to be used to flatten each plank suggests that the exposure to damp had lasted long enough to induce plastic deformation (alteration of the cell structure of the wood), though it can be argued that a flood would have been more likely to affect only part of the panel. It has been speculated that the panel was at one time divided into two, and the left, or Dinteville, half exposed to worse conditions than the right.

One clue to the dating of the damage and restoration is the reconstruction of the Order of Saint Michael worn by Jean de Dinteville. In common with the larger flake losses below it,

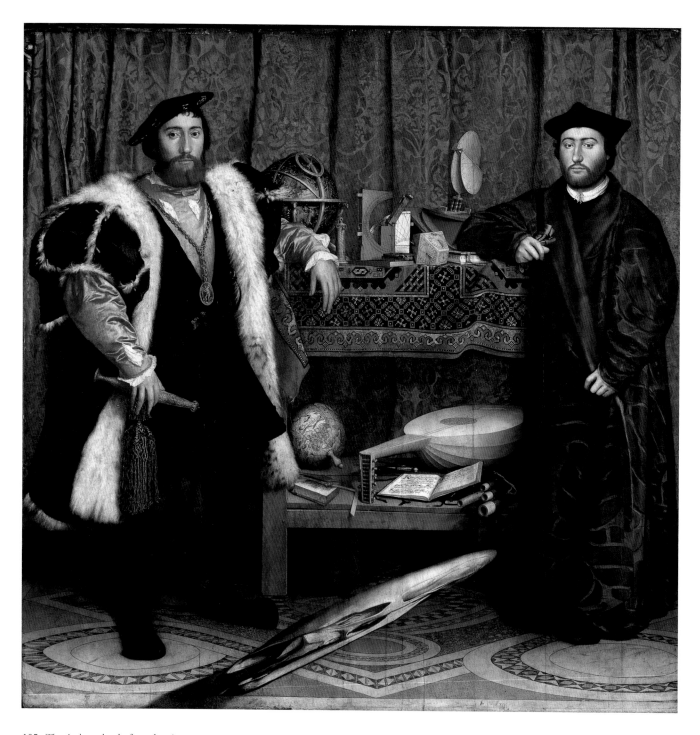

105 *The Ambassadors* before cleaning

106 *The Ambassadors* after cleaning, but before restoration

the ground has here flaked away from the panel and the loss has been filled and the medallion reconstructed. As *The Ambassadors* remained in the possession of Dinteville's descendants until 1787, very shortly before the picture came to England, it may be presumed that this part of the restoration at least must have been done under their guidance. The identity of the sitters was unknown in England until Mary

Hervey's research in the 1890s, and it is almost inconceivable that an English restorer could have known what form the medallion should take. The green curtain and the crucifix may have been overpainted in either France or England, perhaps to make the picture more attractive to a potential buyer.

The Recent Treatment

The behaviour of wooden panels, that is their reaction to changes in temperature and relative humidity, was not well understood in the 1890s and is indeed still the subject of much research. It is now well known that the thinner the panel, the more rapid and pronounced will be its reaction to changes in the environment. Planing the panel of *The Ambassadors*, plank by plank, to about five millimetres thick, thus exposing a new surface, and then forcing the planks flat by 'heavy pressure' and applying a mahogany cradle, followed by the exhibition of the picture in a heated gallery in the winter of 1891–2, was almost guaranteed to provoke movement, and so it proved. On 29 January 1892 Morrill wrote to the Director to say 'I have examined the Holbein panel picture this morning and find the crack is a fresh one altogether, and I have every reason to believe it is between the parquets, and the sooner it is attended to the better so as to save it getting worse, a few days would not hurt, but the earlier attention the better. It would take about 5 days to put it in order.' Several more splits appeared 'at the end of a long frost' in 1895 and further repairs of splits in the panel and of blistering paint were necessary in 1929 and 1939.

In 1940, while *The Ambassadors* was being stored in Wales, an existing split at the top of the panel spread down its whole height just to the right of Dinteville's face. By 1952 incipient flaking was detected and extensive blister laying was necessary, and the panel had again split from top to bottom, this time to the right of centre. Soon after this split had been repaired, air-conditioning was installed for the first time in a few galleries. *The Ambassadors* has been exhibited in stable conditions since then and the panel has remained free from further splitting, though it is clearly under some stress.

The earliest photograph of *The Ambassadors* in the Gallery's archives was taken in or shortly before 1929. It shows considerable changes in the varnish from the illustration in Mary Hervey's book of 1900. Dinteville's coat, tunic and legs, the lute case, and the shadowed parts of the floor are much less distinct in the later photograph. The thick varnish put on by Dyer in 1891 continued to deteriorate and by the mid-1960s the artist's signature had become almost invisible in Gallery light. The increasing cloudiness and opacity of the varnish and the discoloration of Dyer's retouchings eventually made the lute case invisible and much of Dinteville's costume illegible.

Regular checks on the condition of *The Ambassadors* showed that there was some loose paint and filling in the damaged area of Dinteville's costume, but no immediate danger of flaking. In the early 1990s the Director of the National Gallery suggested a discussion on the possibility of cleaning the picture before the planned exhibition of 1997. An X-ray composite of the picture had been made in 1984 and gave a very clear image of where Holbein's paint was missing (Plate 104). Close comparison of the X-ray with the picture enabled a very accurate assessment to be made of the old losses in the skull, the left part of the carpet, Dinteville's costume and the floor below, in the lute case and along the central join. The varnish was analysed and small cleaning tests made to test its solubility. Further discussion between the curator and conservation and scientific staff led to the conclusion that cleaning was technically feasible, straightforward even, given that the varnish and the majority of the retouchings were only a hundred years old. The Director and the Gallery's staff were in agreement that the picture should no longer be displayed with its surface obscured and distorted by the increasingly decayed varnish (Plate 105).

At this early stage it was agreed that the old (pre-nineteenth century) reconstruction of the medallion was both skilful and probably valid, whereas Dyer's reconstruction of the damaged skull was highly speculative and inaccurate and furthermore covered some of Holbein's paint (Plate 107). A detailed report on the condition of *The Ambassadors* and the proposed treatment was submitted to the National Gallery Trustees, who gave their agreement for the removal of the varnish and retouchings, the consolidation of the loose paint, modifications to the cradle if further investigation showed that to be necessary, and, finally, restoration of the losses in the paint layer. The work began in January 1993.

The cleaning tests were enlarged, various solvent mixtures were tested and the solvent combination chosen was assessed for the effect it would have on the paint layer during cleaning. This assessment consisted of two types of study of the effects of the cleaning solvents during varnish removal on the paint surface. The first of these was a detailed analytical comparison of the paint binding medium using gas-chromatography–mass-spectrometry (GC–MS), in uncleaned, mechanically cleaned and solvent-cleaned areas. In the second study the interior micro-texture of the upper paint films was imaged close to their surfaces at high magnification in the scanning electron microscope (SEM). Again, samples were taken from uncleaned areas and solvent-cleaned areas. No evidence for

degradational changes in the paint film as a result of the action of solvents used to remove varnish was found in these studies – either of damage, extraction of components of the paint medium or changes in microporosity in the paint layers.

The area around Dinteville's left hand provided an example of most of the problems that were to arise elsewhere. There was no difficulty in removing the varnish from the fur, the globe, the sleeve, the hand and the carpet. The retouchings along the joins where there was no adjacent paint loss, for example through the pink sleeve and the globe, were either removed with the solvent mixture or, if thicker and containing lead white, softened and removed mechanically. These fillings and retouchings dated from 1891.

Other older retouchings on the carpet were also soluble, but it became clear that in an earlier campaign of filling, much well-preserved original paint had been covered. The X-radiograph (Plate 104) provided an exact guide to where original paint was covered. Some of the fillings could be picked off safely, but some covered original paint and ground that were loose, either as a result of the damp or because the fillings had shrunk and loosened the adhesion of the ground to the panel. Consolidation with sturgeon's glue was effective in some of the loose areas, allowing the older fillings to be removed safely; the remainder were left in order to avoid any possible dislodgement of original paint.

The first part of Dinteville's black costume to be cleaned was his left shoulder, which the X-radiograph showed to be well preserved. The black was thinly painted, mainly in one layer, over the grey priming. Some wearing and many small losses along the various cracks and the grain of the panel were found here, and a horizontal band of blacker, original paint immediately below the fur across the shoulder.

The most difficult part of the surface was the lower left part of Dinteville's coat. The X-radiograph showed large losses in the grey priming (the only component of the layer structure here to absorb X-rays strongly), and the varnish was particularly thick and foggy. It is probable that Dyer in 1891 had repeatedly varnished his retouchings in the black costume, the shadowed parts of the floor and in the lute case; these are the most difficult colours to match and continued reworking and revarnishing led to a greater thickness of varnish.

The varnish over the celestial globe had discoloured to a yellowish brown, not unusual for a mastic containing walnut oil after exposure to probably rather high light and ultra-violet levels from 1890 until the early 1950s, when the Gallery was able to introduce ultra-violet filters. The effect of the varnish, even over the lighter parts of the floor, and the leg of the shelves, was of a turbid greyish fog rather than a normal yellowing.

Some of the varnish was removed from the medallion and the surrounding reconstruction so that its texture would correspond to that of the original paint nearby. This was found to be the roughest area of the surface, with evidence of large blisters having been re-attached to the panel. Much of the detail of the sword hilt, the two belts, the highlights of the folds in the velvet tunic and the three rows of cording along its lower edge and up its central divide became clear. Below, the two garters around Dinteville's left knee, the modelling of his calf and the detail of his shoe became more visible. Fillings were picked away from the damaged lower edge of the dagger's hilt, revealing the original outline and the finger guard.

Where little original paint survived, the old retouchings were not removed once every fragment of original paint was uncovered, provided that the fillings were securely attached. Old reconstructions were left on parts of the globe, including the handle and part of North America, Dinteville's right foot (and the floor either side and below), his medallion and some of the lower part of his costume. In the case of the nose bone of the skull, which had suffered greatly from flaking in the past, Holbein's paint remained only in the brightly lit inside area on the left-hand side. Dyer's retouchings of 1891 had covered some of Holbein's surviving paint and were removed. Older retouching in the middle of the loss in the nosebone was left and can be seen in Plate 106.

Consolidation and Structural Work

Some consolidation had been necessary during cleaning in order to re-attach fragments of original paint which were stuck to the underside of old fillings but not to the panel. No separation between paint and ground was found. Other areas of loose paint were consolidated after cleaning, mainly in the more damaged left part of the panel near losses. The loose paint responded well to sturgeon's glue, which could be introduced through the craquelure without difficulty and was effective in re-attaching the ground to the panel.

Because both sides of the panel had been cut (before 1890) and neither was straight or vertical, stained oak strips about fifteen millimetres wide and shaped to match the edges were fixed to the cradle so that they were in plane with the paint surface. This was done so that the new frame could show both side edges of the panel (the crucifix would have been partly covered by conventional framing, since both sides of the panel sloped to the left after being cut). The edges of the panel had been protected by L-section oak strips since 1952, and these were replaced by new oak strips attached to the cradle with slotted screw holes to allow for panel movement.

Stages in the reconstruction of the skull

107 The skull before cleaning showing the old, incorrect restoration of the nose bone: photographed from the side to correct the distortion

108 The skull after cleaning with all Holbein's remaining paint exposed: the distortion corrected by computer manipulation

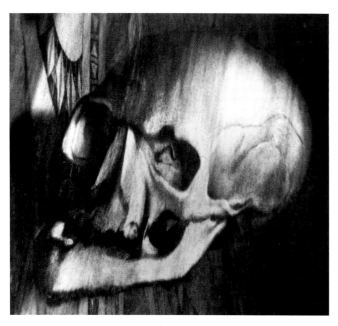

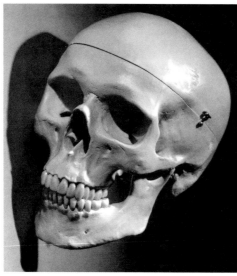

109 Anatomical model of a skull photographed under the same lighting as Holbein's skull to assist in the reconstruction of the nose bone

110 The model skull in Plate 109 manipulated on the computer to simulate Holbein's perspective distortion

111 The skull during the final restoration: losses to Holbein's paint in the lower jaw and nose bone are covered with watercolour imitating Holbein's grey priming

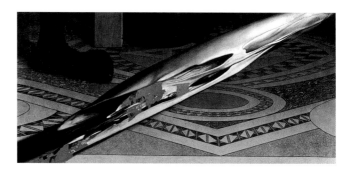

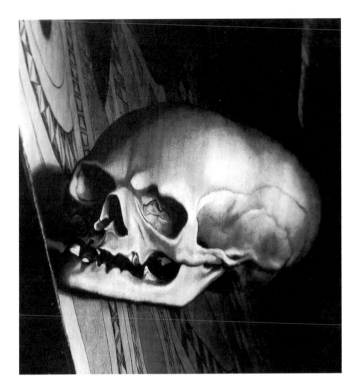

112 The skull with the nose bone as finally reconstructed: photographed from the side to correct the distortion

Restoration

For paintings of the sixteenth century and later the National Gallery has usually chosen deceptive retouchings. Restoration has to balance two conflicting requirements – legibility and authenticity. The Gallery's visitors may wish to see, and are perhaps more likely to enjoy, an image uninterrupted by damage, loss, panel joins, etc. A more specialist viewer may want to know what is original paint and what is not. The full photographic record, particularly the photographs taken at the after cleaning/before restoration stage, documents the condition of the paint layer (Plate 106).

The losses in the floor were reconstructed at the beginning of the restoration because of the relative simplicity of the layer structure and the predictable nature of the pattern repeats. The geometrical discrepancies in the floor did not pose serious problems except in the large loss between Dinteville's

feet, where the freehand design was more difficult to follow.

The restoration of the damaged lower left part of Dinteville's coat was guided by a highlight about twelve centimetres above the fur discovered during cleaning. The highlight indicated the edges of the satin part of the coat, the satin being 'guarded' by black velvet. A similar effect is seen at the shoulders when the fur is abutted by strips of velvet 'guarding'. The remains of the highlight on the satin, lower left, were joined together during retouching to indicate a fold catching the light. The surviving fragments indicated a continuous, though uneven, highlight extending up to the left of the dagger hilt.

The velvet tunic became more legible as the larger losses were touched out. It had become clear during cleaning that the skirt divided, and that the chenille cording or frogging along the bottom edge turned upwards at the central divide. On the left-hand side one of the lines of cording appears from the hidden side about twelve centimetres below the belt. On the right, where the cording is veering to the right just as it is interrupted by the large damage below the waist, it has been suggested that originally a codpiece protruded through the divide in the skirt. This would explain the change in angle of the cording. The reconstruction of the codpiece in the large loss was not seriously considered. Clearly, it would also have been incorrect to continue the cording across the damage. Elsewhere, where the highlights on the velvet were interrupted by losses, they were continued over the lost area and rejoined. The same approach was adopted with the two belts and with the green-tipped knot of the wider of the two.

The losses in the carpet, along the central join, could be logically reintegrated from the evidence of the pattern on either side. To the left, under Dinteville's hand, the pattern had been wrongly reconstructed (partly in artificial ultramarine); there was no red triangle in the corner of the inner field. These details are symmetrical in all known carpets of this date, and it was relatively simple to join up the surviving fragments of Holbein's paint to re-establish the pattern, which could with confidence be presumed to be the artist's original intention.

The folded-back end of the carpet, which had suffered the largest loss of paint, was more difficult to reconstruct. The previous reconstruction, which was not removed since it covered no original paint, had become brown in colour and did not make proper use of the evidence of the adjacent original paint. It is known that elements of the border patterns may be wider at the end of the carpet than at the side because the individual knots are rectangular rather than square. The subtlety and ingenuity of Holbein's handling clearly can not be

imitated, but some of the errors of the old restoration have been avoided.

The restoration of the skull was left until the end of the work, and was the subject of much research and debate. The narrow losses along the panel joins at either end of the skull, other small losses, and the floor above and below were retouched, where Holbein's intentions were clear. The outline of the lower jaw and the cranium were joined together across the larger losses. The remainder of the damage – the end of the lower jaw and part of the nasal aperture and surrounding bone – were left with the grey priming imitated in watercolour pending the progress of research (Plate 111). Sixteenth-century anamorphosis and techniques for distorting and elongating images were considered. Modern imaging techniques seemed to offer the greatest scope for exploring possible reconstructions.

A digital image showing the skull after cleaning was recorded on the computer. A perspective distortion was applied to this image of the skull, and the viewing-point was adjusted in three dimensions to determine that at which the anamorphosis resolves and the skull assumes its 'normal' appearance (Plate 108). Using this adjusted image as a guide, an anatomical model of a skull was photographed under the same lighting conditions as the skull in the painting (Plate 109). A similar computer distortion was then applied in reverse to a digital image of this photograph to achieve as close a representation of the painted skull as possible (Plate 110). If the effect of the strong lighting necessary for the process (which casts the eye sockets in to deeper shadow than in the painted skull) and the presence of a full set of teeth in the modern skull are discounted, there is clearly much to be learnt from the perspective distortion.

Comparison of Plate 106 and Plate 110 shows that the second of these is of considerable help in establishing the relationship between the left-hand end of the upper and lower jaws and is a good guide to the general shape of, and fall of light on, the nose bone. Would it be proper to attempt to reconstruct such an important part of Holbein's composition? Would the surviving fragments of paint in the nose bone fit into a reconstruction based on the perspective distortion?

It was decided to tackle the second question first, thus deferring for the time being ethical considerations and the further question of how the Gallery's visitors might react if an image as famous as Holbein's skull were to be displayed incomplete.

Despite the success of the perspective distortion, no reconstruction could hope to re-create Holbein's missing paint with absolute precision – no restoration can, in any case, aim so high – because of the unique physiognomy of every skull and because the nose bone is the thinnest and most fragile part of the structure. Various skulls and images of skulls had been examined during the restoration; every nose bone was chipped or broken and each had its own particular characteristics.

However, despite these practical and ethical reservations, a tentative reconstruction of the nose bone and the end of the lower jaw was made. It was particularly crucial that the surviving fragments of paint in the nose bone, all of which were brightly lit or in deep shadow, could be integrated into a logical image. These fragments, the larger areas of original paint surrounding them and the perspective distortion together provided enough evidence for a reconstruction which, after many adjustments, was felt to be not too misleading (Plate 112). As the ultimate legibility of the skull was presumably a crucial part of Holbein's intentions, it was decided that it was proper, in this area of the picture, to present it as now reconstructed to the public. The reconstruction can very easily be removed, either down to the level of the grey priming or to the stripped state. Plate 107 shows the old reconstruction of the skull.

Framing and Display

Little is known of the original display of *The Ambassadors* at Polisy, and nothing of Holbein's own intentions. Not one of Holbein's surviving portraits has retained its original or even a contemporary frame, except for some small roundels that have integral mouldings. There is no clear evidence as to the design or finish of any of the lost frames. *The Ambassadors* had been displayed at the National Gallery in an elaborate carved walnut frame made in about 1950, but this frame seemed inappropriate both in design and scale and it was decided to replace it. *The Ambassadors* is now shown in a simple black oak moulding designed and made by the National Gallery's Framing Department; this is based on contemporary Northern European styles and of smaller proportions than the walnut frame.

A longer and more fully illustrated account of the conservation history and recent restoration of The Ambassadors *will be published in the* National Gallery Technical Bulletin, *19, 1998.*

The Physical Structure of *The Ambassadors*

Support, Ground, Drawing and Paint Medium

Support: Oak, 207 x 209.5cm. Ten vertical planks, now *c*.0.5 cm thick, originally butt-joined with dowels.

Ground: Natural chalk (calcium carbonate), bound in animal glue. Vegetable fibres reinforcing the structure are present.

Imprimatura: Cool mid-grey oil paint, composed of lead white and lampblack, leanly bound in plain linseed oil.

Underdrawing: Over grey *imprimatura*. Black chalk or charcoal; lines reinforced with fluid black paint or ink. Detected in outline of Dinteville's costume, shoe and hand; in de Selve's face and costume; and beneath background green curtain.

Paint medium: Analysis of the paint binding medium from a number of samples showed the use of linseed oil throughout. In some areas it had been heated initially to thicken the medium and enhance the drying properties (heat-bodied oil), specifically in the white fur edging of Dinteville's garment, grey paint beneath the crucifix, and blue-green of the celestial globe. This heat-bodied linseed oil, combined with some pine resin, was detected in areas where greater gloss and depth of colour were required, such as in Dinteville's black costume, his pink sleeve and the background green curtain.

Paint Structure and Materials

The sitters: The flesh paints are generally in two layers, composed of lead white, red, yellow and translucent brown earths. Vermilion occurs in the pinker tones; black pigment in the shadows. Finely ground azurite sparingly scumbled over the surface in places. Details of hair and beards painted directly over solid layers for the flesh in thin fluid brown paint. Plain linseed oil binder identified in Dinteville's hand.

Costumes: Dinteville's black costume is a single layer of lampblack, blended with a little white for the transitions to dark grey, bound in heat-bodied linseed oil with added pine resin. Fur edging: white with translucent brownish-black earth, and some black pigment. The pink sleeve is underpainted in white, red lake pigment and vermilion, and glazed with red lake (identified as containing red dyestuff extracted from the lac insect, *Kerria lacca*). The glazes are

bound in heat-bodied linseed oil with added pine resin. De Selve's chestnut-coloured robe consists of lampblack, red earth pigment and varying amounts of white, according to the pattern of the textile.

Background curtain: The green curtain is built up from sequences of four layers of paint, over the grey *imprimatura*; the upper two layers are translucent green glazes. The colour and lightness of tone of the lower layers depends on the location in the patterned design, and contain varying amounts of lead white, verdigris, yellow ochre, lead-tin yellow and black pigment. The different colours and tonalities are used to produce the pattern. The final thin glazes are largely verdigris in heat-bodied linseed oil, with pine resin incorporated (no 'copper resinate' was found).

The tiled floor: The mosaic pavement is painted directly on the *imprimatura*, in simple pigment colour mixtures with lead white, such as light grey (lampblack), pink (red earth), orange-yellow (yellow and orange ochres), pale green (green earth), olive-green (green earth and copper-green glazes). Highlight flecks of lead-tin yellow for the serpentine borders; linear surface designs in thin black paint.

The rug: The strong colours of the knots are laid on as small square slabs of paint over a

very dark grey, virtually black, underpaint, visible at the junctions. The pattern of the design is painted in red (vermilion and red lake), dark blue (mineral azurite), golden yellow (ochre) and grey (white with lampblack).

The objects: Lute case: white, lampblack, translucent brown earth, small amount of red earth. The wood frame of the quadrant: white, brownish black, trace red earth; more red earth in the shadowed parts; linear surface designs in thin black paint. Celestial globe: azurite and white in the lights; pure azurite in the shadows.

Gilding: A small amount of decorative metallic gold is used on the chain and Order of Saint Michael worn by Dinteville (not all original), and on his dagger case and its tassel, each containing azurite in the blue areas. The gold was applied on to a greyish-yellow linseed oil-based adhesive containing pigment (lead white, yellow ochre, calcium carbonate; possibly yellow lake), that is the technique in mordant gilding. The chestnut-coloured underpaint layers contain orange-brown earths, with the mordant and gold leaf laid over. Final touches are in powdered gold paint (shell gold).

Note: The materials noted above have been identified by a variety of methods of pigment and medium analysis in the Scientific Department of the National Gallery.

113 Schematic diagram of the construction of the panel

Glossary

azurite Mineral basic copper carbonate, blue or blue-green in colour according to its source; used as a pigment, but a less pure blue than ultramarine (q.v.).

black chalk A bluish-black clay, coloured by carbon in the form of graphite, used for underdrawing.

butt join A simple join between planks where the edges of the planks are brought together without interlocking overlaps as in a half-lap join (q.v.).

chalk Natural (mineral) calcium carbonate found in large deposits throughout Northern Europe. Widely employed as a white ground layer (q.v.) with a binder of animal glue in Northern panel paintings.

charcoal Carbon made by burning wood, usually willow or beech. Sticks of charcoal were used for drawing. Wood charcoal, powdered and used as a pigment, has a bluish-black colour.

copper resinate A modern general term for translucent green pigments based on a preparation of verdigris (q.v.), or another copper salt, with a natural resin and the addition of other materials such as drying oils. Used as a deep green glaze (q.v.).

cradle A traditional method of strengthening a wooden panel after it has been planed down. Slotted wooden strips are glued over the joins on the back of the panel, parallel to the grain, and flexible slats fitted through the slots.

craquelure The network of cracks in the paint and ground which develop as an inevitable and unavoidable consequence of age in a painting.

cross-section By examining minute samples of paint in cross-section under the microscope, the layer structure of the painting, including the ground layers, can be determined for that sample point. Many pigments can be identified by their colour and optical properties in a cross-section, and chemical analysis can be carried out on individual layers. Samples are mounted in a block of cold-setting resin, then ground and polished to reveal the edge of the sample for examination in reflected (incident) light under the optical microscope. The usual magnification range in 60–800x.

dowel A cylindrical length of wood, sometimes tapered at each end, inserted into pre-drilled holes across a join between pieces of timber to reinforce that join.

earth pigment One of a range of natural pigments found in many part of the world. They consist of a mixture of clay and various oxides of iron in different proportions, and other substances, and are yellow, red, orange, brown or even black in colour. See also green earth; ochre.

gas-liquid chromatography: GLC or GC An analytical separation technique for complex mixtures of organic materials, for example paint media (q.v.), based on the partition of components of a vaporised sample between a moving inert gas stream and a stationary liquid phase. The use of sensitive detectors enables the identification of minute amounts of materials.

glaze Paint which is transparent because the pigment and the medium have similar or identical refractive indices (q.v.). Often applied over more opaque underlayers.

green earth A naturally occurring dull sage-green pigment commonly used as the underpaint for flesh in early tempera painting on panel. The colouring matter is one of two minerals, glauconite or celadonite, in a clay-like matrix. Often called *terre verte*.

ground The layer used to prepare a support for painting. Northern panel paintings usually carry a white chalk ground, generally applied in several coats to fill the grain of the wood. Over this there may be an *imprimatura* (q.v.) of oil paint.

half-lap join A join between pieces of wood where the edges have stepped profiles cut so that they interlock with one another.

heat-bodied oil When drying oils such as linseed oil are heated they become thicker and more viscous. When treated in this way, before being mixed with pigment, the oil medium, and therefore the paint, dries more rapidly. Head-bodied oils are used particularly with pigments that dry slowly in oil, such as most black pigments and organic lake glazes.

imprimatura The first layer of paint on a painting, usually playing no part in the design of the composition. Northern Renaissance panel paintings often have a white or neutral coloured oil paint layer as an *imprimatura* over a chalk (q.v.) ground, on to which the design layers are applied.

infra-red photography/photograph Infra-red radiation is similar to visible light, but slightly too long in wavelength for the eye to see: however, it can be photographed. In conventional infra-red photography an image is recorded using film sensitive to infra-red radiation in an ordinary camera. An infra-red photograph shows layers just below the visible surface of a painting; pentimenti (q.v.) and underdrawings (q.v.) done in carbon black on a white ground show up particularly well.

infra-red reflectography/reflectogram A technique related to infra-red photography (q.v.) in which a television camera adapted to receive infra-red radiation is connected to a television monitor. The image is seen instantaneously, but recording of the image is often made on to a computer. An infra-red reflectogram shows layers below the visible surface of a painting, especially carbon black underdrawings.

lac See scale insect dyestuffs.

lake A pigment made by precipitation on to a base from a dye solution – that is, causing solid particles to form, which are coloured by the dye. Lakes may be red, yellow, reddish brown or yellowish brown and are generally translucent pigments when mixed with the paint medium, particularly oil. Often used as glazes.

lampblack A very fine-grained carbon black pigment formed by condensing a smoky flame on to a cold surface. Often used also for inks employed in an underdrawing.

lead-tin yellow An opaque artificial pigment of pale primrose to daffodil yellow made by combining the oxides of lead and tin and heating these together in a furnace

to above 650° C. The pigment was widely used in painting from the fifteenth to seventeenth centuries, after which it fell into disuse. The preparation derives from ceramic glaze colorant technology.

lead white Basic lead carbonate, synthetically prepared from metallic lead for use as an opaque white pigment.

mass-spectrometry An instrumental technique for determining the mass of a group of atoms, which together constitute a molecule; the latter is a fundamental unit of any chemical substance or compound. This information, coupled with the molecular mass and relative intensity information of characteristic fragments of the molecules themselves can provide a 'fragmentogram' of the molecular species – a kind of molecular 'fingerprint' – which will permit identification of the chemical compound concerned. When combined with a preliminary separation technique such as gas-chromatography (GC, q.v.), to enable individual pure chemical components of a complex mixture, such as a paint binding medium, to be submitted sequentially to analysis of structure by a mass-spectrometer, the analytical technique is termed 'gas-chromatography–mass-spectrometry' (GC–MS). This is probably the most powerful tool available for the analysis of natural materials derived from living organisms.

medium The binding agent for pigments in a painting.

mordant The adhesive used to apply gold leaf to linear designs on to a paint surface; often used to decorate draperies. Where a drying oil such as linseed is incorporated, with or without pigment, the layer is called an oil mordant. See also mordant gilding.

mordant gilding The application of gold leaf with an adhesive to decorate the painted surface of a picture; distinct from shell gold (q.v.).

ochre An earth pigment (q.v.) of a dull red, orange, yellow or brown colour.

oil media Oils extracted from plant sources which will first set and then form a solid film on exposure to the air, therefore known as drying oils. The most common types employed in painting are linseed, walnut and poppyseed oils. Oil paint is made by mixing a drying oil with pigments. Drying oils may be heat treated to modify their properties, as in heat-bodied oil (q.v.).

palette The range of colours selected by the artist.

panel A rigid painting support, usually made from planks of wood. Northern European panel paintings are often on oak panels.

pentimento (plural **pentimenti**) Literally, repentance, that is, an alteration made by the artist to an area already painted.

pigment The colouring matter in paint.

pine resin A sticky liquid exudate produced by coniferous trees (genus *Pinus*) when the bark is damaged. May be collected by tapping. Added to oil paints to increase depth of colour, gloss and body.

pounce To transfer a design by dusting a coloured powder through holes pricked along the outlines of a drawing on paper or parchment.

refractive index The degree to which any material transmits or scatters light. When the refractive indices of pigments and media are close in value the paint is translucent, as in a glaze; when they differ widely the paint is opaque.

scale insect dyestuffs Dyestuffs extracted from the bodies of the wingless females of certain species of scale insect, so called from the hard or waxy protective coating they secrete. Those most likely to have been used include lac, *Kerria lacca*, imported from India, and kermes, *Kermes vermilio* Planchon from southern Europe. After the discovery of the New World, cochineal was also employed.

scanning electron microscopy: SEM A technique capable of revealing the fine details of objects at far higher magnifications than are possible with the optical (light) microscope. The scanning electron microscope uses a beam of electrons to scan the sample under examination, and the electrons scattered by the surface are collected and used to generate a video image. The SEM will show surface topography and three-dimensional structure at magnifications up to 100,000x, but the image can only be in monochrome. Equipment for microanalysis of very small areas of a specimen can be attached to the SEM.

scumble To apply a thin layer of semi-opaque paint over a colour to modify it; layer of paint used in this way.

shell gold Powdered gold used as a paint; so-called because traditionally it was contained in a mussel or similar shell.

ultramarine A fine quality, costly, pure blue natural pigment extracted from the semi-precious stone lapis lazuli. The pigment itself occurs in lapis lazuli as the blue mineral lazurite.

underdrawing Preliminary drawing on the prepared panel before the application of paint and gilding.

verdigris A strongly coloured deep green basic acetate of copper, prepared by exposing sheets of metallic copper to vinegar vapours. Used as a pigment and as a drying agent for oil mordants (q.v.).

vermilion A bright scarlet pigment, mercuric sulphide, usually synthetic but sometimes prepared by pulverising the mineral cinnabar.

X-ray A form of radiation which passes through solid objects, but is obstructed to differing degrees by different materials. The heavier the atoms of which a substance is made, the more opaque it is to X-rays. Lead compounds are particularly opaque, those containing lighter metals less so. Thus in an X-ray image (known as a *radiograph*) of a painting, areas of paint containing lead pigments will appear almost white, while areas containing lighter materials will appear an intermediate grey or dark. In interpreting X-rays, it should be remembered that all layers are superimposed: thus the image of a wood panel, battens and nails may seem to overlie the image of the paint itself.

Notes

ABBREVIATIONS
The following abbreviations are used in the notes:
BL: British Library
BN: Bibliothèque Nationale
Hervey: M. F. S. Hervey, *Holbein's 'Ambassadors': The Picture and the Men*, London 1900
Levey: Michael Levey, *The German School: National Gallery Catalogues*, London 1959
Starkey: D. Starkey, *Henry VIII: A European Court in England*, exhibition catalogue, National Maritime Museum, London 1991

Introduction

1 R. N. Wornum *Some Account of the Life and Works of Holbein*, London 1867, p. 276.
2 This point was kindly made by Lisa Monnas.
3 For the most thorough account of Holbein's career see A. B. Chamberlain, *Hans Holbein the Younger*, 2 vols., London 1913; for the paintings see J. Rowlands, *The Paintings of Hans Holbein the Younger*, Oxford 1985.
4 Engraved by J.-A. Pierron in J.-B.-P. Lebrun, *Galerie des peintres flamands, hollandais et allemands*, Paris and Amsterdam 1792–6, I, facing p. 7. It was sold by the picture dealer Buchanan to the 2nd Earl of Radnor in 1808, Hervey, p. 6, citing payments in the Account Books at Longford Castle for 1808 and 1809.
5 See Hervey, pp. 6–8; A. Woltmann, *Holbein und seine Zeit*, 2nd ed. 1874–6, I, p. 372, II, p. 141, suggested the other figure might be the antiquary John Leland. J. Gough Nicholas in *Archaeologia*, XLIV, pt II, pp. 450–5, dismissed the identifications without offering fresh ones. E. G. Dickes, *Holbein's 'Ambassadors' Unriddled*, London 1903, proposed that the sitters were the Palatine counts Ottheinrich and Phillip. Much debate took place in the newspapers of 1890–2 : see the press cuttings for that year in the National Gallery Archives.
6 Hervey, pp. 10–12, describing the discovery of the document of 1653 (now in the National Gallery Archives, Plate 3), identifying the sitters and the original location of the picture at Polisy, and Hervey, pp. 18–20, citing a document of 1654 that summarises the history of the picture as noted by Nicolas Camusat, a canon of Troyes cathedral and antiquary, who interested himself in the papers left by Jean de Dinteville.
7 Hervey, pp. 22–32. The gap in the painting's provenance in the eighteenth century has been filled by O. Bonfait, 'Les Collections des parlementaires parisiens du XVIIIe siècle', *Revue de l'Art*, 1986, pp. 28–42, p. 36.
8 Hervey, pp. 10–12; she suggests it might have been cut from an inventory and used as a label for the picture.
9 See M. Wyld, 'The Restoration History of Holbein's "Ambassadors"', *National Gallery Technical Bulletin*, XIX, 1998 forthcoming, for a full account of the cleaning, and this volume pp. 88–96.

Part I
Jean de Dinteville and Georges de Selve

1 BN, MS Dupuy 726, f. 46; Hervey, p. 80. There is no contemporary source for the date of De Selve's arrival: Hervey, p. 77, n. 1, cites a seventeenth-century memoir stating that de Selve's visit was made in 1532, from which it has been assumed that he must have arrived before the end of the Old Style year, therefore just before Easter 1533; this is hardly a reliable justification for the frequently made assertion

that De Selve arrived in England in April 1533.
2 BN, MS Fr. 15971, f. 4r.
3 Hervey, pp. 57, 100–3, 105–7, 108–10.
4 For the de Selve family see, in addition to Hervey, pp. 143–97, R. J. Kalas, 'The Selve Family of Limousin: Members of a New Elite in Early Modern France', *Sixteenth-Century Journal*, XVIII, 1987, pp. 147–72, esp. pp. 162–3 for Georges de Selve. I am grateful to Tony Antonovics for this reference.
5 Glenn Richardson, 'Anglo-French Political and Cultural Relations During the Reign of Henry VIII', unpub. PhD thesis, University of London 1996; I am most grateful to Dr Richardson for drawing chap. 5 of his thesis to my attention. For the treaty of 1527 see C. Giry-Deloison, 'A Diplomatic Revolution? Anglo-French Relations and the Treaties of 1527', in Starkey, pp. 77–83.
6 See R. J. Knecht, *Renaissance Warrior and Patron: The Reign of Francis I*, rev. ed. Cambridge 1994, pp. 142ff, and chap. 15, p. 306ff, and idem, 'Francis I, "Defender of the Faith"?', in E. W. Ives, R. J. Knecht and J. J. Scarisbrick, eds. *Wealth and Power in Tudor England: Essays Presented to S. T. Bindoff*, London 1978, pp. 106–27.
7 For a concise account of the English political situation see J. Guy, *Tudor England*, Oxford 1988, pp. 116–35, and p. 183. For Henry and Anne Boleyn see E. W. Ives, *Anne Boleyn*, Oxford 1986, pp. 195–231.
8 'Ceste Reyne est fort grosse' BN, MS Fr. 15971, f. 4r.
9 'Il me fault faire une grosse depense pour se couronnement', BN, MS Dupuy 726, f. 46, Hervey, p. 81. The repayment of the costs in December was recorded by Hervey, p. 82.
10 Hervey, p. 97.
11 See n. 1 above and Hervey, pp. 79–81, for the entire text of the letter of 23 May. I am deeply grateful to Professor E. A. R. Brown for her generosity in giving me the reference to the manuscript volume in which the letter of 4 June was discovered (see n. 2). The volume consists largely of letter concerning French relations with Scotland in the latter part of the sixteenth century, but includes a few earlier letters from Dinteville in which Scotland is mentioned. As this was a volume apart from the main series of Dinteville papers in the Dupuy collection, it remained unknown to Miss Hervey.
12 Richardson (op. cit. n. 5), p. 227; for an interpretation linking de Selve's visit and the painting explicitly with the recognition of Anne Boleyn, see E. W. Ives, 'The Queen and the Painter: Anne Boleyn, Holbein and Tudor Royal Portraits', *Apollo*, July 1994, pp. 36–45, esp. pp. 39–40.
13 The seventeenth-century parchment and other documents of the seventeenth century also mention the friendship between the two men: see Hervey, pp. 12, 18–20.
14 'Je suis et este plus fasche et fascheux que mallade', BN, MS Fr. 15971, f. 4r.
15 'Je suis le plus melancolique fasche et fascheux ambassadeur que vistez oncques'. BN, MS Dupuy 726, f. 46, Hervey, p. 80.
16 See, for example, Hervey, pp. 97–8, and other references.
17 For Anne Boleyn see Ives (op. cit. n. 7) and Ives (op. cit. n. 12).
18 C. Müller, *Katalog der Zeichnungen von Hans Holbein dem Jüngeren*, Basel 1996, no. 243, pp. 138–9.
19 For the pageant see S. Anglo, *Spectacle, Pageantry and Early Tudor Policy*, Oxford 1969, pp. 247–61, and J. Rowlands and D. Starkey, 'An Old Tradition Reasserted: Holbein's Portrait of Queen Anne Boleyn', *Burlington Magazine*, CXXV, 1983, pp. 88–92; the features of the drawing by Holbein called 'Anne Boleyn' do not accord with those of the Queen in a painted image, for which see R. Strong, *Tudor and Jacobean Portraits*, 2 vols., London, National Portrait Gallery 1969, pp. 6–9.

20 The letter of 4 June, cited in n. 2 above, includes a reference in a postscript asking if the Bishop had found the pictures well done: 'mandez moy sy auez trouue les painctures bien fetez'; as the plural is used this cannot refer to Holbein's work, but must refer again to the 'tower and pictures' mentioned in the letter of 23 May: Hervey, p. 81. I am most grateful to Professor E. A. R. Brown and to M. Pierre Janin for their assistance in deciphering this postscript.
21 On early friendship portraits see H. Keller, 'Enstehung und Blütezeit des Freundschaftsbildes', in D. Fraser, H. Hibbard and M. J. Levine, eds., *Essays in the History of Art Presented to Rudolf J. Wittkower*, London 1967, pp. 161–73. The diptych by Quentin Metsys of Erasmus and Pieter Gilles sent to Thomas More in 1517 is, of course, a portrait of two friends sent to a third, but the two are not included in a single composition.

Jean de Dinteville and the Château of Polisy

1 For the patronage and collecting activities of Francis I see C. Scaillierez, *François Ier et ses artistes: monographies des Musées de France*, Paris 1992.
2 See, for example, *Les Trésors du Grand Ecuyer Claude Gouffier, collectionneur et mécène à la Renaissance*, exh. cat., Musée National de la Renaissance, Château d'Ecouen 1994, and S. Beguin, O. Delenda and H. Oursel, *Cheminées et frises peintes du Château d'Ecouen*, Musée National de la Renaissance, Château d'Ecouen 1995.
3 Hervey, pp. 36–8. For the family in the sixteenth century see also E. A. R. Brown, 'Sodomy, Treason, Exile and Intrigue: Francis I, Henry II and the Dinteville Brothers', *Sixteenth-Century Journal*, forthcoming, also E. A. R. Brown, 'Sodomy, Treason, Exile and Intrigue: Four Documents Concerning the Dinteville Affair (1537–8)', *Sociétés et idéologies des temps modernes*, Montpellier 1996, pp. 512–32. I am most grateful to Professor Brown for allowing me to read these articles before their publication.
4 Hervey, p. 41.
5 Hervey, p. 39. Brown, forthcoming (op. cit. n. 3).
6 Hervey, pp. 55–6. Brown, forthcoming (op. cit. n. 3).
7 Hervey, p. 54.
8 Brown, 1996, Brown, forthcoming (see n. 3 above).
9 Ibid.
10 See Introduction, n. 7, and Provenance, p. 87.
11 See T. Crépin-Leblond, *Livres d'heures royaux*, exhibition catalogue, Musée National de la Renaissance, Château d'Ecouen 1993, no. 15, pp. 48–9. The manuscript also bears the arms of Henry II, for the making of it was probably interrupted by the death of the Bishop in 1554, and it was subsequently presented to Henry II.
12 Hervey, p. 137.
13 H. Zerner, *Ecole de Fontainebleau: gravures*, Paris 1969, DB 2.
14 *De Triomf van het Manierisme*, exh. cat., Rijksmuseum, Amsterdam, 1955, p. 82, S. Béguin, *L'Ecole de Fontainebleau*, Paris 1960, p. 54. The painting is undocumented, although in 1551 or 1552 Primaticcio wrote to the Bishop offering to paint a portrait of Jean de Dinteville for the Duc de Guise, Cardinal of Lorraine. See I. Wardropper, 'Le voyage italien de Primatice en 1550', *Bulletin de la Société de l'Histoire de l'Art Français*, 1981, pp. 27–31, and for the letter L. Dimier, *Le Primatice*, Paris 1928, Appendix I. In another letter, probably of the same period, also referring to an altarpiece for the Abbey of Montiéramey, Primaticcio wrote to the Bishop mentioning a work to be made after a 'pourtraict', but this probably means 'design' rather than 'portrait'; I. Wardropper, 'The Sculpture and Prints of Domenico del Barbiere', unpub. doctoral diss., New York University 1985, pp. 98–9. I am most grateful to Dr Wardropper for supplying me with a copy of the relevant chapters.

15 M. Hervey and R. Martin-Holland, 'A Forgotten French Painter: Felix Chrétien', *Burlington Magazine*, XIX, 1911, pp. 48–55; C. Sterling, *A Catalogue of French Paintings of the Metropolitan Museum of Art: XV–XVIII Centuries*, New York 1955, pp. 44–7.

16 Professor E. A. R. Brown is preparing a detailed study of the painting in the light of the political fortunes of the Dinteville family.

17 J. Bruyn, 'Over de betekenis van het wek van Jan van Scorel omstreeks 1530 voor oudere en jongere tijdgenoten (4)', *Oud-Holland*, 1984, pp. 98–110 (English summary pp. 109–10).

18 I am most grateful to Hubert von Sonnenburg and Charlotte Hale of the Conservation Department of the Metropolitan Museum, New York, for providing me with measurements of the New York picture, and details of its structure. The New York picture (69¼ x 75⅞ in.) appears to be cut on all sides, and may have lost a plank at the top edge, bringing its size to 81 in., only ¼ in. short of the *The Ambassadors*, which preserves its original top and bottom edges.

19 Lons-le-Saunier, Archives Départementales Jura, E 722. I am deeply grateful to Riccardo Famiglietti who discovered the inventory and to Professor E. A. R. Brown for allowing me to read her transcription.

20 The view was taken in 1629, according to L. Coutant, 'Vue du Château de Polisy au XVIII siècle', *Almanach-Annuaire de l'Arrondissement de Bar-sur-Seine*, Paris 1864, pp. 97–104, p. 97. Reproduced by Hervey, facing p. 35.

21 See Coutant (op. cit. n. 20), A. Gaussen, *Portefeuille archéologique de la Champagne*, Bar-sur-Aube 1861, chap. 10, pp. 3–15, pl. 129.

22 See above, 'Jean de Dinteville and Georges de Selve', n. 20.

23 Buildings in the grounds of the main château were evidently also added at this period. Hervey recorded a small house dated 1545 with a winged column over a window. This she connected specifically with François II Dinteville, the Bishop of Auxerre, although the device appears earlier in the Book of Hours in the British Library belonging to the previous Bishop (BL, MS Add. 18854) and was not exclusively his. Hervey, pp. 130–2.

24 See n. 14 above.

25 See Wardropper, thesis (op. cit. n. 14).

26 Domenico and Hubert Julyot were witnesses to the document. A. Babeau, 'Dominique Florentin, sculpteur du seizième siècle', *Réunion des Sociétés savantes des Departements à la Sorbonne du 4 au 7 Avril 1877*, Section des Beaux-Arts, Paris 1890, pt, I, p. 108; I am most grateful to Rosalys Coope and Françoise Hamon for their efforts in obtaining a copy of this article for me; Hervey, p. 127; discussed by Wardropper, thesis (op. cit. n. 14).

27 H. Zerner, *Ecole de Fontainebleau: gravures*, 1969, DB 11. *La Gravure française à la Bibliothèque Nationale*, exhibition catalogue, Grunewald Center for the Visual Arts. University of California, Los Angeles 1994, pp. 291–2.

28 The floor was removed to the USA earlier this century, but recorded in some detail in the last century; a few fragments now remain in the Musée des Beaux-Arts de Troyes: see E. LeBrun-Dalbanne in Gaussen (op. cit. n. 21), chap. 10, pp. 3–15, with 8 colour plates; L. Leclert, *Musée de Troyes: carrelages vernissés, inscrustés, historiés et faiencés*, Troyes 1892, pp 80–2; and A. Brejon de Lavergnée, 'Masséot Abaquesne et les pavements du château d'Ecouen', *La revue du Louvre et des Musées de France*, no. 5/6, 1977, pp. 307–15, repr. fig. 18, p. 314.

29 Also seen in the book of hours made for the previous bishop, his uncle, BL MS Add. MS 18854.

30 See Brejon de Lavergnée (op. cit. n. 28).

31 'Vng Grand tableau ou sont en painz les feuz Sieurs de Polisy & dauxerre'; de Selve is misidentifed as the Bishop. See n. 19 above.

32 J. Baltrusaitis, *Anamorphoses: les perspectives depraveés*. Paris 1984, pp. 104–5. The idea that the painting was hung on a staircase was discussed by David Piper in 'Holbein's *Ambassadors*', a BBC radio talk in 1961, published in *The Listener*, 12 Jan. 1961, pp. 68–70, and kindly brought to my attention by Professor Kerry Downes and by Patricia Wheatley; see also A. Cole, *Perspective*, London 1992, p. 33.

33 Hervey, p. 81, see also above, 'Jean de Dinteville and Georges de Selve', n. 20.

34 For staircases in sixteenth-century French architecture see *l'Escalier dans l'architecture de la Renaissance*, série *De Architectura*, dirigé par André Chastel et Jean Guillaume, Paris 1985; I am greatly indebted to Dr Rosalys Coope for advice on the disposition of rooms and staircases of French châteaux of the period.

35 Baltrusaitis (op. cit. n. 32), p. 101.

The Objects in the Painting

1 On the carpet, see J. Mills, *Carpets in Paintings*, London, National Gallery 1975, p. 17.

2 See K. Charlton, 'Holbein's "Ambassadors" and Sixteenth-Century Education', *Journal of the History of Ideas*, 21, 1960, pp. 99–109, also S. Greenblatt, *Renaissance Self-Fashioning from More to Shakespeare*, Chicago and London 1980, p. 19.

3 See Starkey, p. 72, V.16. I am grateful to Dr Willem Hackmann for his advice. The time shown appears to be mid-morning. The sign for Virgo should appear instead of Aquarius: see F. A. Stebbins, 'The Astronomical Instruments in Holbein's "Ambassadors"', *The Journal of the Royal Astronomical Society of Canada*, 56, no. 2, April 1962, pp. 45–52.

4 Levey, pp. 46–54, 50–1; see also E. W. Ives, 'The Queen and the Painter: Anne Boleyn, Holbein and Tudor Royal Portraits', *Apollo*, July 1994, p. 40, who argues that the date coincides with recognition of Anne at court in preparation for her coronation.

5 See above, 'Jean de Dinteville and Georges de Selve', n. 1.

6 See Stebbins (op. cit. n.14). Discrepancies in the representation of the instruments have also been noted and pointed out to me by Dr Kristen Lippencott and Dr Willem Hackmann, to whom I am most indebted. See also P. Drinkwater, 'A Cold Look at Kratzer's "Polyhedral" Sundial', *Bulletin of the British Sundial Society*, 1993, no. 2, pp. 8–10, 20; I am indebted to Alan Mills for a copy of this article.

7 Hervey, p. 80.

8 I am grateful to Dr Willem Hackmann for pointing this out. On the left-hand quadrant, see also P. I. Drinkwater, *The Sundials of Nicholaus Kratzer*, Shipston-on-Stour 1993, pp. 7–9.

9 I am indebted to Alan Mills for much information on the torquetum, and am also grateful for information on this and other instruments to Neil Brown of the Science Museum, London.

10 Starkey, no. XII.6, p. 179.

11 Levey, p. 51. Stebbins (op. cit. n. 6), p. 47, notes the setting of the globe is for latitude 43° North by the metal meridian, but nearer 53° from the positions of the constellations.

12 See *The World in Your Hands: An Exhibition of Globes and Planataria*, Christie's, London, and Museum Boerhaave, Leiden 1994–5, p. 20, referring to Dr Ellie Dekker's reattribution of the globe. I am most grateful to Jane Wess and Kevin Johnson of the Science Museum, London, for advice and literature on the globe and Dr Dekker's discoveries, as also to Dr Kristen Lippencott.

13 Troyes, Archives Départementales, Aube, E 217, f. 17r.

14 Starkey, pp. 58–69.

15 J. D. North, 'Nicolaus Kratzer: The King's Astronomer', in *Science and History: Studies in Honor of Edward Rosen*, *Studia Copernica*, XVI, Ossolineum, Polish Academy of Sciences 1978, pp. 205–34, pp. 232–3.

16 On the problem of its authenticity see Starkey, no. V.15, p. 72.

17 North (op. cit. n. 13), pp. 205–34; Starkey, pp. 70–3.

18 Chap. 1 of the forthcoming book, L. Jardine and J. Brotton, *Global Ventures*.

19 Helen Wallis, unpub. report of 16 June 1960 in National Gallery dossiers disputed the identification with Schöner's globe; see also her article 'Globes in England up to 1660', *The Geographical Magazine* pp. 267–79, esp. pp. 268–70. More recently it has been shown that most of the surviving similar globes are fakes: see A. D. Baynes-Cope, 'The Investigation of a Group of Globes', *Imago Mundi*, 33, 1981, pp. 9–20. Peter Barber has pointed out that painted globes were still prevalent in the period, so Holbein's globe need not be based on any printed gores.

20 P's and B's are often confused in South German dialect, especially near Augsburg where Holbein was born.

21 Anne-Marie Lecoq, *François Ier Imaginaire: symbolique et politique à l'aube de la Renaissance française*, Paris 1986, pp. 69–117, esp. pp. 74–7, and J. M. Massing, *Erasmian Wit and Proverbial Wisdom: An Illustrated Moral Compendium for François I*, Studies of the Warburg Institute, I, 1995.

22 J. Rowlands with G. H. Bartrum, *Drawings by German Artists … in the Department of Prints and Drawings in the British Museum: The Fifteenth Century, and the Sixteenth-Century by Artists born before 1530*, 2 vols., London 1993, I, no. 346(e), p. 163. I am most grateful to Professor Pauline Smith of the University of Hull for her comments on the meaning and translation of this motto.

23 See E. Panofsky, *The Life and Art of Albrecht Dürer*, Princeton 1955, esp. pp. 161–8. In Holbein's portrait of Sir Henry Guildford (Royal Collection) the sitter wears a hat badge with the instruments of the Typus Geometriae.

24 M. Jenny, 'Ein frühes Zeugnis für die kirchen-verbindende Bedeutung des evangelischen Kirchenliedes', *Jahrbuch für Liturgik und Hymnologie*, VIII, 1963, pp. 124–8; Jenny states that the 1525 edition is closer to Holbein's painting than the first edition of 1524.

25 R. J. Knecht, *Renaissance Warrior and Patron: The reign of Francis I*, rev. ed., Cambridge 1994.

26 F. Palmer, 'Musical instruments from the *Mary Rose*: A report on work in progress', *Early Music*, Jan. 1983, pp. 53–9. The wind instruments found were a shawm and a tabor pipe. I am most grateful to Frances Palmer and to Alexandra Hildred of the *Mary Rose* Trust for information on this point.

27 For example de Selve's own translation of Plutarch's Lives, *Les Vyes de huict excellens … personnaiges …*, Paris 1543, p. 60v, where the playing of flute and lyre is contrasted, 'mais du ieu des fluttes il se fuyoit, & evoit en horreur!'

28 E. M. W. Tillyard, *The Elizabethan World Picture*, Harmondsworth 1972, chap. 8, pp. 107–14, and J. Hollander, *The Untuning of the Sky: Ideas of Music in English Poetry, 1500–1700*, Princeton, NJ, 1961, pp. 47–8; see also J. Baltrusaitis, *Anamorphoses: les perspectives depravées*, Paris 1984, pp. 106–7.

29 Hollander (op. cit. n. 28), p. 48, points out that Horapollo *Hieroglyphs*, published in 1505, includes the lute as the symbol of political leader.

30 M. Rasmussen, 'The case of the flutes in Holbein's *The Ambassadors*', *Early Music*, February 1995, pp. 114–23; I am grateful to Frances Palmer for bringing this to my attention.

31 E. W. Ives, 'The Queen and the Painters: Anne Boleyn, Holbein and Tudor Royal Portraits', *Apollo*, July 1994, pp. 36–45, esp. 39–40, R. Foster, *Patterns of Thought: The Hidden Meaning of the Great Pavement of Westminster Abbey*, London 1989, p. 59.

32 S. Thurley, *The Royal Palaces of Tudor England*, London and New Haven 1993, p. 221, suggests the interior

of Bridewell Palace is shown and Foster (op. cit. n. 31), suggests that Holbein took this type of patterned floor not from the Abbey but from the palace of Greenwich, where, later in the decade, it is recorded that there was a painted decoration with circular patterns. However, the description of this as 'antique work' makes it clear that this could not have resembled the floor in *The Ambassadors*. See also, P. C. C. Claussen, 'Der doppelte Boden unter Holbeins *Gesandten*', in A. Beyer, V. Lampugnani and G. Schweikhart, eds., *Hülle und Fülle: Festschrift für Tilmann Buddensieg*, Alfter 1993, pp. 177–202.

33 On possible meanings of the star see Foster (op. cit. n. 31), Hervey, pp. 323–5, Baltrusaitis (op. cit. n. 28), p. 99.

34 P. Binski, *Westminster Abbey and the Plantagenet Kingship and the Representation of Power, 1200–1400*, New Haven and London 1995, pp. 95ff, and Foster (op. cit. n. 31).

Death and Distortion

1 For example in the National Gallery see NG 1256, Harmen Steenwyck, *Still Life*, Maclaren/Brown, pp. 434–5, NG 6533, Jan Jansz. Treck, *Vanitas Still Life*; *National Gallery Report* 1990–1, pp. 14–15.

2 For example the pair of portraits in Cleveland, Ohio, of *c*.1470–80, illus. A. Dülberg, *Privatporträts: Geschichte und Ikonologie einer Gattung im 15. und 16. Jahrhundert*, Berlin 1990, pl. 126; for skulls and skeletons as reverses of portraits in general see ibid., pp. 153–63 and pls. 107–33.

3 J. Osborn, ed., *The Autobiography of Thomas Whythorne*, Oxford 1961, pp. 133–5.

4 H. Rupprich, ed., *Dürer: Schriftliche Nachlass*, 3 vols., Berlin 1956–69, I, p. 160; for the rings see D. Scarisbrick, *Tudor and Stuart Jewellery*, Tate Gallery, London 1995, pp. 501 and pls. 36, 37.

5 For Holbein's Hanseatic portraits see D. Markow, 'Hans Holbein's Steelyard Portraits Reconsidered', *Wallraf-Richartz Jahrbuch*, XL, 1978, pp. 39–47, and T. S. Holman, 'Holbein's Portraits of the Steeelyard Merchants: An Investigation', *Metropolitan Museum Journal*, XIV, 1979, pp. 139–58.

6 J. O. Hand with S. E. Mansfield, *German Paintings of the Fifteenth through Seventeenth Centuries*, National Gallery of Art, Washington, and Cambridge University Press 1993, pp. 83–91, also J. O. Hand, 'The Portrait of Sir Brian Tuke by Hans Holbein the Younger', *Studies in the History of Art*, 9, 1980, pp. 33–49; there is no evidence that Holbein planned to include a skeleton in his original composition.

7 This has been noticed by various commentators, e.g. D. Piper, 'Holbein's "Ambassadors"', *The Listener*, 12 Jan. 1961, pp. 68–70, and Levey, p. 53, n. 15.

8 M. Kemp, *The Science of Art*, London and New Haven 1990, p. 50.

9 L. Wedel: the relevant passage is quoted in R. Strong, *Tudor and Jacobean Portraits*, 2 vols., London 1967, I, p. 89; for another account of the picture see also G. W. Groos, ed., *The Diary of Baron Waldstein: A Traveller in Elizabethan England*, London 1981, pp. 43–5.

10 I am most grateful to Catherine Macleod and Richard Hallas of the National Portrait Gallery for information on this point. See also J. Simon, *The Art of the Picture Frame*, exhibition catalogue, National Portrait Gallery, London 1996, p. 150.

11 *Mr Cartwright's Pictures*, exhibition catalogue, Dulwich Picture Gallery, London 1988, transcript of Cartwright's inventory pp. 20–17, no. 41, p. 22.

12 For example Daniele Barbaro 1569, Vignola and Danti 1583, as cited in C. Brown, D. Bomford, J. Plesters and J. Mills, 'Samuel van Hoogstraten: Perspective and Painting', *National Gallery Technical Bulletin*, XI, 1987; pp. 67–8 give a useful brief explanation of anamorphosis. See also M. Kemp,

The Science of Art, London and New Haven 1990, pp. 208–9 and J. Balustraitis, *Anamorphoses. les persepctives dépravés*, 3rd ed., Paris 1986, pp. 91–112.

13 First suggested by J. Marshall, *The Times*, 20 Oct. 1890, and recently elaborated by Viviana Giovanozzi from Università La Sapienza, Rome, who demonstrated an experimental projection at the National Gallery while on attachment to the VASARI/MARC electronic imaging project at the Gallery in 1995.

14 It should be noted that there are a number of positions along the line joining the centre of the skull to the optimum viewing-point along which the skull can be viewed, once the viewer is around 1000 mm from the skull, owing to the small angle of divergence of the grid used to construct the perspective.

15 E. R. Samuel, 'Death in the Glass: A New View of Holbein's "Ambassadors"', *Burlington Magazine*, CV, Oct. 1963, pp. 436–41. I am most grateful to Mr Samuel for demonstrating his thesis in front of Holbein's picture.

16 *Mr Cartwright's Pictures* (op. cit. n. 11), nos. 35–9, pp. 21–2.

17 I am grateful to David Saunders and John Cupitt for demonstrating this.

18 J. M. Massing, 'Dürer's Dreams', *Journal of the Warburg and Courtauld Institutes*, XLIX, 1986, pp. 242–4.

19 See E. de Jongh, *Portretten van echt en trouw*, exh. cat., Frans Hals Museum, Haarlem 1986, no. 11, pp. 98–101.

20 Hervey, pp. 232–5, Baltrusaitis (op. cit. n. 12), pp. 96–9.

Part II

1 See, for example, L. Campbell, S. Foister and A. Roy, eds., *National Gallery Technical Bulletin: Early Northern European Painting*, XVIII, 1997.

2 R. Strong, 'Holbein's Cartoon for the Barber-Surgeons Group Rediscovered', *Burlington Magazine*, CV, no. 718, 1963, pp. 4–14.

3 No trace of charcoal is apparent today, as Catherine Macleod of the National Portrait Gallery has kindly confirmed. Tom Henry has suggested that an auxiliary cartoon may have been used. We are grateful to him for pointing out this interesting possibility. See also S. Fairbrass and K. Holmes, 'The Restoration of Hans Holbein's Cartoon of Henry VIII and Henry VII', *Conservator*, 10, 1986, pp. 12–16.

4 L. Dimier, *Histoire de la peinture de portrait en France, xvi siècle*, 2 vols., Paris and Brussels 1924, I, p. 22.

5 Levey, pp. 54–7.

6 For Holbein's Basel drawings, see C. Müller, *Katalog der Zeichnungen von Hans Holbein dem Jüngeren*, Basel 1996, p. 67, nos. 92,93.

7 S. Foister, 'Holbein and his English Patrons', unpub. PhD thesis, University of London 1981, pp. 70–9 and Appendix III, pp. 511–2.

8 M. Ainsworth, '"Paternes for phisioneamyes": Holbein's portraiture reconsidered', *Burlington Magazine*, CXXXII, no. 1044, 1990, pp. 173–86

9 Foister, *Drawings by Holbein from the Royal Library Windsor Castle*, New York 1983, pp. 21–5.

10 Müller (op. cit. n. 6), cat. no. 189, p. 126.

11 S. Foister (op. cit. n. 9), pp. 14–15.

12 S. Foister, M. Wyld and A. Roy, 'Hans Holbein's *A Lady with a Squirrel and a Starling*', *National Gallery Technical Bulletin*, XV, 1994, pp. 6–19.

13 E. Foucart-Walter, *Les peintures de Hans Holbein le Jeune au Louvre*, exh. cat., Museé du Louvre, Paris, 1985, pp. 22–3 and 72, nos. I.10 and I.11.

14 For the drawings of Wingfield and Cobham, see K. T. Parker, *The Drawings of Hans Holbein in the Collection of His Majesty the King at Windsor Castle*, Oxford and London 1945, nos. 36 and 53; for the panel painting of Cobham, see S. Foister in K. Hearn, ed., *Dynasties*, exhibition catalogue, Tate

Gallery, London, 1995, no. 9, p. 44.

15 BL, MS Royal 7 C XV, f. 18r ff.

16 Although in Holbein's drawing a note indicates some jewels should be green, when the miniature in the Royal Collection was examined under the microscope it was clear that they are evidently painted in a black pigment and must have been intended to be black. For the drawings of Lady Audley and Richard Southwell, see Parker (op. cit. n. 14), nos. 58 and 38.

17 Müller (op. cit. n. 6), no. 197, p. 128.

18 The Meyer portraits were originally framed as a diptych, see J. Rowlands, *The Paintings of Hans Holbein the Younger: Complete Edition*, Oxford 1985, pp. 21–2 and 125, no. 2.

19 These touches appear to be small impasto highlights of lead-tin yellow.

20 For a discussion of Leonardesque methods of painting, see L. Keith and A. Roy, 'Giampietrino, Boltraffio and the Influence of Leonardo', *National Gallery Technical Bulletin*, XVII, 1996, pp. 4–19.

21 The edges of the portrait of Georg Gisze were examined under the stereomicroscope; a mid-grey *imprimatura* over the chalk ground, very similar to that on *The Ambassadors*, was clearly present.

22 Wood panelled backgrounds are seen in several portraits by Holbein of the second English visit: see Rowlands (op. cit. n. 18), nos. 72, 89, 91.

23 Identified in the course of dendrochronological investigation by Dr Peter Klein, University of Hamburg, who gives an earliest felling date for the wood of the panel as 1524. Report dated 8 Aug. 1995 in the National Gallery 'Conservation Dossier'.

24 A detailed account of the conservation treatment of the painting may be found in M. Wyld, 'The Restoration History of Holbein's *Ambassadors*', *National Gallery Technical Bulletin*, XIX, 1998, forthcoming, see also pp. 88–91 above.

25 For the method of analysis of the red dyestuff, see J. Kirby and R. White, 'The Identification of Lake Pigment Dyestuffs and a Discussion of their Use', *National Gallery Technical Bulletin*, XVII, 1996, pp. 56–80; esp. pp. 59–61, 73.

26 See above, Introduction, n. 2.

27 This information on the priming was kindly supplied by Marlies Giebe and will be published in the proceedings of the 1997 Basel Holbein symposium, in *Zeitschrift für Schweizerische Archäologie und Kunstgeschichte*.

28 J. O. Hand with S. E. Mansfield, *German Paintings of the Fifteenth through Seventeenth Centuries*, National Gallery of Art, Washington, and Cambridge University Press 1993, pp. 83–91.

29 Analysis using gas-chromatography linked to mass-spectrometry by R. White showed the presence of small amounts of dehydroabietic and 7-oxodehydroabietic acid components, indicating the addition of pine resin to the medium of linseed oil. Green glazing paints of this general constitution seem less prone to discoloration than do true 'copper resinate' type pigments.

30 Hand (op. cit. n. 28), pp. 83–91.

31 Ibid.

Provenance

1 As the portrait of Jean de Dinteville and the Bishop of Auxerre, the latter mistaken for Georges de Selve. See above, Part I, 'Jean de Dinteville and Polisy', no. 19, 31.

2 Hervey, pp. 14–20.

3 Olivier Bonfait, 'Les Collections des parlementaires parisiens du XVIIIe siècle', *Revue de l'Art*, 1986, p. 36.

4 See Introduction, n. 4, Levey, p. 53, and Hervey, pp. 5–6, for the picture's subsequent history.

Select Bibliography

M. Ainsworth, '"Paternes for phio-sioneamyes": Holbein's portraiture reconsidered', *Burlington Magazine*, CXXXII, no. 1044, 1990, pp. 173–86

C. K. Aked, 'The Ambassadors', *Antiquarian Horology*, Winter 1976, p. 70–7

Amsterdam, Rijksmuseum, *De Triomf van het Manierisme*, exh. cat., 1955

S. Anglo, *Spectacle, Pageantry and Early Tudor Policy*, Oxford 1969

A. Babeau, 'Domenique Florentin, Sculpteur du seizième siècle', *Réunion des Societes savantes des Departements a la Sorbonne du 4 au 7 Avril 1877*, Section des Beaux-Arts, Paris 1890, pt. I

J. Baltrustaitis, *Anamorphoses: les perspectives dépravés*, 3rd ed., Paris 1986, pp. 91–112

Basel, Kunstmuseum, C. Müller, *Hans Holbein d. J.: Zeichnungen aus dem Kupferstichkabinett der Offentlichen Kunstsammlung Basel*, exh. cat., 1988

A. D. Baynes-Cope, 'The Investigation of a Group of Globes', *Imago Mundi*, 33, 1981

S. Béguin, *L'Ecole de Fontainebleau*, Paris 1960

S. Béguin, O. Delenda and H. Oursel, *Cheminées et Frises Peintes du Château d'Ecouen*, Musée National de la Renaissance, Château d'Ecouen 1995

P. Binski, *Westminster Abbey and the Plantagenet Kingship and the Representation of Power, 1200–1400*, New Haven and London 1995

O. Bonfait, 'Les Collections des parlementaires parisiens du XVIIIe siècle', *Revue de l'Art*, 1986, pp. 28–42, p. 36

A. Brejon de Lavergnée, 'Masséot Abaquesne et les pavements du château d'Ecouen', *La revue du Louvre et des Musées de France*, no. 5/6, 1977, pp. 307–15

C. Brown, D. Bomford, J. Plesters and J. Mills, 'Samuel van Hoogstraten: Perspective and Painting', *National Gallery Technical Bulletin*, XI, 1987

E. A. R. Brown, 'Sodomy, Treason, Exile and Intrigue: Four Documents Concerning the Dinteville Affair (1537–8)', *Sociétés et idéologies des temps modernes: hommage à Arlette Jouanna*, Montpellier 1996, pp. 512–32

E. A. R. Brown, 'Sodomy, Treason, Exile and Intrigue: Francis I, Henry II and the Dinteville Brothers', *Sixteenth-Century Journal*, forthcoming

E. A. R. Brown and M. D. Orth, 'Jean du Tillet et les illustrations du grand "Receuil des roys"', *Revue de l'Art*, 115, 1997, pp. 7–24

J. Bruyn, 'Over de betekenis van het wek van Jan van Scorel omstreeks 1530 voor oudere en jongere tijdgenoten (4)', *Oud-Holland*, 1984, pp. 98–110

L. Campbell, *Renaissance Portraits: European Portrait-Painting in the Fourteenth, Fifteenth and Sixteenth Centuries*, New Haven and London 1990

L. Campbell, S. Foister and A. Roy (eds.), *National Gallery Technical Bulletin: Early Northern European Painting*, XVIII, 1997

A. B. Chamberlain, *Hans Holbein the Younger*, 2 vols., London 1913

K. Charlton, 'Holbein's "Ambassadors" and Sixteenth-Century Education', *Journal of the History of Ideas*, 21, 1960, pp. 99–109

A. Chastel and J. Guillaume (eds.), *l'Escalier dans l'architecture de la Renaissance*, série De Architectura, Paris 1985

P. C. C. Claussen, 'Der doppelte Boden unter Holbeins Gesandten', in A. Beyer, V. Lampugnani and G. Schweikhart (eds.), *Hülle und Fülle. Festschrift für Tilmann Buddensieg*, Alfter 1993, pp. 177–202

L. Coutant, 'Vue du Château de Polisy au XVIII siècle', *Almanach-Annuaire de l'Arrondissment de Bar-sur-Seine*, Paris 1864

M. Davies, *The Early Netherlandish School*, National Gallery Catalogue, 3rd ed., London 1968

P. Drinkwater, 'A Cold Look at Kratzer's "Polyhedral" Sundial', *Bulletin of the British Sundial Society*, 1993

P. I. Drinkwater, *The Sundials of Nicholaus Kratzer*, Shipston-on-Stour 1993

A. Dülberg, *Privatporträts: Geschichte und Ikonologie einer Gattung im 15. und 16. Jahrhundert*, Berlin 1990

Château d'Ecouen, Musée National de la Renaissance, *Livres d'heures royaux*, exh. cat., 1993

Château d'Ecouen, Musée National de la Renaissance, *Les trésors du Grand Ecuyer Claude Gouffier, collectionneur et mécène a la Renaissance*, exh. cat., 1994

S. Fairbrass and K. Holmes, 'The Restoration of Hans Holbein's Cartoon of Henry VIII and Henry VII', *Conservator*, 10, 1986, pp. 12–16

S. Foister, *Drawings by Holbein from the Royal Library Windsor Castle*, New York 1983

S. Foister, 'Holbein and his English Patrons', unpub. Ph.D. thesis, University of London 1981

S. Foister, 'The Production and Reproduction of Holbein's Portraits', in K. Hearn ed., *Dynasties* exhibition catalogue, Tate Gallery, London 1995, pp. 21–6

S. Foister, M. Wyld and A. Roy, 'Hans Holbein's *A Lady with a Squirrel and a Starling*', *National Gallery Technical Bulletin*, XV, 1994, pp. 6–19

R. Foster, *Patterns of Thought: The Hidden Meaning of the Great Pavement of Westminster Abbey*, London 1989

R. Foster and P. Tudor-Craig, *The Secret Life of Paintings*, Woodbridge 1986

E. Foucart-Walter, *Les dossiers du Département des Peintures: les peintures de Hans Holbein le Jeune au Louvre*, Paris, Musée du Louvre, 1985

A. Gaussen, *Portefeuille archéologique de la Champagne*, Bar-sur-Aube 1861

S. Greenblatt, *Renaissance Self-Fashioning from More to Shakespeare*, Chicago and London 1980

G. W. Groos, *The Diary of Baron Waldstein: A Traveller in Elizabethan England*, London 1981

J. Guy, *Tudor England*, Oxford 1985

Haarlem, Frans Hals Museum, *Portretten van echt en trouw*, 1986

F. Hallyn, 'Holbein: la mort en abyme', *Gentsche Bijdragen tot de Kunstschiedenis*, 1979–80, pp. 1–13

J. O. Hand with the assistance of S. E. Mansfield, *The Collections of the National Gallery of Art Systematic Catalogue: German Paintings of the Fifteenth through Seventeenth Centuries*, National Gallery of Art, Washington, and Cambridge University Press 1993

G. Heise, *Der Kunstbrief: Die Gesandten von Hans Holbein*, Berlin 1946

M. F. S. Hervey, *Holbein's "Ambassadors": The Picture and the Men*, London 1900

M. Hervey and R. Martin-Holland, 'A Forgotten French Painter: Felix Chrétien', *Burlington Magazine*, XIX, 1911

K. Hoffmann, 'Hans Holbein d.J.: "Die Gesandten"', in A. Lenteritz et al. (eds.), *Festschrift für Georg Scheja zum 70. Geburtstag*, Sigmaringen 1975, pp. 133–50

J. Hollander, *The Untuning of the Sky: Ideas of Music in English Poetry, 1500–1700*, Princeton, NJ, 1961

T. S. Holman, 'Holbein's Portraits of the Steeelyard Merchants: An Investigation',

Metropolitan Museum Journal, xiv, 1979, pp. 139–158

E. W. Ives, *Anne Boleyn*, Oxford 1986

E. W. Ives, 'The Queen and the Painter: Anne Boleyn, Holbein and Tudor Royal Portraits', *Apollo*, July 1994, pp. 36–45

H. Jenny, 'Ein frühes Zeugnis für die kirchen-verbindende Bedeutung des evangelischen Kirchenliedes', *Jahrbuch für Liturgik und Hymnologie*, VIII, 1963, pp. 123–8

R. J. Kalas, 'The Selve Family of Limousin: Members of a New Elite in Early Modern France', *Sixteenth-Century Journal*, XVIII, 1987, pp. 147–72

L. Keith and A. Roy, 'Giampietrino, Boltraffio and the Influence of Leonardo', *National Gallery Technical Bulletin*, XVII, 1996, pp. 4–19

M. Kemp, *The Science of Art*. London and New Haven 1990

J. Kirby and R. White, 'The Identification of Lake Pigment Dyestuffs and a Discussion of their Use', *National Gallery Technical Bulletin*, XVII, 1996, pp. 56–80

W. Kloek, 'The Drawings of Lucas van Leyden', *Lucas van Leyden Studies: Nederlands Kunsthistorisch Jaarboek*, 29, 1978, pp. 425–58

R. J. Knecht, 'Francis I, "Defender of the Faith"?', in E. W. Ives, R. J. Knecht and J. J. Scarisbrick (eds.), *Wealth and Power in Tudor England: Essays Presented to S. T. Bindoff*, London 1978

R. J. Knecht, *Renaissance Warrior and Patron: The Reign of Francis I*, rev. ed., Cambridge 1994

H. Keller, 'Enstehung und Blütezeit des Freundschaftsbildes', in D. Fraser, H. Hibbard and M. J. Levine (eds.), *Essays in the History of Art Presented to Rudolf J. Wittkower*, London 1967

L. Leclert, *Musée de Troyes: carrélages vernissés, inscrustés, historiés et faiencés*, Troyes 1892

Anne-Marie Lecoq, *Francois Ier Imaginaire: Symbolique et politique à l'aube de la Renaissance française*, Paris 1986

M. Levey, *The German School*, National Gallery Catalogues, London 1959

London, British Museum, G. Bartrum, *German Renaissance Prints, 1490–1550*, exh. cat., 1995

London, Christie's, and Leiden, Museum Boerhaave, *The World in Your Hands: An Exhibition of Globes and Planetaria*, exh. cat., 1994–5

London, Dulwich Picture Gallery, *Mr Cartwright's Pictures*, exh. cat. 1988

London, National Portrait Gallery, J. Simon,

The Art of the Picture Frame, exh. cat. 1996

London, Tate Gallery, *Dynasties*, exh. cat., 1995

Los Angeles, Grunewald Center for the Visual Arts, University of California, and Paris, Bibliothèque Nationale, *La Gravure française à la Bibliothèque Nationale*, exh. cat. 1994

D. Markow, 'Hans Holbein's Steelyard Portraits, Reconsidered', *Wallraf-Richartz Jahrbuch*, XL, 1978, pp. 39–47

J. M. Massing, 'Dürer's Dreams', *Journal of the Warburg and Courtauld Institutes*, XLIX, 1986, pp. 242–4

J. M. Massing, *Erasmian Wit and Proverbial Wisdom: An Illustrated Moral Compendium for Francois I*, Studies of the Warburg Institute, I, 1995

P. Mellen, *Jean Clouet: Complete Edition of the Drawings, Miniatures and Paintings*, London and New York 1971

John Mills, *Carpets in Paintings*, National Gallery, London 1975

C. Müller, *Oeffentliche Kunsammlung Basel, Kupferstichkabinett: Katalog der Zeichnungen von Hans Holbein dem Jüngeren*, Basel 1996

J. D. North, 'Nicolaus Kratzer: The King's Astronomer', in *Science and History: Studies in Honor of Edward Rosen, Studia Copernica*, XVI, Ossolineum, Polish Academy of Sciences 1978

J. Osborn (ed.), *The Autobiography of Thomas Whythorne*, Oxford 1961, pp. 133–5

F. Palmer, 'Musical instruments from the *Mary Rose*: A Report on Work in Progress', *Early Music*, January 1983, pp. 53–9

E. Panofsky, *The Life and Art of Albrecht Dürer*, Princeton 1955

K. T. Parker, *The Drawings of Hans Holbein in the Collection of His Majesty the King at Windsor Castle*, Oxford and London 1945 (repr. with appendix by S. Foister, London and New York, 1983)

K. T. Parker, *Catalogue of the Collection of Drawings in the Asmolean Museum*, 2 vols., Oxford 1938

J.-B.-P. Lebrun, *Galerie des peintres flamands, hollandais et allemands*, Paris and Amsterdam 1792–6

David Piper, 'Holbein's *Ambassadors*', *The Listener*, 12 January 1961, pp. 68–70

M. Rasmussen, 'The Case of the Flutes in Holbein's *The Ambassadors*', *Early Music*, February 1995, pp. 114–23

Glenn Richardson, 'Anglo-French Political and Cultural Relations During the Reign of Henry VIII', unpub. Ph.D.

thesis, University of London 1996

M. Roskill and C. Harbison, 'On the Nature of Holbein's Portraits', *Word and Image*, Jan.–March 1987, pp. 1–26 (17–18)

J. Rowlands, *The Paintings of Hans Holbein the Younger: Complete Edition*, Oxford 1985

J. Rowlands with G. Bartrum, *Drawings by German Artists … in the Department of Prints and Drawings in the British Museum: The Fifteenth Century, and the Sixteenth Century by Artists born before 1530*, 2 vols., London 1993

J. Rowlands and D. Starkey, 'An Old Tradition Reasserted: Holbein's Portrait of Queen Anne Boleyn', *Burlington Magazine*, CXXV, 1983

E. R. Samuel, 'Death in the Glass: A New View of Holbein's "Ambassadors"', *Burlington Magazine*, CV, October 1963, pp. 436–41

C. Scaillierez, *François Ier et ses artistes: monographies des Musées de France*, Paris 1992

F. A. Stebbins, 'The Astronomical Instruments in Holbein's "Ambassadors"', *Journal of the Royal Astronomical Society of Canada*, LVI, no. 2, April 1962, pp. 45–52

C. Sterling, *A Catalogue of French Paintings of the Metropolitan Museum of Art, XV–XVIII Centuries*, New York 1955

R. Strong, 'Holbein's Cartoon for the Barber-Surgeons Group Rediscovered', *Burlington Magazine*, CV, no. 718, 1963, pp. 4–14

R. Strong, *Tudor and Jacobean Portraits: National Portrait Gallery*, 2 vols., London 1967

S. Thurley, *The Royal Palaces of Tudor England*, New Haven and London 1993

E. M. W. Tillyard, *The Elizabethan World Picture*, Harmondsworth 1972

Ian Wardropper, 'Le voyage italien de Primatice en 1550', *Bulletin de la Société de l'histoire de l'art français*, 1981 (1983), pp. 27–31

I. Wardropper, 'The Sculpture and Prints of Domenico del Barbiere', unpub. doctoral diss., New York University 1985

A. Woltmann, *Holbein und seine Zeit*, 2 vols., 2nd ed., Leipzig 1874–6

R. N. Wornum, *Some Account of the Life and Works of Holbein*, London 1867

M. Wyld, 'The Restoration History of Holbein's "Ambassadors"', *National Gallery Technical Bulletin*, XIX, 1998, forthcoming

H. Zerner, *Ecole de Fontainbleau: gravures*, 1969

Lenders to the Exhibition

Her Majesty The Queen (60, 61, 65, 66, 68, 72, 73, 74)

The Visitors of the Ashmolean Museum, Oxford (19, 76)

Bibliothèque Nationale de France, Paris (3, 4, 14, 15, 16, 59)

Bodleian Library, University of Oxford (44)

City of Bristol Museums and Art Gallery (42)

British Library Board, London (7, 8, 13)

The British Museum, London (20, 21, 22, 23, 24, 25, 27, 36, 37, 38, 39, 53, 54, 55, 56, 77, 78)

The Syndics of Cambridge University Library (33, 34, 35)

Corpus Christi College, Oxford (45)

The Barbara Piasecka Johnson Collection Foundation (12)

Lutherhalle, Wittenberg (Stiftung Luthergedenkstätten in Sachsen-Anhalt) (51)

Musée du Louvre, Département des Arts Graphiques, Paris (70, 71)

Musée des Beaux-Arts de Troyes (France) (17, 18)

Museum of the History of Science, Oxford (46, 47, 48, 49, 50)

National Galleries of Scotland, Edinburgh (52)

The National Maritime Museum, Greenwich (40)

National Portrait Gallery, London (28, 31, 41, 57)

Collection of the Duke of Northumberland (58)

Öffentliche Kunstsammlung, Basel, Kupferstichkabinett (6, 79, 80)

Private Collection (69)

Public Record Office, Kew (9, 10, 11, 62)

The Royal Astronomical Society and the Trustees of the Science Museum, London (43)

Staatliche Museen, Berlin, Kupferstichkabinett (5)

Staatliche Kunstsammlungen Dresden, Kupferstich-Kabinett (75)

Städelsches Kunstinstitut, Frankfurt am Main (67)

The Board of Trustees of the Victoria & Albert Museum, London (64)

The Worshipful Company of Barbers, London (32)

Works in the Exhibition

1
HERVEY, Mary
Holbein's Ambassadors: The Picture and the Men, London, 1900
Printed book, 41 x 25 cm
London, National Gallery

2 *Plate 3*
Fragment of an inventory dated 1653, identifying the sitters in Holbein's painting
Manuscript, 18 x 34.5cm
Lit: Hervey, pp. 11–12
London, National Gallery

3
Letter from Jean de Dinteville, 1533
Manuscript
Paris, Bibliothèque Nationale de France
(BN MS Fr. 15971, f. 4r)

4
Letter from Jean de Dinteville, 1533
Manuscript
Lit: Hervey, pp. 79–81
Paris, Bibliothèque Nationale de France
(BN MS Dupuy 726, f. 46)

5 *Plate 6*
HOLBEIN the Younger, Hans
Apollo and the Muses on Parnassus, 1533
Ink and wash on paper, 42.3 x 38.4 cm
Lit: Anglo, pp. 247–61; Rowlands and
Starkey
Berlin, Staatliche Museen,
Kupferstichkabinett

6 *Plate 5*
HOLBEIN the Younger, Hans
Table-fountain design for Anne Boleyn,
1533
Ink and black chalk on paper, 17.1 x 10.1 cm
Lit: Müller, no. 243
Basel, Öffentliche Kunstsammlung,
Kupferstichkabinett

7
Garter Statutes for Francis I, 1527
Manuscript, 27.5 x 39 cm
Lit: Starkey, VI.4, p. 97
London, British Library Board (BL MS
Add. 5712)

8
'Les Commentaires de la Guerre Gallique',
vol. I, 1519
Manuscript, 25 x 12.5 cm

Lit: Starkey, V.40, p. 87; Scaillierez, no. 1,
p. 118
London, British Library Board (BL MS
Harley 6205)

9
Commission of Henry VIII to the Order of
Saint Michael, 1527
Manuscript with wax seal, 30.5 x 56.7 cm
Lit: Starkey, VI.1, p. 96
Kew, Public Record Office (PRO MS
E30/1447)

10
Election of Henry VIII to the Order of
Saint Michael, 1527
Manuscript with wax seal, 65 x 60.3 cm
Lit: Starkey, VI.1, p. 97
Kew, Public Record Office (PRO MS
E30/1448)

11
Statutes of the Order of Saint Michael, 1527
Manuscript, 28.5 x 40 cm
Lit: Starkey, VI.3, p. 97
Kew, Public Record Office (PRO MS
E36/276)

12 *Plate 14*
PRIMATICCIO, Francesco
Jean de Dinteville as Saint George, c.1544/5
Oil on canvas, 163.8 x 119.4 cm
Lit: Amsterdam
The Barbara Piasecka Johnson Collection
Foundation

13
Dinteville Book of Hours, c.1525
Manuscript, 25.5 x 16.5 cm
London, British Library Board (BL MS
Add. 18854)

14 *Plate 11*
MASTER OF THE HOURS OF
HENRY II
The Dinteville Hours, c.1553
Manuscript, 23 x 15 cm
Lit: Crespin-Leblond; Brown and Orth
Paris, Bibliothèque Nationale de France
(BN MS Lat. 10558)

15 *Plate 19*
BARBIERE, Domenico del
Landscape in an Ornamental Frame,
mid-1540s
Engraving, 17.5 x 22.6 cm

Lit: Zerner 11; Los Angeles, no. 68, pp. 91–3
Paris, Bibliothèque Nationale de France

16 *Plate 12*
BARBIERE, Domenico del
The Stoning of Saint Stephen, probably late 1530s
Engraving, 27.2 x 15.5 cm
Lit: Zerner, DB 2; Wardropper 1985, p. 32
Paris, Bibliothèque Nationale de France

17 *Plate 20*
Tile from the Château de Polisy, 1549
Tin-glazed earthenware, 10.7 x 10.8 x 1.8 cm
Lit: Gaussen; Brejon de Lavergnée
Musée des Beaux-Arts de Troyes, France
(tile 226)

18
Tile from the Château de Polisy, 16th
century
Tin-glazed earthenware, 6.6 x 6.7 x 1.8 cm
Lit: Gaussen; Brejon de Lavergnée
Musée des Beaux-Arts de Troyes, France
(tile 227)

19 *Plate 56*
LEYDEN, Lucas van
Saint Jerome, 1521
Black chalk with brown and dark washes,
ink, heightened with white, blue bodycolour
on paper, 37.6 x 28.1 cm
Lit: Kloek, pp. 449–50
Oxford, The Visitors of the Ashmolean
Museum

20
DÜRER, Albrecht
Saint Jerome in his Study, 1514
Engraving, 24.9 x 19.2 cm
Lit: Panofsky, pp. 154–6; London, British
Museum, no. 34, p. 48
London, The British Museum

21
DÜRER, Albrecht
Coat of arms with a skull, 1503
Engraving, 22 x 15.7 cm
Lit: Panofsky, p. 90; London, British
Museum, no. 18, pp. 32–5
London, The British Museum

22
DÜRER, Albrecht
Melancholia, 1514
Engraving, 24.1 x 19.2 cm
Lit: Panofsky, pp. 156–71; London, British

Museum, no. 33, pp. 46–7
London, The British Museum

23 *Plate 47*
HOLBEIN the Younger, Hans
Dance of Death series, *c*.1525
Woodcuts, each *c*.6.5 x 4.9 cm
Lit: London, British Museum, no. 232,
pp. 226–31
London, The British Museum (1895-122-
786 . . . 823)

24
HOLBEIN the Younger, Hans
Dance of Death series, *c*.1525
Woodcuts, each *c*.6.5 x 4.9 cm
Lit: London, British Museum, no. 232,
pp. 226–31
London, The British Museum (1895-1-22-
802 . . . 829)

25
HOLBEIN the Younger, Hans
Dance of Death series, *c*.1525
Woodcuts, each *c*.6.5 x 4.9 cm
Lit: London, British Museum, no. 232,
pp. 226–31
London, The British Museum (1895-1-22-
826 . . . 834)

26 *Plate 44*
NETHERLANDISH SCHOOL
A Man with a Pansy and a Skull, *c*.1535
Oil on oak, 27.3 x 21.6 cm
Lit: Davies, pp. 137–8
London, National Gallery

27 *Plate 50*
SCHÖN, Erhard
Anamorphosis of Emperor Ferdinand, *c*.1531–4
Woodcut, 17.3 x 76.7 cm
Lit: London, British Museum, no. 85,
pp. 97–8
London, The British Museum

28 *Plates 51, 52*
SCROTS, William
Edward VI, 1546
Oil on wood, 42.5 x 160 cm
Lit: Strong 1967 pp. 88–9; London, National
Portrait Gallery, no. 4, p. 150
London, National Portrait Gallery

29 *Plate 114*
HOLBEIN the Younger, Hans
*Jean de Dinteville and Georges de Selve ('The
Ambassadors')*, 1533
Oil on oak, 207 x 209.5 cm
Lit: Hervey; Levey, pp. 47–54; Rowlands,
no. 47
London, National Gallery

30 *Plate 64*
HOLBEIN the Younger, Hans
Christina of Denmark, Duchess of Milan,
c.1538
Oil on oak, 179.1 x 82.6 cm
Lit: Levey, pp. 54–7; Rowlands, no. 66
London, National Gallery

31 *Plate 61*
HOLBEIN the Younger, Hans
Henry VII and Henry VIII, *c*.1536–7
Ink and watercolour on paper mounted on
canvas, 257.8 x 137.2 cm
Lit: Strong 1967, I, pp. 153–5
London, National Portrait Gallery

32 *Plate 9*
HOLBEIN the Younger, Hans
Henry VIII and the Barber-Surgeons, 1541
Oil on oak, 182 x 311 cm
Lit: Strong 1963; Rowlands, no. 78
London, The Worshipful Company of
Barbers

33 *Plate 40*
ALCIATI, Andrea
Emblemata, Augsburg, 1531
Printed book, 14.4 x 8.7 cm
The Syndics of Cambridge University
Library

34 *Plate 36*
APIAN, Peter
*Eyn Newe unnd wohlgegründte underweysung
aller Kauffmanss Rechnung*, Leipzig 1543
Printed book, 16 x 9.5 cm
Lit: Hervey, p. 224
The Syndics of Cambridge University
Library

35
MÜNSTER, Sebastian
Compositio horologiorium, Basel, 1531
Printed book, 18.3 x 14 cm
The Syndics of Cambridge University
Library

36
HOLBEIN the Younger, Hans
Portable cylinder sundial, *c*.1532–43
Pen and black ink with grey wash on paper,
8.4 x 2.7 cm
Lit: Rowlands with Bartrum, no. 335, p. 158
London, The British Museum

37 *Plate 34*
HOLBEIN the Younger, Hans
Design for a medallion with a pair of
compasses, serpents, dolphins and cornu-
copias, *c*.1533
Pen and black ink wash on paper, 4.9 x
5.1 cm

Lit: Rowlands with Bartrum, no. 346(e),
p. 163
London, The British Museum

38
HOLBEIN the Younger, Hans
Design for a clock salt, *c*.1543–4
Pen and black ink with grey and red wash
on paper, 41 x 21.3 cm
Lit: Rowlands with Bartrum, no. 328, p. 151
London, The British Museum

39
MÜNSTER, Sebastian, and HOLBEIN the
Younger, Hans
Map of the World, 1532
Woodcut, 35.3 x 55 cm
Lit: London, British Museum, no. 237,
pp. 234–5
London, The British Museum

40 *Plate 26*
APIAN, Peter
Astronomicum Caesareum, Ingolstadt, 1540
Printed book, 46.7 x 34 cm
Lit: Starkey, XII.6, p. 179
Greenwich, The National Maritime Museum

41
HOLBEIN the Younger, Hans (after)
Nicolaus Kratzer, late sixteenth century
Oil on panel, 81.9 x 64.8 cm
Lit: Starkey, V.13, p. 70
London, National Portrait Gallery

42 *Plate 33*
KRATZER, Nicolaus
Polyhedral sundial from Acton Court, 1520
Carved limestone, 34.9 x 26.7 x 34.9 cm
Lit: Starkey, VIII.1, p. 124
City of Bristol Museums and Art Gallery

43 *Plate 29*
SCHÖNER, Johannes
Celestial globe on wrought-iron stand, 1533
26.5 cm diameter
Lit: London, Christie's
By courtesy of the Royal Astronomical
Society and the Trustees of the Science
Museum, London

44 *Plate 30*
HOLBEIN, Hans, and KRATZER,
Nicolaus
Canones Horoptri, 1528
Manuscript, 23 x 16 cm
Lit: Starkey, V.14, p. 71; North
The Bodleian Library, University of Oxford
(MS Bodley 504)

45 *Plates 27, 32*
KRATZER, Nicolaus

*De Horologis, c.*1517
Manuscript, 23 x 17 cm
Lit: North
Oxford, Corpus Christi College (MS CCC 152)

46
Dividers (French or Italian), 17th-century
Brass and steel, 24.5 x 18.5 x 2.7 cm
Oxford, Museum of the History of Science

47
Quadrant (English), 17th-century
Wood and brass, 16 x 22.2 x 1 cm
Oxford, Museum of the History of Science

48
Equinoctial dial (French), *c.*1500
Brass, 2.2 x 6.5 x 6.5 cm
Oxford, Museum of the History of Science

49
Cylinder dial (German), 17th-century
Wood and brass, 10.8 x 4.6 x 3 cm
Oxford, Museum of the History of Science

50
KRATZER, Nicolaus (attributed to)
Polyhedral dial with Cardinal Wolsey's coat of arms, *c.*1525
Gilt brass, 10 x 9 x 5.3 cm
Lit: Starkey, v.15, p. 72
Oxford, Museum of the History of Science

51
WALTHER, Johannes
Geystliche gesangk Buchleyn, 1524
Printed book, 13 x 17.5 cm
Lit: Jenny
Wittenberg, Lutherhalle (Stiftung Luthergedenkstätten in Sachsen-Anhalt)

52 *Plate 95*
HOLBEIN the Younger, Hans
*Allegory of the Old and New Testaments,
c.*1535
Oil on wood, 50 x 60 cm
Lit: Rowlands, no. 56
Edinburgh, National Galleries of Scotland

53
BOURBON, Nicolas
Paidagogeion, Lyon, 1536
Printed book, 14.7 x 9.45 cm
Lit: Parker 1945, no. 37
London, The British Museum

54
HOLBEIN the Younger, Hans
*Christ before Pilate, c.*1538
Woodcut, 4.3 x 5.9 cm

Lit: Foister 1981, pp. 307–15
London, The British Museum

55
HOLBEIN the Younger, Hans
*Christ casting out a Devil, c.*1538
Woodcut, 4.2 x 5.9 cm
Lit: Foister 1981, pp. 307–15
London, The British Museum

56
HOLBEIN the Younger, Hans
Title-page of the Coverdale Bible, 1535
Woodcut, 27 x 16.3 cm
Lit: Rowlands, p. 91
London, The British Museum

57
HOLBEIN the Younger, Hans (after)
Thomas Cromwell, 1st Earl of Essex
Oil on wood, 78.1 x 61.9 cm
Lit: Strong, pp. 113–14
London, National Portrait Gallery

58 *Plate 59*
The Ecclesiaste, 1533–6
Manuscript, 19 x 14 cm
Lit: Ives, 1986, pp. 289–92
Collection of the Duke of Northumberland (Percy MS 465)

59
SELVE, Georges de
Oeuvres, Paris, 1559
Printed book, 34.2 x 23.1 cm
Lit: Hervey, pp. 173–4
Paris, Bibliothèque Nationale de France

60
HOLBEIN the Younger, Hans
*Solomon and the Queen of Sheba, c.*1534
Miniature painting, with pen and brush, including some use of gold paint, on vellum, 22.8 x 18.1 cm
Lit: Parker 1945, p. 35; Rowlands, no. M.1
Lent by Her Majesty The Queen

61 *Plate 39*
HOLBEIN the Younger, Hans
*Nicholas Bourbon, c.*1535
Black, white and coloured chalks, pen and black ink on pink-primed paper, 30.7 x 26 cm
Lit: Parker 1945, no. 37
Lent by Her Majesty The Queen

62
Page from the accounts of the Greenwich festivities of 1527
Manuscript, 30.5 x 22 cm
Lit: Starkey, pp. 58–60; Foister 1981, pp. 230–2, 533–4

Kew, Public Record Office (PRO MS SP2/Henry VIII C, f. 329r)

63 *Plate 74*
HOLBEIN the Younger, Hans
*A Lady with a Squirrel and a Starling,
c.*1526–8
Oil on oak, 56 x 38.8 cm
Lit: Rowlands, no. 26; Foster, Wyld and Roy
London, National Gallery

64 *Plate 103*
HOLBEIN the Younger, Hans
Anne of Cleves, 1539–40
Watercolour on vellum in an ivory box, 4.5 cm diameter
Lit: London, Tate Gallery, no. 66, p. 119
London, The Board of Trustees of the Victoria & Albert Museum

65 *Plate 69*
HOLBEIN the Younger, Hans
*William Reskimer, c.*1533
Oil on wood, 46 x 33.5 cm
Lit: Rowlands, no. 39
Lent by Her Majesty The Queen

66 *Plate 70*
HOLBEIN the Younger, Hans
*William Reskimer, c.*1532–3
Black, white and coloured chalks with metalpoint on pink-primed paper, 29 x 21 cm
Lit: Parker 1945, no. 31
Lent by Her Majesty The Queen

67 *Plate 72*
HOLBEIN the Younger, Hans
*Simon George, c.*1535
Oil on wood, 31 cm diameter
Lit: Rowlands, no. 63
Frankfurt am Main, Städelsches Kunstinstitut

68 *Plate 73*
HOLBEIN the Younger, Hans
*Simon George, c.*1535
Black and coloured chalks with black ink on pink-primed paper, 27.9 x 19.1 cm
Lit: Parker 1945, no. 31
Lent by Her Majesty The Queen

69 *Plate 78*
HOLBEIN the Younger, Hans
Erasmus, 1523
Oil on wood, 73.6 x 51.4 cm
Lit: Rowlands, no. 13
Private Collection, on loan to the National Gallery

70 *Plate 77*
HOLBEIN the Younger, Hans

Study of hands of Erasmus, *c*.1523
Metalpoint with red and black chalk on
paper, 20.6 x 15.3 cm
Lit: Foucart-Walter, I.11, pp. 22–3
Paris, Musée du Louvre, Département des
Arts Graphiques

71 *Plate 76*
HOLBEIN the Younger, Hans
Study of head and hand of Erasmus, *c*.1523
Metalpoint with red and black chalk on
paper, 20.1 x 27.9 cm
Lit: Foucart-Walter, I.10, pp. 22–3
Paris, Musée du Louvre, Département des
Arts Graphiques

72 *Plate 46*
HOLBEIN the Younger, Hans
William Parr, 1st Marquess of Northampton,
c.1541–2
Black and coloured chalks with white
bodycolour and ink on pink-primed paper,
31.7 x 21.1 cm
Lit: Parker 1945, no. 57
Lent by Her Majesty The Queen

73 *Plate 81*
HOLBEIN the Younger, Hans
An Unidentified Gentleman, c.1532–4
Black, white and coloured chalks with black
ink on pink-primed paper, 27.2 x 21 cm

Lit: Parker 1945, no. 32
Lent by Her Majesty The Queen

74
HOLBEIN the Younger, Hans
Mary Duchess of Richmond and Somerset,
c.1533
Black and coloured chalks with black ink
on paper, 26.6 x 19.9 cm
Lit: Parker 1945, no. 16
Lent by Her Majesty The Queen

75 *Plate 99*
HOLBEIN the Younger, Hans
Charles de Solier, Sieur de Morette, 1534–5
Black and coloured chalks, ink and
watercolour on pink-primed paper, 33 x
24.9 cm
Lit: Foister 1983, pp. 3–12
Dresden, Staatliche Kunstsammlungen,
Kupferstich-Kabinett

76
HOLBEIN the Younger, Hans
A Young Englishwoman, c.1526–8 or
c.1532–43
Pen and black ink and watercolour on
paper, 16 x 9.2 cm
Lit: Parker 1938, pp. 132–3
Oxford, The Visitors of the Ashmolean
Museum

77 *Plate 80*
HOLBEIN the Younger, Hans
Costume study of a woman, *c*.1527/8 or
1532/3
Black ink with pink and grey wash on
paper, 15.9 x 11 cm
Lit: Rowlands with Bartrum, no. 319, p. 149
London, The British Museum

78
HOLBEIN the Younger, Hans
Design for a dagger, *c*.1532–43
Black ink on paper, 45.5 x 12.6 cm
Lit: Rowlands with Bartrum, no. 325, p. 149
London, The British Museum

79 *Plate 82*
HOLBEIN the Younger, Hans
Two sketches of Saint Michael, *c*.1532–6
Black chalk and grey wash on paper, 6.3 x 9.2 cm
Lit: Müller, no. 197
Basel, Öffentliche Kunstsammlung,
Kupferstichkabinett

80 *Plate 71*
HOLBEIN the Younger, Hans
Sketches of heads and hands, after 1538
Pen and chalk on paper, 13.2 x 19.2 cm
Lit: Müller, no. 189
Basel, Öffentliche Kunstsammlung,
Kupferstichkabinett

Index

Numbers printed in italics refer to plate numbers

Picture Credits

Windsor Castle, The Royal Collection © 1997 Her Majesty The Queen: Plates 8, 39, 46, 69, 73, 70, 79, 81

Amsterdam, © Amsterdams Historisch Museum: Plate 58

Basel, Öffentliche Kunstsammlung Basel, Martin Bühler: Plates 5, 7, 65, 66, 67, 68, 71, 82, 83, 84, 85, 86, 87, 88

Berlin, Gemäldegalerie, Staatliche Museen zu Berlin, Preußischer Kulturbesitz (Photo: Jörg P. Anders, Berlin): Plate 91

Berlin, Kupfertichkabinett, Staatliche Museen zu Berlin, Preußischer Kulturbesitz (Photo: Jörg P. Anders, Berlin): Plate 6

Cambridge, by permission of the Syndics of Cambridge University Library: Plates 36, 40

Cambridge, Mass., © President and Fellows, Harvard College, Harvard University Art Museums, Courtesy of the Fogg Art Museum, Gift of Howland Warren, Dr Richard P. Warren, and Mrs Grayson M. P. Murphy: Plate 57

Dresden, Klut/Dresden: Plate 98

Dresden, Staatlichen Kunstsammlungen: Plate 99

Edinburgh, The National Gallery of Scotland: Plates 94, 95

Lawrenceville, New Jersey, The Barbara Piasecka Johnson Collection Foundation: Plate 14

London, The Worshipful Company of Barbers: Plate 9

London, Copyright © The British Museum: Plates 24, 34, 47, 50, 80

London, English Heritage Photo Library: Plate 33

London, National Maritime Museum, Greenwich: Plate 26

London, By courtesy of the National Portrait Gallery: Plates 51, 52, 61

London, Science Museum/Science & Society Picture Library: Plate 29

London, V & A Picture Library: Plate 103

London, Copyright: Dean and Chapter of Westminster: Plate 41

New York, Copyright The Frick Collection: Plate 90

New York, Photograph © 1983 The Metropolitan Museum of Art, Wentworth Fund, 1950. (50.70): Plates 15, 96

Collection of the Duke of Northumberland: Plate 59

Oxford, Ashmolean Museum, University of Oxford: Plate 56

Oxford, The Bodleian Library, University of Oxford: Plate 30

Oxford, Reproduced by permission of the President and Fellows of Corpus Christi College, Oxford: Plates 27, 32

Paris, Photo: Bibliothèque Nationale de France: Plates 11, 12, 19

Paris, © Photo RMN: Plates 42, 76, 77; L'Hoir/Popovitch: Plate 18; Jean Schormans: Plate 31

Peissenburg, Joachim Blauel-ARTOTHEK: Plate 72

Troyes, Cliché des Musées de Troyes (Photographie: Jean-Marie Protte): Plate 20

Vanves, Photographie Giraudon: Plate 13

Vienna, © Kunthistorisches Museum: Plate 97

Vienna, Österreichische Nationalbibliothek, Musiksammlung (S.A.78.F.21): Plate 38

Washington, Andrew W. Mellon Collection © Board of Trustees, National Gallery of Art, Washington: Plates 48, 100

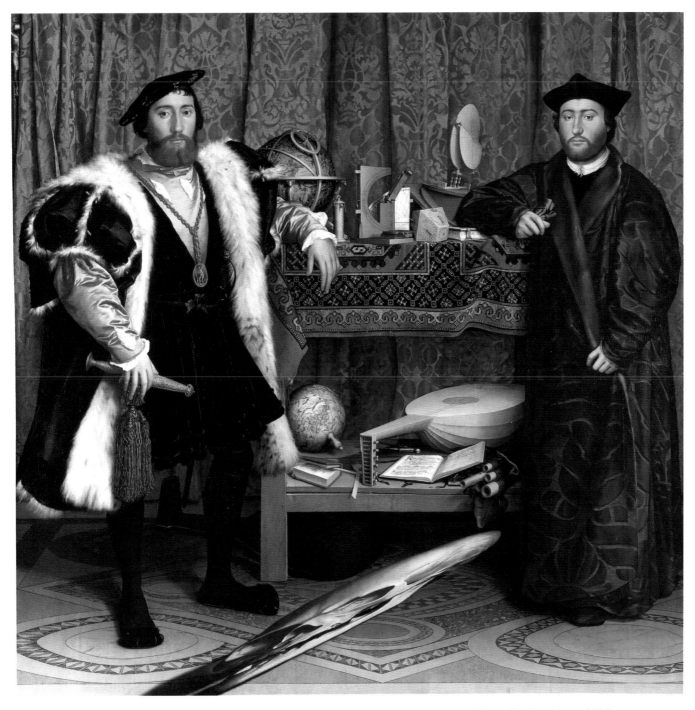

114 *Jean de Dinteville and Georges de Selve ('The Ambassadors')*, 1533. Oil on oak, 207 x 209.5 cm. London, National Gallery